THE PIPESTONE WOLVES

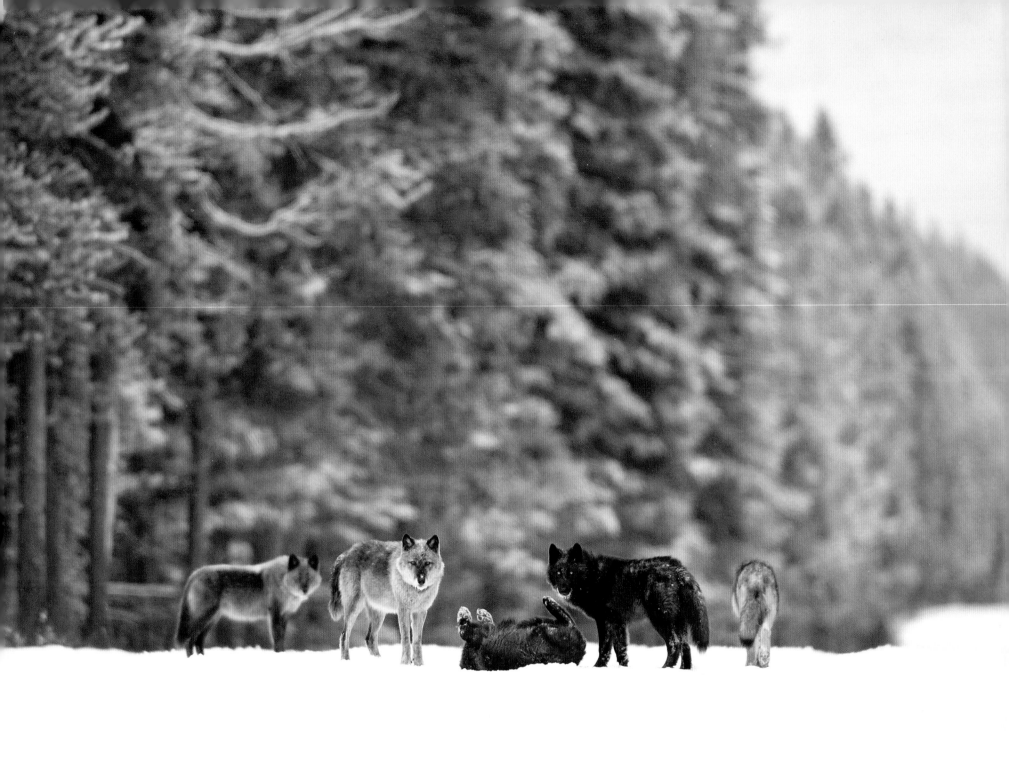

THE PIPESTONE WOLVES

The Rise and Fall of a Wolf Family

BY GÜNTHER BLOCH

Photography by John E. Marriott

Foreword by Mike Gibeau

Epilogue by Paul Paquet

RMB

RMB | Rocky Mountain Books Ltd.
rmbooks.com
@rmbooks
facebook.com/rmbooks

Cataloguing data available from Library and Archives Canada

ISBN 978-1-77160-160-3 (hardcover)

Printed and bound in China by 1010 Printing International Ltd.
Distributed in Canada by Heritage Group Distribution and in
the U.S. by Publishers Group West

For information on purchasing bulk quantities of this book, or
to obtain media excerpts or invite the author to speak at an event,
please visit rmbooks.com and select the "Contact Us" tab.

RMB | Rocky Mountain Books is dedicated to the environment
and committed to reducing the destruction of old-growth
forests. Our books are produced with respect for the future and
consideration for the past.

We acknowledge the financial support of the Government of
Canada through the Canada Book Fund and the Canada Council
for the Arts, and of the province of British Columbia through
the British Columbia Arts Council and the Book Publishing
Tax Credit.

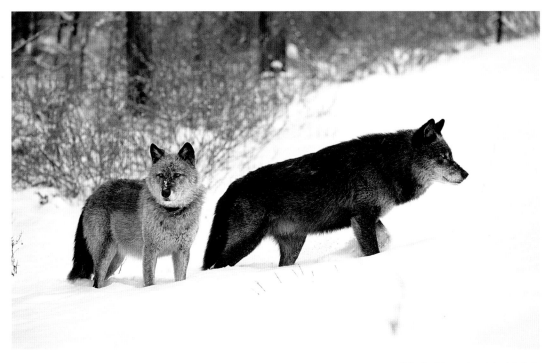

Faith (left) and Spirit (right).

This book is dedicated to the wolf parents Faith and Spirit and all of their wonderful sons and daughters who taught the authors of this book how to connect just a little bit closer with nature.

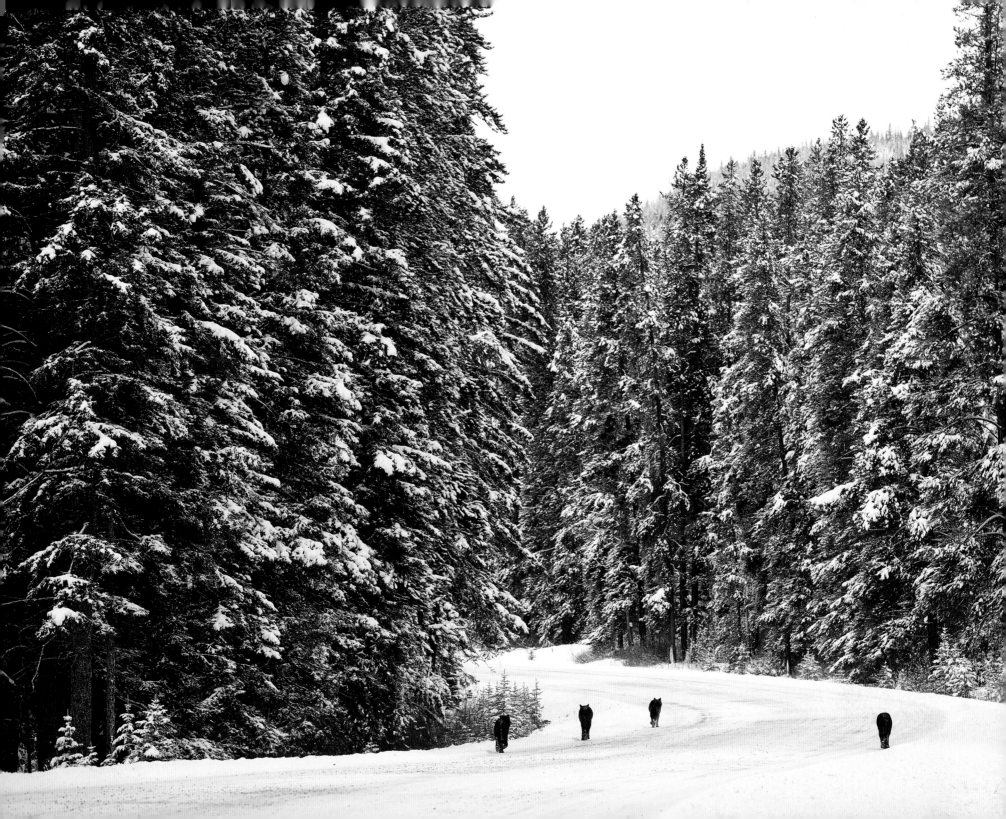

CONTENTS

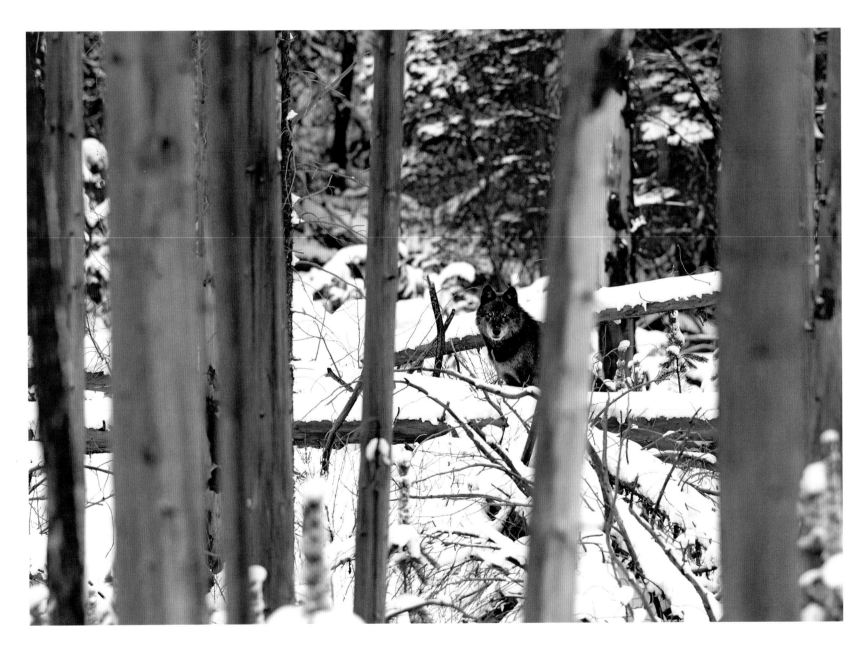

FOREWORD

ETHOLOGY IS THE STUDY of animal behaviour, and it's the cornerstone of our understanding of why animals do the things they do. And what more pure a form of ethology exists than direct observation? The hours, days, weeks, months and years of placing yourself in the surroundings of your subject species and just watching is both an underrated and underappreciated research technique here in North America. Indeed, many biologists have either forgotten about, or never even considered, using direct observation to gather data, opting instead for the high-tech "collar and foller" approach to scientific enquiry. These days you don't even have to participate in the "foller" part of the process. Just put a radio collar on your study subject and let the GPS data, which arrive via satellite on your notebook computer, amass as you sit in your pajamas sipping a latte. How times have changed... It is refreshing, then, that this book is all about that underrated and underappreciated skill of direct observation.

I first started my wildlife research career in the mid-1980s, studying black bears in Banff National Park. I got the job because at the time I had been a park warden for almost a decade and I knew how to capture bears and handle a gun. The approach we took then was much the same as other North American researchers. Capture an animal, put a radio collar on it, turn it loose and try to locate it daily through triangulation of the radio signals. By connecting the locations together over time, we inferred details of individuals' use patterns. From black bears, I moved on to study wolves in the late 1980s, coyotes in the early 1990s, followed by a decade of studying grizzly bears. Same technique, different species. By 2011, when I retired from Parks Canada as the carnivore specialist for the Mountain National Parks, I had amassed several dozen published papers in over a dozen of the world's most prestigious scientific journals, all from data based on the collar and foller approach to scientific enquiry.

Fortunately, however, early in my research career while we were studying wolves, Paul Paquet introduced me to

Spirit in the Sawbuck burn.

9

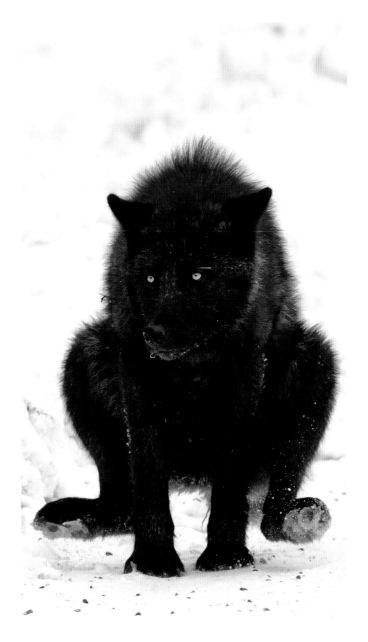

Lillian on the Bow Valley Parkway doing her version of wolf yoga in an attempt to clean her rear end.

Günther Bloch. Günther's approach was different. He chose to just watch animals – that direct observation technique many North Americans knew little about. One of my first recollections of spending time with Günther was while I was studying coyotes. While driving around my study area, I mentioned there was a coyote den just metres off the roadway. Günther really wanted to see the place, so we parked the truck some distance away and just sat there. Günther was quite content just to wait to see if anything happened. I, on the other hand, was quite anxious to move on as "nothing was happening." At the time, the whole notion of the power of observation was lost on me. Eventually, a number of coyote pups emerged and Günther got a stunning photo of them playing at the base of a willow bush.

Günther loved to watch wolves and so, through my position with Parks Canada, I arranged for Günther and his wife Karin to conduct den site observations of little-known wolf packs. For a number of years we would load Günther and Karin in a helicopter, fly them into some remote corner of the park and drop them off, telling them we'd be back in three weeks to pick them up. Observing wolves in the proximity of their den sites provided all kinds of previously unknown information, much to the distress and misgivings of some of my colleagues. Some of them never did get over that skepticism.

In the mid-1990s, I was invited to present some of my coyote research to the International Symposium on Canids in Cologne, Germany. While there, I took the opportunity to visit Günther and Karin at their dog-training facility and kennel in the Eifel mountains. One afternoon,

we visited a tourist town where we strolled through the pedestrian streets and central square. Every few metres, Günther was stopped by someone to chat. We dropped in to a local sidewalk cafe and we had barely sat down before people began to continually stop by, eager to shake Günther's hand, wanting to engage in a conversation about dogs, wolves or canid behaviour. The poor fellow hardly had time to eat his ice cream before it melted. As I watched this steady stream of people file by, I began to wonder if Günther was some kind of rock star I didn't know about. As I discovered later, he was indeed a celebrity due to a television show he hosted on dogs and dog training that had a larger following in Europe than the adult population of Canada. I came away from that trip understanding that Europeans take dog behaviour and training to another level that we just don't see in North America. Dogs are totally integrated into European society, and it is common to see dogs in restaurants, on the train and in shopping malls. And, of course, they are all very well behaved.

Over the past 20 years now, Günther has applied the same knowledge he had been sharing with the public in Germany to wild canids here in Canada. One of those to embrace the notion of gaining understanding through direct observation has been John Marriott. I first met John in the early 1990s when he took a job with Parks Canada. With an infectious smile and an abundance of enthusiasm, John has used the lens (literally) to bring our wild world to the public. His photography and all the understanding that goes into choreographing and creating those stunning images comes from spending time watching and waiting. That tenacity has earned him a reputation as one of Canada's foremost wildlife and nature photographers.

While there are many ways to gather information and gain knowledge, this volume is the culmination of decades of observing wolves in their natural environment. The book will elevate your overall understanding of canid behaviour and challenge the conventional wisdom of some long-held myths. Lastly, there are insights here that you would never discover with the collar and foller technique, and it all comes from being out there every day, all day, for years on end.

—Mike Gibeau, Ph.D.
Carnivore Specialist (retired), Parks Canada
Canmore, Alberta

Acknowledgements

First and foremost, I would like to thank my wife Karin for giving me the opportunity to be who I am.

My company, and all of our sponsors who have sponsored a wolf through our Canid Behaviour Centre have supported and funded us for the duration of the project, which has been much appreciated. Mike Gibeau and Paul Paquet have always supported our work and both have encouraged Karin and I to stick to our beliefs: always look at the big picture, observe animals from a distance in a respectful and responsible way and let them decide what to do next, and continue to tirelessly advocate on behalf of the wolves of Banff. We are grateful to both of them for their unwavering support over the years and for their assistance in our fieldwork, always answering our questions professionally and quickly. They were the perfect choices to write the foreword and epilogue of this book. We would like to thank Hendrik Bösch for conducting wolf observations for us after my heart attack and for his kind support, both logistically and financially. Hendrik's critical views were most appreciated; we admired his fiery spirit in the letters he wrote to Parks Canada and in the views he expressed on social media. What a great "straight shooter"! Karin and I would also like to thank Helga Drogies for her assistance and all her generosity in supporting our wolf behaviour work, as well as Elli Radinger, Christine Holst, Konstantin Ludwichowski, Doris de la Osa and all the other wolf sponsors who drove us around in their cars to enable us to discreetly observe the wolves without being recognized by rabid photographers and park visitors. We also appreciated all of the honest talks we had with some "Park people," whose names we will not publish, out of respect.

I also want to thank John Marriott again for making all of the edits and corrections on the original draft version of this book. And, of course, we want to thank our dogs Chinook, Jasper and Timber for all of their hard work, dedication and companionship. Without them, half of this book could not have been written with such accuracy. Timber, especially, did a fantastic job in showing us the wolves long before we had recognized them to be present. Timber died on February 1, 2016, after a long fight with cancer. However, in our minds, Timber will be forever remembered as the ultimate "timber wolf search dog."

We apologize if we have forgotten to mention anyone else who was involved in our wolf work: thank you all.

—Günther Bloch

Thank you to my wife, Jenn, for putting up with three consecutive years of having a husband addicted to looking for the Pipestones from dawn to dusk, seven days a week, 12 months a year. It can't be easy being married to a guy who thinks backtracking a family of wolves for four hours on snowshoes just to see "what they've been up to" is a good time. I also want to extend a very special thank you to Günther and Karin Bloch for teaching me most of what I know about wolves and for giving me the opportunity to be a part of this incredible and timely book. And, finally, thank you to everyone else who helped me in the course of this project: you know who you are.

—John E. Marriott

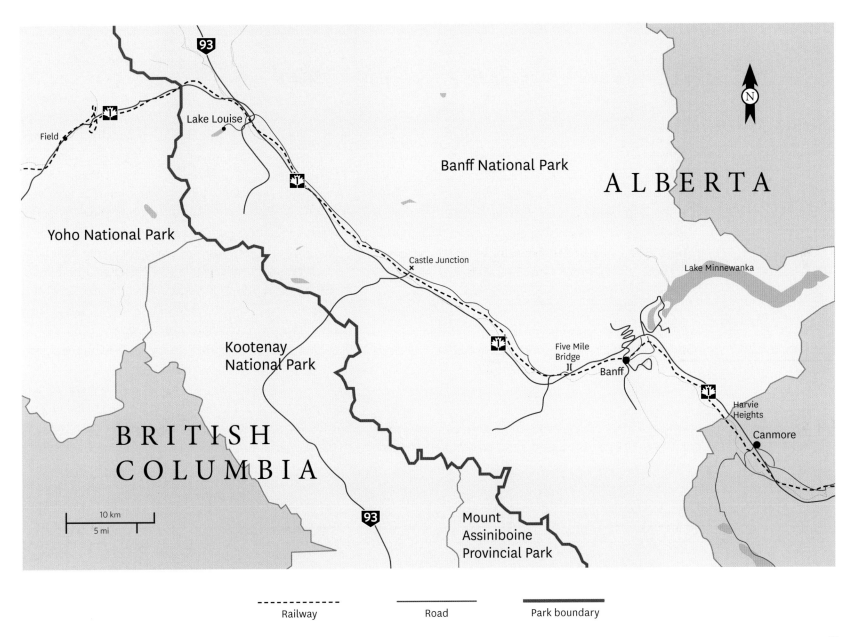

Railway Road Park boundary

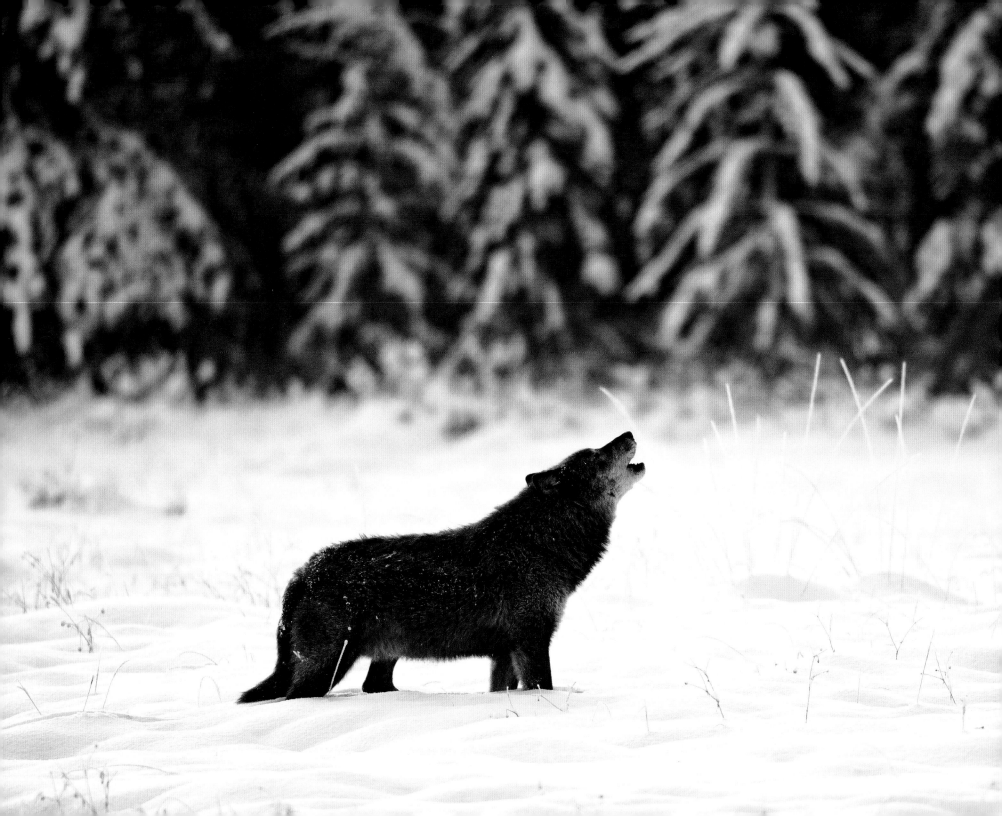

INTRODUCTION

WHEN WE THINK OF WOLVES, we tend to think of mysterious animals well hidden in the forest and rarely seen. Most of the time that holds true. Wolves are indeed secretive enough by nature that information on their behaviour in the wild (their behavioural ecology) is still rare. Nine out of ten books describing the social lives of wolves are based on observations of wolves living in enclosures. The problem with this is that we know that captive wolves do not interact in exactly the same fashion as wild wolves do, but we do not know precisely what the differences are. What if captive wolves actually behave more like human prisoners do?

In order to find out more about how wild wolves live and interact with one another, we needed to find an area where we could observe wolf families at length for years on end. And in Canada, that's not particularly easy to do. Wild areas that are home to wolves are vanishing before our eyes, and the ones that do remain intact often see wolves heavily persecuted – hunted, trapped and poisoned – in favour of ranching and hunting interests, as well as a misguided attempt to "save" caribou.

Even "protected landscapes," such as the picturesque Canadian Rocky Mountain national parks, are no longer safe havens for a number of different wildlife species. While wild animals in Banff, Canada's flagship national park, don't have to deal with hunting or trapping, they do have to live in a human-dominated environment, the product of a thriving tourism industry and greed-inspired overdevelopment (after all, money is what makes the world go round, right?).

Despite this human-saturated setting in Canada's first national park, Banff is still home to a special subspecies of the gray wolf. These mighty timber wolves (*Canis lupus lycaon*) live in many of the protected valleys and forests in the park, including the densely populated and developed Bow Valley between Banff and Lake Louise.

Modern technology such as GPS radio collars and remote infrared wildlife cameras have helped provide

Spirit howling near Moose Meadows.

Four members of the family near Baker Creek in November 2011, including Faith in the lead and Spirit third in line.

some ecological insights into the behaviour patterns and habits of these Banff wolves, but they tell us little to nothing about the important details that are the essence of "wolf family living." There was really only one way to uncover those details: via long-term observation. And so, more than 24 years ago, we embarked on our Bow Valley Wolf Behaviour Observations project. This book is a result of those observations – the culmination of several thousand direct sightings of wild wolves in the central Canadian Rocky Mountains.

The challenges facing us were unique. Direct observations of an animal that's as elusive and tough to find as the wolf are not easy, especially when we needed long enough observations to gather information on individual behaviour. We knew that some wildlife managers believed that wolf societies all operate in the same way and that "modifying" their behaviour is an easy thing for them to accomplish, but we felt that behaviours and habits in an environment such as the Bow River Valley differed not only among the different wolf families living in the valley over time but also from individual to individual within those families. So in order to "manage" and understand the evolution of wolf behaviour within its territory in a man-made environment, we needed to figure out how to make these direct observations. Since habitat dictates behaviour, we know that it is impossible for all wolves to behave the same and we know that as observers we are light years away from "knowing it all."

Most national park visitors who are fortunate enough to see wolves in Banff are lucky if the encounter lasts a minute. Yet this is hardly enough time to take a photo or

count the number of wolves, let alone make critical observations on behaviours and interactions.

But imagine instead if you were able to watch wolves in the wild for hours and hours, for days and even weeks in a row, for years on end. Imagine finding wolves from a vehicle by using specially trained domestic dogs. Imagine travelling respectfully at a distance with an entire wolf family. Imagine carrying out long-term observations for decades without disturbing the daily routines of the wolves you were following. Imagine collecting detailed field notes on wolf behaviour and making new discoveries about how a wolf family is structured socially. Mission impossible? No. In fact, our project was so successful that we got to know every wolf in this book personally, which is why we named each one. While Parks Canada gives their research animals numbers rather than names, we have always felt that living creatures that are observed closely should be recognized and respected as individuals. Products get numbers, not living creatures.

Why not just leave the wolves alone? We thought about this, but there was more to our project than just observing behaviour. If one were to believe the public relations department of the national parks, then everything in Banff is doing wonderfully and the wolf population is just fine. But even before our project began, we suspected that everything was not all fine with the park's wolves and that this one-sided message was misleading. So the primary objective of our fieldwork was to give these wolves a voice by directly observing the effects of humans on the everyday life of a particular wolf family.

As part of our project, my wife Karin and I established

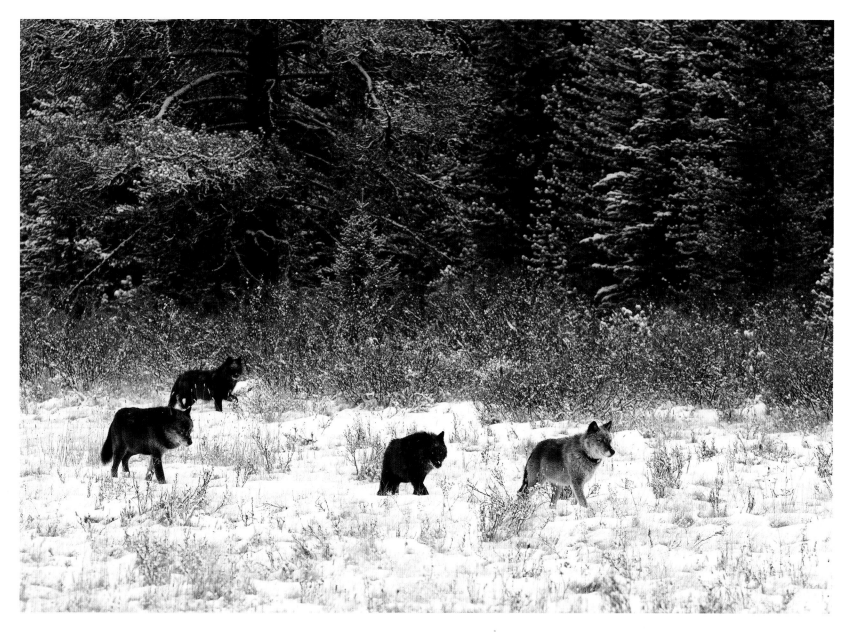

an innovative new technique for finding wolves for long-term field observations that hadn't been attempted before. Using the scenting capabilities of our four-legged friends, our dogs, we were able to track and find wolves from our vehicle in a way that had never been done before. However, we were still extremely careful to ensure that our new approach and methodology were carried out in a very responsible way. After all, we were interested in documenting natural wolf behaviour, not in observing fleeing creatures. We established an ethical principle at the beginning: we would never run after the wolves or chase them.

Some readers may argue that the terms we use in this book such as "wolf family," "moral life" or "character/personality" sound too anthropomorphic. Until recently, behaviourists characterized all animals as being purely instinctually driven creatures. We disagree. Our beliefs line up more with renowned animal behaviour researchers such as Marc Bekoff, Jane Goodall, George Schaller, Richard Wrangham or Dale Peterson, the latter of whom argued in his book *The Moral Lives of Animals*, published in 2011, that the main function of morality is to negotiate inherent serious conflict between self and others. As far as wolves are concerned, the majority of people are definitely more familiar with the term "a pack of wolves" than they are with "wolf family" when it comes to describing a wolf society. However, the widespread term "pack" suggests a strict, linear, rank-order hierarchy, which we very rarely observed in our wild subjects.

In Chapter 1 we delve into general wolf information and explain some of the different behaviours we will discuss throughout the book. In particular, we answer some of the questions we are most often asked about wolf behaviour and terminology. We'll describe why often-used terms like "pack," "alpha wolf" and "pecking order" are no longer as valid as they were once thought to be.

Chapters 2 through 4 are the heart and soul of this book – the story of the rise and fall of "the Pipestones." Chapter 2 introduces you to the Pipestones and vividly and comprehensively describes how they rose to prominence in the Bow Valley using remarkable adaptive behaviour strategies. We methodically explain the different character types in the family that we got to know over the years. How wolf pups get raised in the traditional and cultural environment of their parents and how they show a range of emotions is detailed along with our observations on an age-related, parent–offspring formal dominance system with a very distinguishable three-class society.

In chapter 3, we discuss the golden years of the Pipestones and delve further into several forms of dominance we witnessed during this period in relation not only to social status and age but also to gender and character types and even momentary conflicts over food. We found the social status of the "leader of the pack" was not related to sex – our observations regularly documented adult females functioning and acting as the primary decision makers within family groups. And we discovered that our so-called alpha wolves were not always the first to feed at kills, often giving way to socially subordinate family members, especially juveniles.

Chapter 4 covers the tragic and heart-wrenching fall of the Pipestone dynasty and explains why the family's leaders were not able to maintain their home territory.

In short, we look at how the continued transformation of Banff into a giant amusement park under Parks Canada's management plan, focused on mass tourism rather than on ecological balance, led in part to the demise of the Pipestones.

In chapter 5, we attempt to look ahead and predict what kind of a future wolves will have in the Bow Valley and in Banff National Park. As we write this, a new wolf family (the "Banff Town Pack") arrived in Banff in early 2015 and appears to have established territory in the entire Bow River Valley in spring 2016. How long will they last? Will Parks Canada re-embrace its philosophy of environmental stewardship and turn things around in time to help not only this wolf family but other wildlife as well, or will it be the same old story with a familiar sad ending?

In the epilogue, Dr. Paul Paquet provides his thoughts as one of the world's leading large-carnivore scientists on the ecological stresses that the wolves and other wildlife in Banff are facing every day of their lives as the park's mass tourism industry grows unchecked.

Finally, in the appendices you'll find very detailed information on the Pipestones' social structure, population trends, sex and age ratios, character types and mortalities over the six years they ruled the Bow Valley.

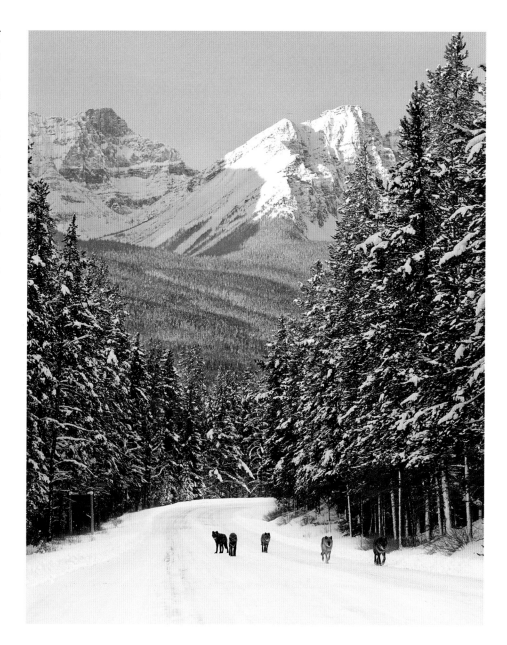

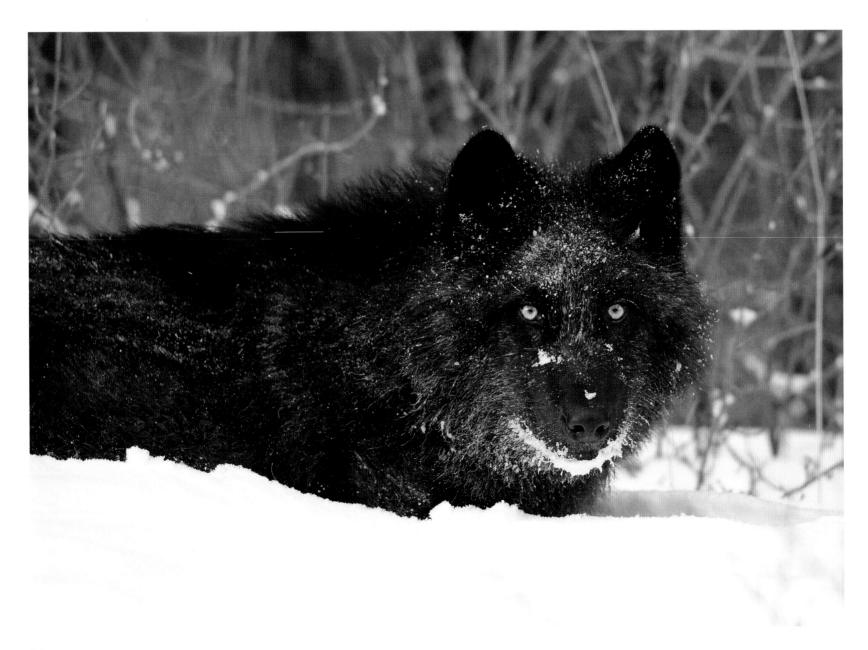

Photographer's Note

Wolves are one of the most difficult subjects to photograph in the wild. As Günther has described in this book, they are elusive animals, most commonly active at dawn and dusk when there is an obvious lack of decent light for photography. But light is just one of the many challenges I faced trying to get good photos of the Pipestones.

From fall 2009 to summer 2012, I fed my growing addiction to wolves and spent thousands of hours driving, hiking and snowshoeing in the Bow Valley trying to find the Pipestones. Occasionally, they were easy to find – I would drive around a corner and the wolves would be standing in the middle of the road – but more commonly we had to work at it. It was often a game of sitting and waiting after getting a signal from Günther that the wolves were around or after spotting tracks in the snow heading in a certain direction. Fairly often, and most challenging by far, it would be me on my own after Günther and Karin had returned home for the afternoon or when they were away in Germany tending to business. I would backtrack incessantly through the snow and mud, often walking tens of kilometres in a day, trying to figure out the patterns of the wolves so that I might finally have some information to pass on to Günther instead of the other way around.

I first photographed wild wolves in Mount Robson Provincial Park in British Columbia in 1997. For the next decade, I continued to photograph them sporadically whenever I had a chance run-in with them. But when I had an unforgettable encounter with Delinda and the Bow Valley wolf family in June 2007, something changed in me forever.

By the time the Pipestones began to appear regularly along the Bow Valley Parkway in November 2009, I was ready to feed my new addiction in full force. I joined Günther and Karin as much as I could while still running my full-time wildlife photography business with all of the travel and office work associated with it. That meant that in the winter I was often out searching for the Pipestones five to six days a week in the Bow Valley, in the summer I was out three to four days a week and in the spring and fall shoulder seasons, my busiest time for trips to other parts of the country, I was able to get out one to two days a week on average.

I think many of you would assume that going out on a daily basis tagging along behind Günther and Karin would be a dream for a wildlife photographer – and it was. But while we saw wolves fairly frequently, photographing them was an entirely different story. And getting good photographs of them seemed almost impossible on many days. Looking back now, my entire collection of Pipestone photos is made up almost exclusively of about 30 good days in the field, where the light was "good enough," the wolves were cooperative and close enough, the wolves weren't disturbed by traffic, tourists or other photographers and the weather wasn't a factor.

Günther and Karin were painstakingly diligent at keeping their distance from the wolves (though sometimes the wolves did choose to come closer), so I would often be trying to photograph them from hundreds of metres away, which was simply too far in most cases to get good sharp shots. Getting out the car and pursuing them on foot simply wasn't an option, as Günther has clearly outlined

Djingo in November 2011.

21

in the book, so if the wolves decided to keep their distance, as they often did, then I spent my time just watching them and revelling in the experience.

There were times when it seemed everything was working out, only to have my once-in-a-lifetime photos foiled by one factor I hadn't considered or couldn't do anything about. For instance, on the day we watched incredulously as Blizzard played with a mouse in the middle of the road in front of us, my vehicle was behind Günther's on a narrow section of the Bow Valley Parkway and my only choice to shoot the action was to pop out of my sunroof and photograph over the hood of my car. Unfortunately, it was −28°C that morning and the heat waves coming off my cooling engine left all of the pictures looking unfocused.

I was extremely fortunate to learn most of what I know about wolves from Günther, including the wolf behaviour knowledge he imparted to me. But perhaps the most important thing he taught me was how to ethically photograph wolves. When I first started photographing wildlife, I had no sense of just letting animals be and do their thing while I photographed from the sidelines. Rather, it was all about me getting the shot and hoping the subject didn't run away. My first few wolf encounters in the 1990s all went more or less the same way: see wolf, jump out of car, chase wolf with camera, wolf runs away, John gets zero good shots.

By the time I ran into Delinda in June 2007, I was in the process of developing a completely different set of ethics for photographing wildlife – it had finally dawned on me that it was not about getting the shot at all costs but that the welfare of the animal always had to come first. But Günther was the one who taught me first-hand how to employ these ethics when photographing wolves. I learned that it was pointless, and disruptive to the wolves, to chase them on foot or with a vehicle. Instead, Günther showed me that a much more productive way to get good shots was to pull off the road ahead, turn off the vehicle's engine and sit quietly and patiently until events unfolded in front of you.

That does not mean that I haven't made mistakes over the years. There is always a part of every photographer that wants to get closer, change angles, move a tiny bit to the left. And while there are certainly a few instances I can think of where I made mistakes and disturbed the Pipestones, by and large I am extremely proud to be able to say that every photograph you see in this book was acquired naturally, with the wolves simply being wolves, unperturbed by my presence.

In July 2012, with a vast collection of Pipestone wolf images in my library (1,853 "keepers" up to that point), and a growing horde of photographers chasing the wolves daily on the Bow Valley Parkway, I made a decision to stop following the Pipestones. I felt I was becoming a part of the problem, so I went cold turkey on the wolves, hoping to set an example for many of the younger photographers who were just getting into wildlife photography and, in particular, wolf photography. From that date onwards, I only photographed the Pipestones three more times: on October 23, 2012, during a chance encounter on Highway 93 South; on December 3, 2013 (on the first morning I had driven the Bow Valley Parkway since July 2012); and on February 19, 2014, when I drove the Bow Valley Parkway for the second and last time before the Pipestones disappeared.

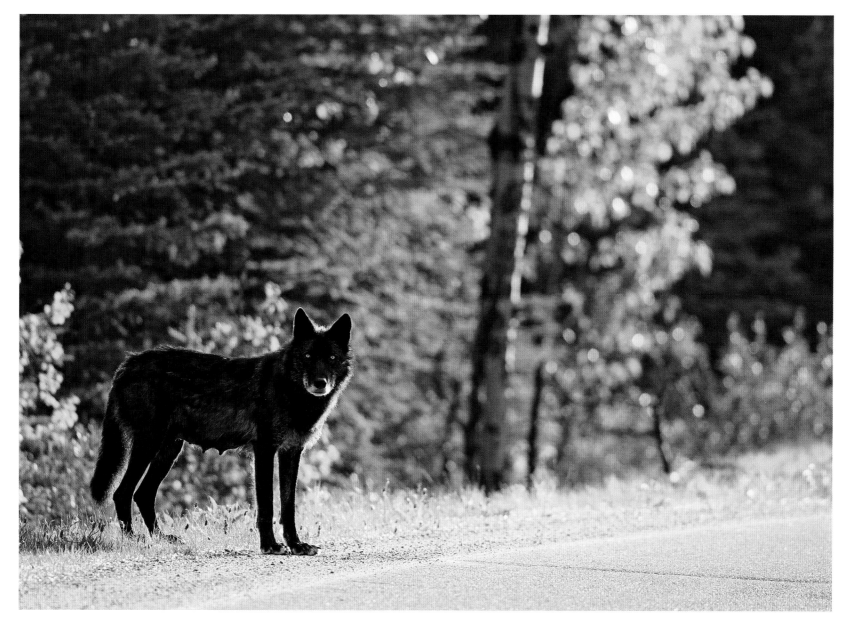

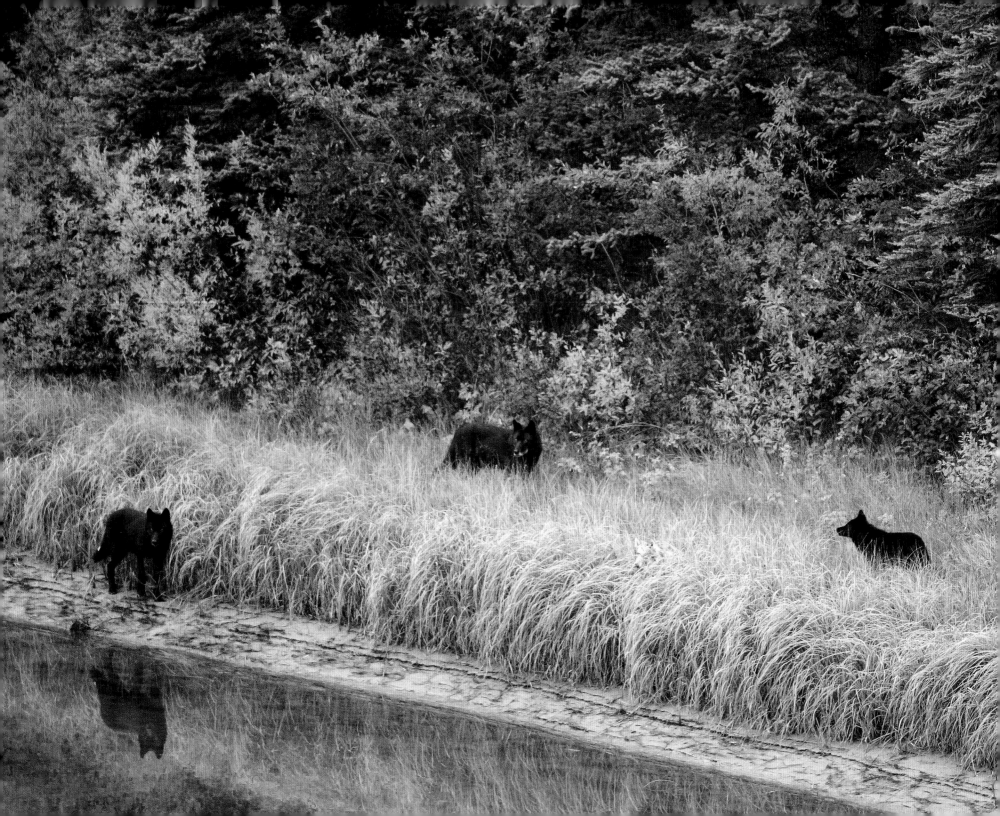

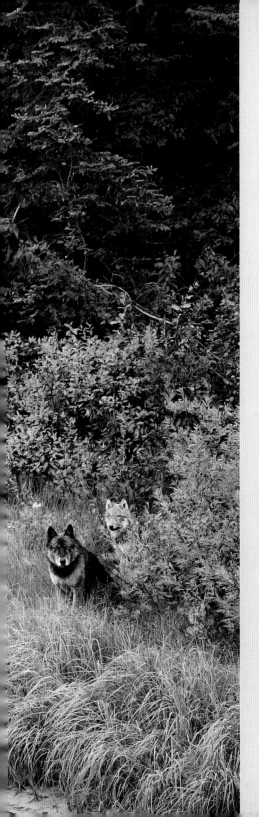

Wolves like the Bow Valley family, pictured here in September 2007, have long been adapted to living with humans in the park.

FAQs about Our Fascinating Observations on Rocky Mountain Timber Wolves

For the past 23 years, we have been following Banff's wolves through the trials and tribulations of raising their families in one of the world's most famous, and most heavily visited, national parks. In order to provide sufficient information documenting changes in wild wolf family dynamics, we have collected as many methodically written field notes and as much film footage as we could from the spring of 1992 until late fall of 2014. The information published in this book helps to improve our understanding of the adaptation process that wolves living in areas close to humans and/or cars have to go through to

Diane with a young pup in the Spray Valley, 1992.
PHOTO | GÜNTHER BLOCH

survive. It should also contribute to our knowledge of the effects of human activities, infrastructure and vehicle traffic on movement and hunting patterns, as well as on mortality and the social structure of wolf families.

Our fieldwork involved patient, time-consuming behaviour observations made day after day for over 20 consecutive years, resulting in matchless ecological and behavioural insights that go well beyond the usual useful information that comes from studying wild wolves using telemetry, GPS and radio collaring.

What follows are the ten questions we get asked the most concerning our constant daily observations for decades.

When Did You Start Working in the Field Observing Wild Canids?

The first wolf sighting my wife Karin and I had in the wild was in Jasper National Park during a vacation in October 1988. Watching an entire group of majestic black timber wolves chasing a beaver (they didn't succeed in catching it) was a moment we will never forget. It was the start of a newfound fascination with wolves, and we have watched wild wolves every year since that first magical encounter.

However, our wolf research did not start until May of 1992, almost four years later. That spring, while Karin remained back home in Germany running our Canid Behaviour Centre (studying the behaviour ecology of domestic dogs and captive wolves is where our original expertise lay), I began documenting wolf behaviour for Parks Canada in Banff, carrying out den site observations in the Bow River Valley.

From day one, all of the behavioural work we did was based on the wolf research conducted by Dr. Erik Zimen in Italy and the results of his wolf–dog behaviour comparison. Our direct observations at several den site locations were carried out under the direction of renowned behaviour ecologist Dr. Paul Paquet. For Paul, it simply wasn't enough to only do telemetry work like most wolf researchers do; he wanted to have direct observation data as well. So right from the start, in 1992, Paul encouraged me to write methodically organized behaviour protocols based on direct sightings, which were later published in Paul's final report on the behaviour ecology of gray wolves in 1993. It was exactly the type of work I was already used to doing at our Canid Behaviour Centre. Being German, I always tried as hard as I could to do things systematically and double-checking my facts – nothing is ever done without putting a lot of effort into organization.

There was another very important point I learned early on that I tried to remember every single day of my fieldwork: behaviour and the surrounding environment are two sides of the same story. Focusing solely on observing wolf behaviour just wasn't going to cut it; I also had to study the environment the wolves were living in to round out the big picture.

That first spring, one of Paul's students, Shelley Alexander, directed me to a location in the core area of the Spray wolf family, near the Trans-Canada Highway, where I could hide in a carefully pre-prepared tree stand surrounded by thick shrubs to watch the wolves undisturbed. As long as the wind direction was in my favour, I sat at the observation place from dawn to dusk, collecting daily field

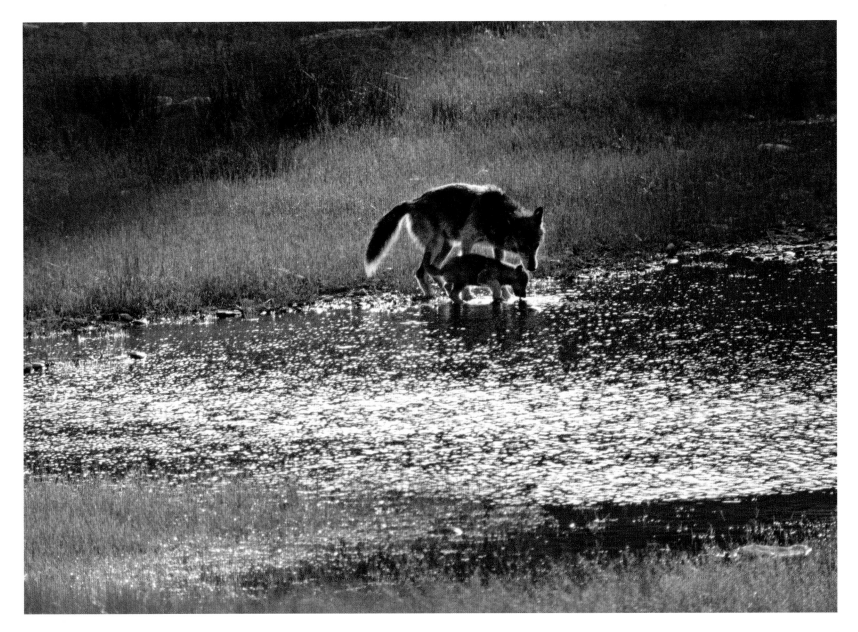

notes and filming the social life of these wild Spray family wolves. For those of you who love wolves like I do, you can imagine what a dream come true this was. It was truly a sensational feeling to sit there on the edge of a wolf family's "living room" (rendezvous site) and watch them day after day after day, documenting it all.

Right from the beginning I learned that "real" wolf life is not like what we're used to reading about in books. I watched a beautiful female named "Diane" raise pups that were not her own (the biological mother of the pups had been killed on the Trans-Canada Highway just weeks prior to my first observation). Astonishingly enough, Diane, now the female leader of this family of seven wolves, had started lactating to be able to provide for the two seven-week-old pups. It taught me a very important lesson in studying wolves: nothing is impossible!

As I'm sure many of you can imagine, I had a great time watching the wolves and informing Paul every day of my findings on the social structure of the Spray family.

I continued to collect hard data on the social organization of wolves and especially on the adult individuals taking care of pups. It amazed me how similar they were to human families with their "uncles," "aunts," "social helpers" and "babysitters." And I have to admit that one thing popped into my mind right away: we humans could learn a lot from the civilized lessons provided by wolves and other canids – but only if we are humble enough to do so.

All of my research conducted near the den and rendezvous site of the Sprays was completely stationary. Every morning I went to the same spot, where I would lie down in deep grass and wait for the wolves or any other wildlife

to show up. There were a lot of students before me who had tried observing the wolves, yet, with the exception of a student named Elisabeth, who watched the Sprays in 1991, all of the other students had come away somewhat frustrated from the experience because they had only seen the wolves a few times for just a second or two. In fact, I recall Shelley warning me, "Don't be disappointed when you don't see the wolves, especially up close. That's normal." And I thought, "Oh shit! That's why I had come to Canada to live out my dream, I wanted to see wolves up close!"

At the time, I was a heavy smoker. Everybody in Canada kept shaking their heads when they saw me standing there with a cigarette in one hand and a Coke can in the other – the "crazy" German. So on my first day at the den location, I sat down in my hiding spot and rolled a cigarette. And before I even had time to finish rolling it, as if I was being served on a golden platter, Diane walked out of the den to stand 200 metres in front of me, followed by two gray pups. All three of them wandered over to a nearby pond and drank. I was extremely nervous but still managed to film the whole scene, including when Diane approached to within just ten metres of me and my camera. It was the first time I had ever experienced (and collected evidence of) wild wolves behaving curiously toward humans; there was not even a hint of aggression or danger. And when it was over, I sat there in awe of what I'd just seen. I was dumbstruck at my good luck.

Yet my luck continued. Every day I saw at least one family member, and most days I saw several. Incredibly, I broke the record for wolf visuals at the den site within the first four weeks.

Every spring after that for years I would come from Germany to Canada for den site observations and considered myself "the lucky one."

What Was the Purpose of Your Fieldwork with the Pipestones?

When we began studying the Pipestone wolf family in 2008, we wanted to outline the differences between a wolf "pack" and a wolf family, and we wanted to describe the wolves' different personality types and how this impacted their survival rates in the Bow Valley. Watching wolves in the wild is absolutely fascinating. On one hand you think you know it all after a few years of observations, but then you get confronted by new facts and realize you really don't know anything. Not every wolf family in the wild behaves the same way. There always seems to be a moment that catches you off guard, where you sit with an open mouth and think, "I'll be damned, I had no idea!" Of course, there are also those endless (extremely) boring periods, hours and hours on end, where nothing happens and you don't see or hear a thing.

We knew that our enthusiasm for watching wolves wasn't going to fund us. Nobody was paying us to watch the Pipestones (the majority of our 20-plus years of wolf work in Banff has been without pay), so we needed to finance our work in other ways. Fortunately for us, our Canid Behaviour Centre, established in the spring of 1977, was able to provide the financial cushion we needed for our project. Through the centre, we trained 30,000 human–dog teams and ran a dog kennel, and my expertise

with domestic dog and wolf behaviour led to giving seminars throughout Europe, teaching at a private academy and writing bestselling nonfiction books and over 100 magazine articles.

As a professional canid behaviour consultant in Germany and other European countries such as Switzerland and Austria, my main interest in studying wild wolves was to compare "typical" wolf and dog behaviour, as well as to learn more about wolves' social structure and communications systems. But what should be considered as "typical behaviour" for wild living wolves? We hoped to find out.

Dog people love to learn nuances of wolf behaviour, since the wolf is the ancestor of all domestic dogs. Dr. Erich Klinghammer, the founder of the research and education centre Wolf Park in Indiana, provided us with the great opportunity to study the behavioural ecology of captive wolves in the spring of 1990. We also received formal ethological training in wolves and dogs from Eberhard Trumler and Dr. Erik Zimen (both students of Konrad Lorenz) and by Professor Ray Coppinger, who, in particular, taught us the wonders of the world of livestock guardian dogs. So we had learnt fundamental behaviour of several canine species from the ground up, but it was still not enough to fully understand a canine species that is extremely mobile and has to provide for itself. So the main purpose of our observation work was to figure out how wild wolves raise their pups, how they prepare them socio-emotionally for every single stage of life and how all of them learn cognitive abilities.

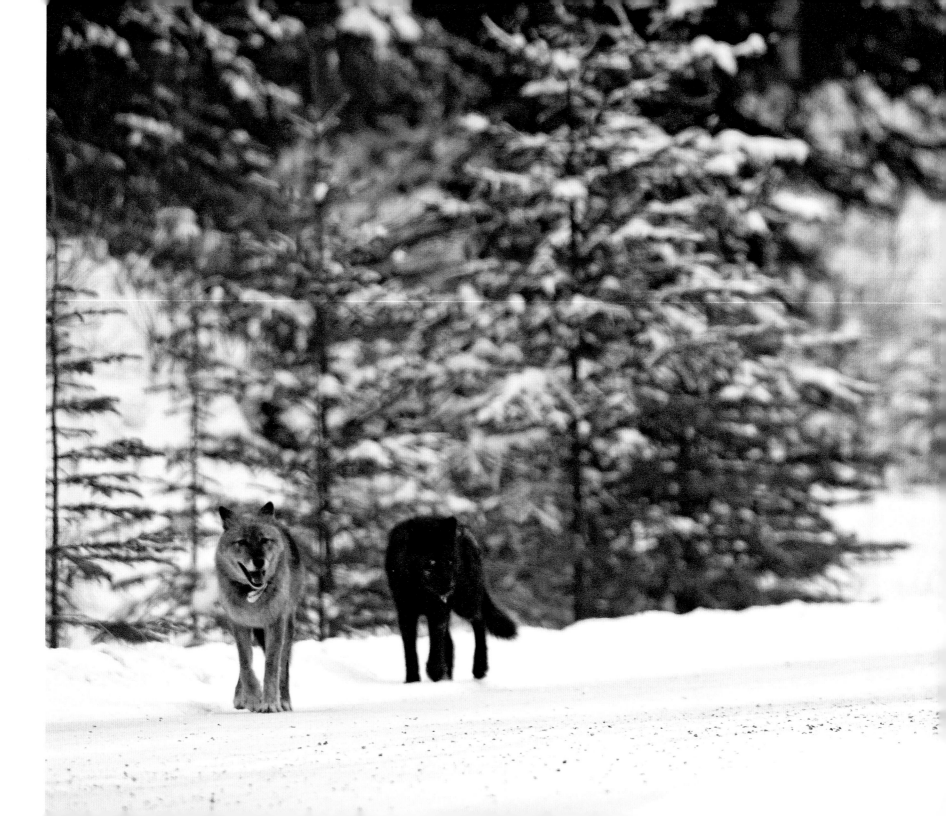

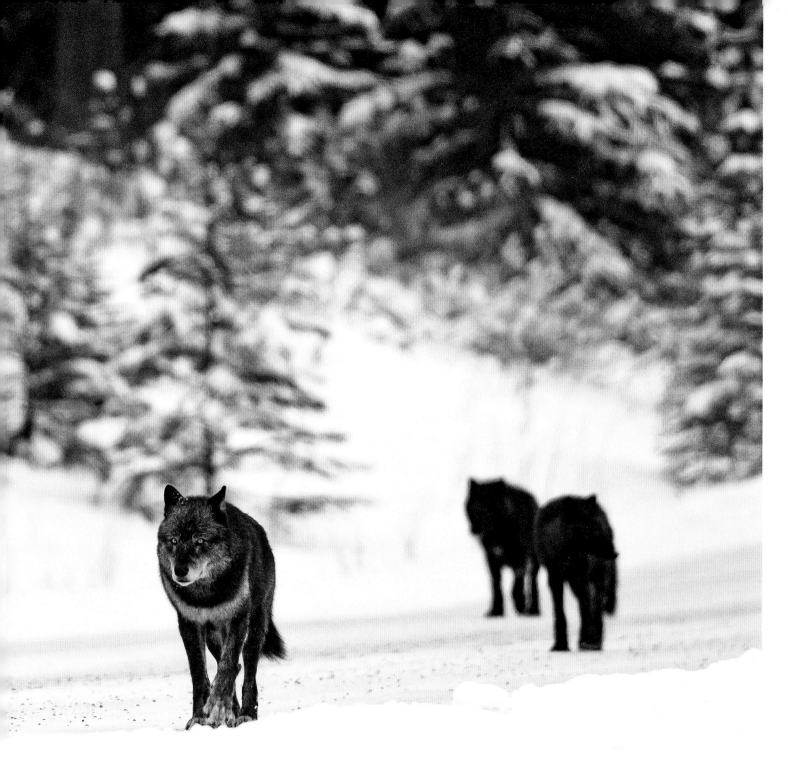

One of the purposes of our fieldwork was to outline the differences between a wolf "pack" and a wolf family. Here, Spirit (middle) and Faith (far left) lead the family down a section of the Bow Valley Parkway in January 2011.

31

The scientific community is split on whether or not animals like wolves are able to show cognitive behaviour and emotions; however, the discussion is too abstract until someone actually goes out there and watches wolves long enough to describe their body language and adaptive behaviour strategies as precisely as possible in an environmental context. That was one of the central questions we asked ourselves during this project: Is there any socio-emotional cooperation and mutual consideration (of different individual needs) between wolves? In other words, do they help each other, or do they simply abandon handicapped and injured individuals because they are only "instinct-driven machines" like many wildlife behaviourists argue?

And, finally, we were interested in answering this question: How do humans shape wild wolf behaviour in their environment?

How Was It Possible to Watch the Natural Behaviour of Extremely Mobile and Elusive Wolves?

Because we were interested in finding out how all of the tourists in Banff influenced wolf behaviour, we first had to investigate what "typical" behaviour was for wild wolves in closed areas in the park devoid of people. Den sites and rendezvous locations are particularly sensitive areas and therefore are often closed to the public. So, in the years 1992 – 1998, with a special permit in hand, issued by Parks Canada, our fieldwork was restricted to stationary observations in these areas closed to the public, where we were like flies on the walls of the wolves' "living rooms."

Later, we expanded our research not only to den and rendezvous sites but also to more detailed behavioural insights when the wolves were on the move. This portion of our project began in the winter of 1998 – 1999.

So how did we find the wolves within their huge territory on a daily basis? We desperately wanted to be able to detail behaviour beyond the den and rendezvous sites, so we had to come up with an innovative way to view the wolves on the move. We had always been impressed by the detailed behaviour descriptions of wolves like "Mom" and "Left Shoulder" in the early nineties by Dave Mech and Jim Brandenburg on Ellesmere Island in Nunavut, but we couldn't use all-terrain vehicles to follow the Banff wolves like they had done in the Arctic. We had also watched the wildlife movies made by Bob Landis in Yellowstone National Park and Jeff Turner in Canada that showed detailed wolf behaviour. But, similarly, we could not follow the wolves in Banff by helicopter like many of the best filmmakers had. So we asked ourselves: Why not copy the extraordinarily successful system of watching wildlife in Africa? The idea appealed to us of slowly and ethically desensitizing wolves to our presence by observing them from a vehicle, just like a lot of people have done while on safari.

From the very beginning of our den site observations, we always tried our best to maintain the highest level of ethical standards. Every day our goal was to avoid trampling on wildlife's nerves, and this remained our personal ethical motto for the entire project from the Spray wolves in 1992 to the Pipestones in 2014. We patiently stayed in our vehicle when wolves were nearby, drove to the far side

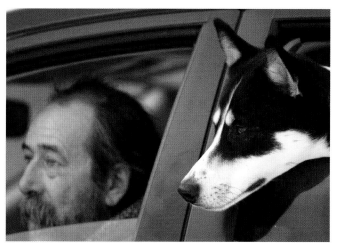

Spirit crossing the road in front of our car on the Bow Valley Parkway in January 2011.

Timber hard at work on the Bow Valley Parkway.

of the road to give the animals space to roam and immediately turned off the engine when we saw wolves or suspected they were close by.

With a Little Help from Our Friends

There have always been three ways for researchers to find wolves: by luck/seeing them (by having a wolf cross the road in front of you as you drive along, for instance); by backtracking them (in snow or mud); and by homing in on them using telemetry (provided the wolf is collared). However, being canine behaviour observers, we decided to try using dogs in our field research to help us find wolves. We chose what is, even today, the very natural breed West Siberian Laika and drove through Banff with our dogs Chinook, followed by Jasper and then Timber, in the car, sitting in the back seat with their noses out the back window. The dogs would sniff the air, having been trained, using positive reinforcement, to "sign" the location of the wolf/wolves to us. It proved to be highly successful – the dogs were truly fantastic at finding the wolves.

Of course, our dogs were specially trained and behaviourally conditioned to not only find wolves but to not disturb them in any way. We won't divulge our training methods for fear that they'll be copied and imitated incorrectly, but our West Siberian Laika dogs really did a tremendous job of helping us during our project. While they are often very independent working dogs, they also required a lot of professional communication from us, their human partners.

We knew that one mistake could end a day of wolf watching in an instant and that even staying in close proximity to wild wolves in a car could be unacceptably intrusive if it wasn't done properly. Our dogs were trained to

33

Spirit resting close
to John's vehicle in
December 2009.

find the wolves and then to sit or lie down and be quiet. They were not allowed to bark at the wolves, move around in the car or jump against the car windows, display threatening body postures or signal interspecific aggression of any sort toward a wolf. Together, we quickly learned what we had to do to not disturb the dog's wild ancestor.

How Did You Manage to Avoid Interfering with the Wolves?

Wolves living in a human-dominated landscape often appear to behave in a pretty relaxed manner. They always know exactly what humans are doing, and if we think about it, it's the wolves that are observing us, not the other way around. Wolves are also aware of every human element in their environment. So, with that knowledge, it's impossible to have a research concept that is completely free from interference. Even so-called noninvasive camera traps turn out to influence animal behaviour. If you were to check the camera trap photos (as we did hundreds of times), you would notice immediately that nearly all of the animals detected the "hidden" camera right away. What differs is the individual's reaction to the camera: the curious ones might sniff or even nibble at it, while the shy ones might watch the camera from a distance camouflaged behind a bush. Whatever humans do, animals are aware of it. They are not stupid. So being "intrusive" is relative; professionally conducted observations are not irresponsible or unethical, even though they will have some impact on the momentary behaviour of the subjects.

There is no way to describe wolf behaviour without knowing every single individual making up a wolf family. Otherwise there would always be gaps in knowledge, and any statements made on social structure or behaviour would be speculative. This is one of the primary reasons why we wanted to learn as much as we could about each wolf we observed, so we could be as informed as possible about their cultural behaviour patterns.

We set out basic guidelines that we tried to follow to minimize our interference while collecting our observation data. For example, we always kept a distance of a minimum of 200 metres when we saw wolves approaching on the road or when we followed them in our vehicle. That does not mean the wolves didn't choose to come closer at times, because they certainly did. But that was a behaviour chosen by a wolf or several wolves – not influenced by us. We always, without exception, completely avoided driving into the midst of travelling wolves, like we often saw ignorant tourists or disrespectful local wildlife photographers doing.

When we were near the wolves, they always behaved absolutely naturally. By this I mean that their behaviour was relaxed; we never saw them running away from us, and their body postures did not show any signs of fear (e.g., tails tucked, ears flattened and/or stress-related yawning). Their natural behaviour meant that they just did what wild wolves always do: travelling; hunting; patrolling and scent marking their territory; controlling all sorts of resources (e.g., controlling and staying near kills, resting spots and sleeping spots); playing; chasing mice or splashing around in a pond. Sometimes the wolves even rested close to our car. Instead of looking at those wolves as being "too habituated," to us this was an absolute sign of trust!

34

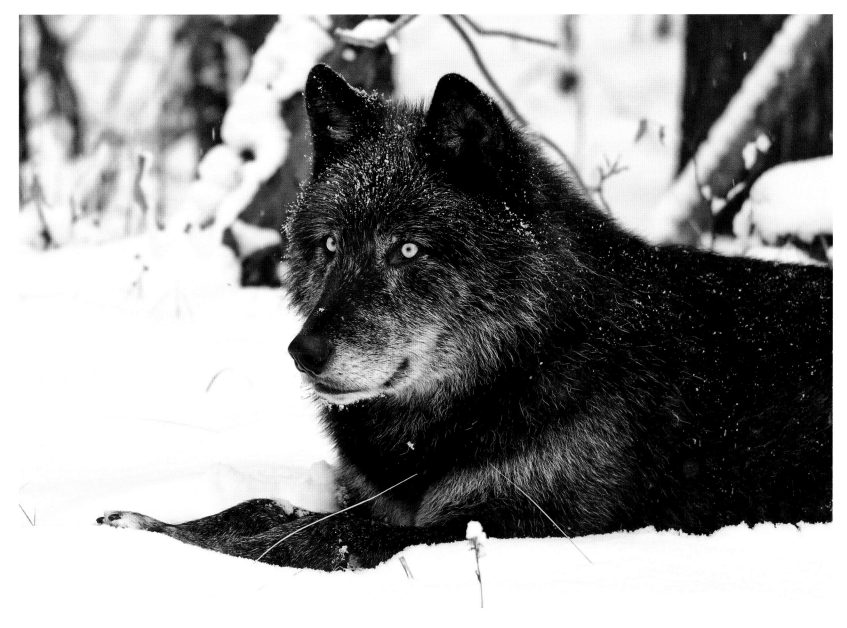

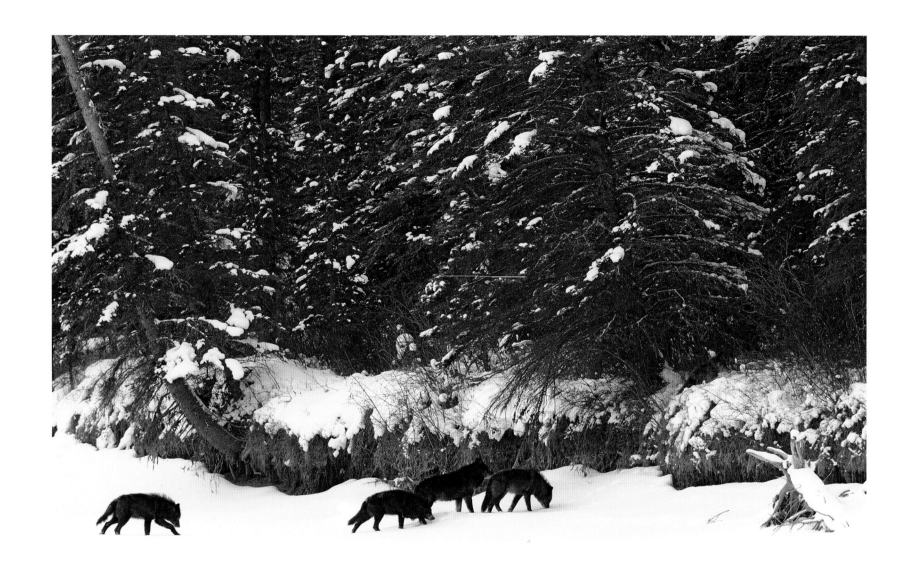

What Is the Difference between Habituation and Adaptation?

This is an excellent question that has been mangled a bit in the media and by Parks Canada. Our observations suggest that parked cars do not play an essential role in making wolves more habituated. From 1992 to date, we have collected a tremendous amount of information and stories about the "Sprays" (Banff National Park and Spray Lakes Provincial Park), the "Cascades" (Banff National Park), the "Fairholmes" (Banff National Park, as well as around the town of Canmore) and the "Bow Valley Pack" (Banff, Kootenay and Yoho national parks), some of which have been published in printed media and online by Parks Canada personnel either in an incomplete fashion or incorrectly. For instance, according to Parks Canada, the Pipestone wolves suddenly morphed overnight into the "highly human-habituated Bow Valley Pack," which was incorrect on both levels (they were not the Bow Valley Pack, nor were they highly human-habituated). It became commonplace for us to read wolf articles coming out of Banff that all too often began with phrases like "It is believed that..." Well, as my grandmother used to say, "Believing is not knowing." In this book, we tell a different story. All of the information contained on these pages isn't based on hearsay (except for the question of where the Pipestone leaders came from) but rather on what we actually saw. We do not describe any behaviour that was not directly observed.

All of the above-mentioned wolf families, from the Sprays to the Pipestones, have been accused of being "habituated," which means simply that they've become accustomed to human infrastructure and parked vehicles. However, in wildlife management circles this has become a negative term, referring to problem animals or wildlife that run into issues with humans. In the case of the Banff wolves, this term is definitely wrongly used. All of these wolves had no choice but to adapt to the habitat they lived in. All of them had to figure out how to cope with the presence of car traffic and occasionally with people running around. In our eyes, the habituation debate regarding Banff wolves is completely unnecessary, because there is a big difference between habituation (used in the negative sense) and adaptation.

As far as all wolves living in the Bow Valley are concerned, they have been nonconsequentially exposed to thousands and thousands of people – more than in any other place in Canada. For them to use adaptive behaviour strategies to carve out a niche for themselves in Banff is absolutely normal. In fact, all of the den sites used by Bow Valley wolves were located only a few hundred metres away from human infrastructure (like roads, where hundreds of cars passed by on a daily basis).

Think about that. Wolf pups growing up in the Bow Valley are predisposed to the sounds of traffic and the smells and visual impressions of vehicles, bikers and hikers from a very early age in their lives. This is called habitat imprinting. In this context, it is also important to note that there are two other types of imprinting that form behaviours: social imprinting and food imprinting. However, in the case of the Bow Valley wolves that we have observed over the years, one can clearly point to habitat imprinting as the reason we got to experience unforgettable wolf pairs

The family on the frozen Bow River near Muleshoe.

and personalities such as "Storm" and "Aster," "Kashtin" and "Big-One," "Nanuk" and "Delinda" and "Spirit" and "Faith" – they were used to roads and had adapted to the presence of cars. Although all of these wolves had gotten used to human infrastructure, they never showed any signs of offensive aggression or threatening behaviour patterns toward humans.

There still seems to be some confusion among park personnel, wildlife managers, photographers and the general public about the terms "habituation" versus "adaptation." However, in her 2004 book *Hundepsychologie* (Dog Psychology), renowned German ethologist Dorit Feddersen-Petersen described the differences perfectly well: *habituation* is a characteristic that increases an individual's overall fitness through adjusting or conforming, while *adaptation* is a learning process in which individuals stop reacting to stimuli that have no consequences.

So What Does That Mean?

[1] National Park Service, *Management of Habituated Wolves in Yellowstone National Park* (Yellowstone National Park, WY: National Park Service, 2003), 11.

Let's look at several examples. If wolves are travelling along the train tracks and don't run away when a train approaches, then they are habituated. But if they do run away, then they are adapted to railways. If wolves actively approach humans displaying neutral body language and not displaying aggression or predatory behaviour, then they are habituated and probably curious (but not dangerous!). If they show begging behaviour, they are likely food-conditioned, which can lead to dangerous behaviour. But if they avoid people or keep their distance, then they are adapted to human presence.

Several years ago, Parks Canada irresponsibly accused wildlife photographers of trying to feed "habituated" Bow Valley wolves without presenting any evidence to support their accusations. Thankfully, no one ever did find food-conditioned wolf individuals in the Bow River Valley that actively approached people. If someone had, it would have ended poorly for the wolves, because "a fed wolf is always a dead wolf."

Yellowstone biologist Doug Smith stated in 2003 that "wolves living in fragmented habitat, or areas with partial to frequent human presence, generally show a high degree of tolerance towards human activity and infrastructure, but still exhibit avoidance and fear in direct encounters. In such areas, wolves traveling near human developments, using roads as travel corridors, and showing a certain level of curiosity towards human activity, should all be considered normal wolf behavior, because these behaviors reflect wolves' natural ability to adapt to their surroundings."[1] This is exactly what we had been observing in the Bow Valley: adaptation and normal wolf behaviour in a human-dominated world! In this context, wildlife managers in Banff have wrongly classified all Bow Valley wolves as being too habituated.

Dr. Paul Paquet once told us that he believes that most wildlife managers are not competent in the field of animal behaviour. We couldn't agree more. What we documented in the Bow Valley were wolves adapting to a specific environment. Therefore, any attempt to associate habituation with there being a potential danger to humans in terms of the Banff wolves is misleading, and, as our behaviour analysis shows, wrong.

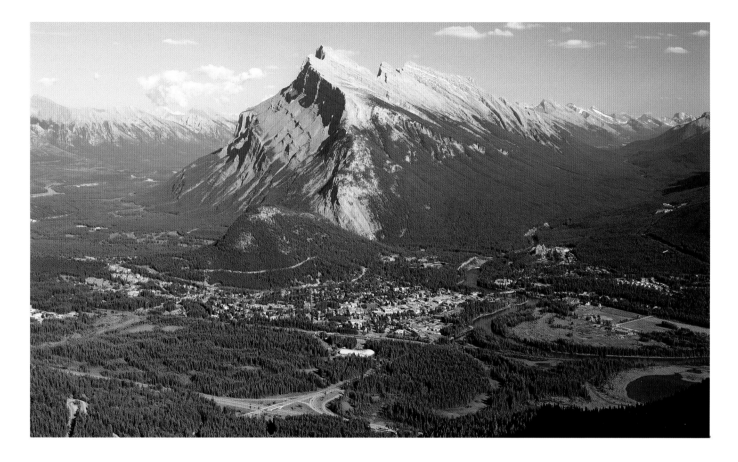

When the Bow Valley is viewed from the slopes of Mount Norquay, the fragmentation caused by the town of Banff and the accompanying highways and railways is obvious.

Where Did You Carry Out Your Behaviour Observations and What Kind of Species Were Living in the Research Area?

Our intensive fieldwork was mainly done within the protected boundaries of Banff National Park, which is situated in the central Canadian Rocky Mountains and covers 6641 square kilometres. The topography in the park is rugged and varied, ranging from 1000 to 3450 metres in elevation. Our primary research area, however, was within a section of the Bow River Valley, from the town of Banff in the east to the Lake Louise ski area and the village of Lake Louise to the west. This stretch ranges in elevation from 1400 metres to almost 1700 metres at the ski area. The population hub is in the town of Banff with its 8,500 permanent residents, but Lake Louise is also home to approximately

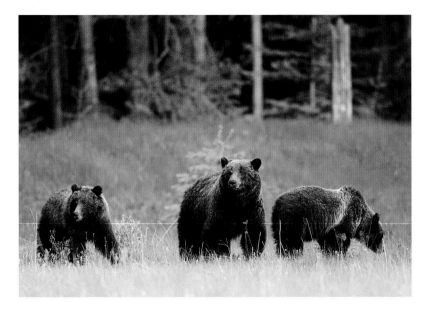

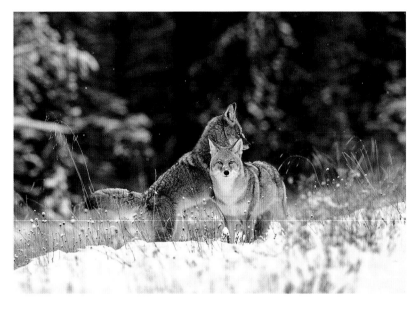

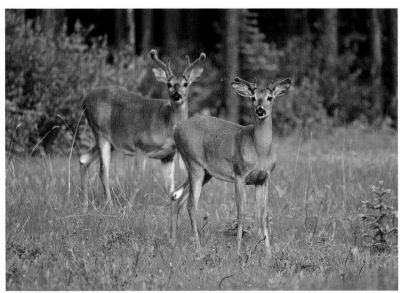

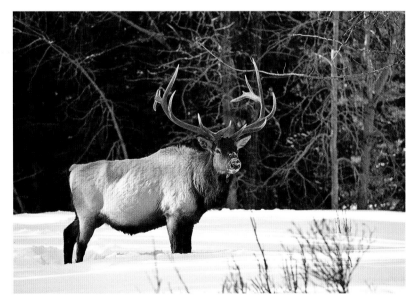

800 residents. The area is fragmented by two major high-volume highways, the Trans-Canada Highway (Highway 1) and Highway 93 North and South, as well as by a secondary highway that also sees significant traffic at certain times of the year, Highway 1A (the Bow Valley Parkway [BVP]). The valley is also bisected by the busy Canadian Pacific Railway (CP) line, which runs parallel to the Trans-Canada, and by several other transportation corridors. Human use within the study area includes sightseeing from vehicles, hiking, biking, skiing, camping, picnicking and shopping. Human activity peaks during the summer months when all of the hotels, resorts, campgrounds and picnic areas are open. A typical summer day in the project area has tens of thousands of park visitors bustling about.

The heavily fragmented habitat of the Bow Valley in our project area is a combination of montane and subalpine ecological zones, dominated by lodgepole pine (*Pinus contorta*), Douglas fir (*Pseudotsuga menziesii*), white spruce (*Picea glauca*) and aspen (*Populus tremuloides*).

Besides timber wolves (*Canis lupus*), the valley is home to the full range of large carnivores typically found in the Canadian Rocky Mountains, including grizzly bear (*Ursus arctos*), black bear (*Ursus americanus*), wolverine (*Gulo gulo*), cougar (*Felis concolor*), lynx (*Felis lynx*) and, of course, two additional canid species: coyote (*Canis latrans*) and red fox (*Vulpes vulpes*). In the early part of our project, the main prey species of the wolves in the Bow Valley was elk (*Cervus canadensis*), but the elk population declined drastically over the years, primarily due to extremely high railway and highway mortality and Parks Canada's elk relocation and culling programs. As a result, by the end of our fieldwork, wolves had primarily switched to other prey species like mule deer (*Odocoileus hemionus*), white-tailed deer (*Odocoileus virginianus*), bighorn sheep (*Ovis canadensis*), moose (*Alces alces*) and even mountain goat (*Oreamnos americanus*).

What Were the Main Challenges for Wolves and Other Wildlife in the Bow River Valley?

The wolves we observed (other than the Spray family) had the core of their territory in the Bow River Valley. Because of the incredibly scenic landscape, the wildlife and an aggressive marketing campaign from entities such as the Banff–Lake Louise Tourism Bureau, the Bow River Valley is a tourist magnet.

Particularly in the summer, we observed people doing whatever they wanted to do in wolf territory, behaving completely recklessly at times. This unchecked human activity has resulted in a drastic change in quality of life for nearly all wildlife species in the Bow River Valley. In recent years, we have watched commercial event after commercial event occur in the valley, from marathons to dragon boat races, which has led to predators, including wolves, being forced to continuously change their adaptive behaviour skills. We have seen visitors and locals alike jumping out of their cars to run after bears with cubs and wolf parents with their pups hundreds of times, to stand metres away from a bull elk for a "selfie," or even to stomp their feet on top of a coyote den in order to get the pups to come out. Sadly, the Bow River Valley in the past five

Clockwise, from top left: Grizzly bear #64 with two cubs along the Bow Valley Parkway in June 2008.

A mating pair of playful coyotes near Storm Mountain Lookout in the Bow Valley.

A big bull elk at the start of the Bow Valley Parkway. Elk were initially the main prey species of wolves in the Bow Valley.

Two white-tailed deer bucks near Castle Mountain.

A lone wolf pup gets pressured from behind by a line of cars intent on following it along the road.

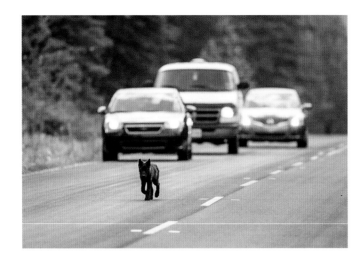

years has often seemed like the old Wild West to us, where everybody can do whatever they want to.

In true Wild West fashion, even the sheriffs are missing. In other words, the park authorities basically stand by and let it happen. Once in awhile, offenders are "educated," or once in a while they receive a fine for speeding, for instance, but these are rarely levied, and there is almost no policing of human behaviour. It has left us wondering for decades now if perhaps park managers should stop worrying about "wildlife management" and instead focus on "people management." Most of the time it is humans that are the problem and not the so-called problem animals.

Studies on Banff's grizzly bears have shown that they have extremely high stress levels. In order to deal with this influx of poorly behaving humans, more and more bears and wolves have to work harder than ever before to find enough food. Obviously, the presence of millions of

park visitors is inevitably stressful. And, to date, wildlife managers in the park have completely failed to adequately address this massive problem. Instead of keeping the last undeveloped areas of the Bow River Valley, like the wilderness surrounding the Lake Louise Ski Area, in their natural state for generations to come, nearly all management actions during the course of our project have been dominated by economic interests.

Living within the man-made environment of the Bow River Valley, the heart of Banff National Park, has been particularly problematic for sensitive wildlife species like wolves, bears and wolverines. The problems have grown so extensive that we often find ourselves asking whether or not that "heart" is even still beating. The urgent survival needs of the valley's wildlife always seem to play second fiddle to the greed-filled desire to please developers, businesses and tourists with more and more infrastructure. In 2009, Dr. Paul Paquet stated in the preface to the book Karin and I wrote, along with photographer Peter Dettling, *Auge in Auge mit dem Wolf* (*Eye to Eye with the Wolf*), that "the needs of wolves living in the Bow Valley continue to be subsumed to the increasingly selfish commercial and recreational requirements of people. In essence, this impoverished environment is a 'wilderness ghetto' for wolves." And, indeed, the survival of individual wolves is tenuous in the valley, and wolf families are ephemeral. We agree completely with Paquet's statement and wonder why he is one of the few people courageous enough to speak out about what is going on in Banff. In our opinion, any denial of this statement is either based on poor judgment or is articulated by individuals who one-

sidedly support the commercial interests of the business community regardless of the ecological outcome.

Perhaps worst of all, and most threatening to the valley's wildlife, there seems to be no long-term plan or consistency coming from Parks Canada's management strategies. Its policies have changed completely over the years, from predator control in the 1960s to the protection of large carnivores today, from a no-hunting-elk policy to an elk relocation program and an initiative for "removing" habituated elk from the ecosystem (in fact, elk management has included culling/killing elk for over a decade) and a "most wanted list" for problematic elk that wildlife managers specifically target for removal. A program of "let nature take its course" has been replaced with aggressive habitat management, which includes prescribed burns that target specific tree species such as lodgepole pines. In fact, at the Sawback Range prescribed burn along the BVP, Parks Canada specifically targeted young pine trees, singling them out and burning them to encourage aspen growth – its management actions were the direct opposite of "letting nature take its course."

It's come to the point that we have to ask ourselves, What segment of nature will be manipulated next? And what challenges will that pose to Banff's wolves?

When and Where Did You Meet the Photographer John E. Marriott?

Karin and I met John on the Bow Valley Parkway in the fall of 2007. John was in the company of Peter Dettling, a photographer we had been working with while watching

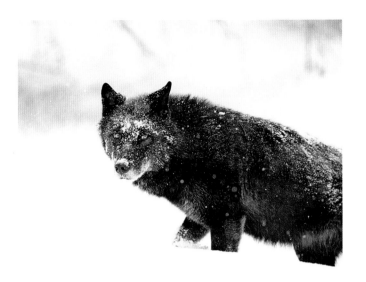

The famous "turbo queen," Delinda.

the Bow Valley wolf family. After meeting John with Peter, the four of us regularly observed the Bow Valley family and their famous "turbo queen," Delinda (we called her the turbo queen because of her explosive Type A personality).

After Delinda was hit and killed on the Trans-Canada Highway in August 2008, the Bow Valley wolf family slowly began to fall apart. By fall 2009, they had been displaced by the Pipestones, bringing an end to the Bow Valley family's legacy. With the demise of the Bow Valley family, Peter Dettling moved on to concentrate on writing his wonderful book about the Bow Valley wolves, *The Will of the Land* (2010). It was at this time in the fall of 2009 that John started joining Karin and I in our daily search for this new wolf family, the Pipestones.

Our work together involved extensive time in our

vehicles from pre-dawn to post-dusk, looking for tracks, scat, urination spots and any other clues to the wolves' whereabouts (John also spent a considerable amount of time backtracking the wolves on their trails away from the road in order to learn their routes and habits). We shot video footage while John took photos, and together we would go out in the dark and come home in the dark day after day for months on end over the course of four years.

What was the purpose of John's work and why did he do it? Was it passion or addiction? It was both!

Funnily enough, in the beginning when we first met John, we honestly didn't think it would be helpful at all having another photographer around. After all, we already had Peter helping us, so we wondered why we should add anyone else to the mix.

Fortunately, it turned out John was not only a nice guy but also a very good wildlife photographer with a very specific eye for catching behaviourally important situations. John was different than the majority of wildlife photographers we ran into over the course of our project in that he showed a real interest in wolf behaviour and constantly asked us behaviour-related questions. We remember very well when we discussed the "alpha" issue with John and how he wanted to know in detail why we didn't use the term "alpha wolf" anymore. And perhaps most importantly, John showed a great deal of patience with the wolves and with getting his shot. He always kept himself at a distance and did not run after them like nearly all of the other photographers did.

We are grateful that John's vivid photos accompany our text for this behaviour-oriented book.

What Kind of Societies Do Wolves Form in the Wild, and Why Don't You Use the Term "Alpha"?

As dog trainers, we were used to hearing and reading the term "alpha wolf" and always assumed that a male individual would aggressively hold the highest social status and position. In the old days, everybody also thought and assumed that an "alpha male" would be the main decision maker. Well, it turns out this is Stone Age thinking! We were convinced about the whole "alpha" thing, too, until we witnessed the theory falling apart before our very eyes in the winter of 1998 – 1999.

That winter, Carolyn Callaghan and Steve Wadlow from the Central Rockies Wolf Project were observing the Cascades wolf family and invited me to join them. All of the wolves were sleeping on a frozen lake when all of a sudden a radio-collared, smoky-gray wolf got up. Almost immediately, a dozen or so other individuals followed suit in a domino effect. But who was who? Of course, my initial reaction was that it was the alpha male that got up first and everybody else in the family reacted to that. The alpha then trotted away and all of the others trotted after him. After 500 metres, the wolf in front stopped and laid down again, and all the others did the same thing. I said to Carolyn and Steve, "See? Typical alpha wolf behaviour!" But this turned out to be the lousiest comment I have ever made in my wolf behavioural research career (from then on, I learned to shut up until I actually knew what was going on).

Why was my comment so lousy? Because after carefully

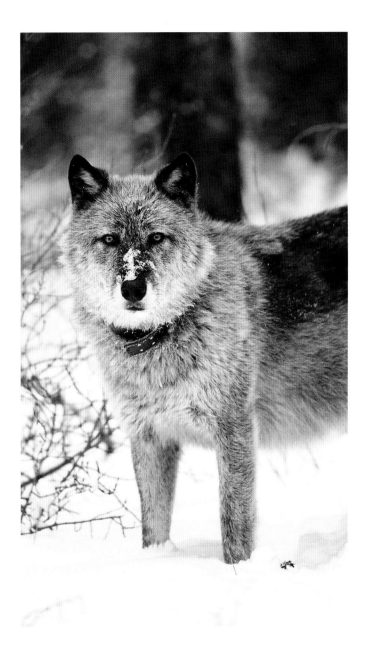

watching that particular wolf family through a high-quality scope, I recall it was Carolyn who said, "Damn, the male wolf in front is not a male, it's a female!" And, indeed, it was a radio-collared "alpha" female named "Betty" that was in the front making the decisions.

The mistake all three of us had made was to confuse the two alphas: with the alpha male myth in our heads, we had mistaken smoky-gray, radio-collared alpha Betty for smoky-gray, radio-collared alpha male "Stoney," who was also roughly the same size. And as Steve and I learned later in the summer of 1999, Stoney was not the brother of Betty as Carolyn had thought, but rather he was Betty's partner and together they formed the highest-ranking pair in the Cascade wolf family. At the time, the full story was a revelation to all of us. We had discovered that a wolf family can not only be led by a female but that the female can also direct and/or delegate the collective behaviour of a "pack" – getting up, trotting in a certain direction and laying down again. The alpha male myth was debunked forever.

Nearly a year after our discovery, I read a scientific paper written by internationally renowned wolf expert Dr. Dave Mech in which he questioned the "alpha wolf" concept, too. Instead, Mech used and created the concept of a "parent–offspring formal dominance system" that we delve into later in the book. Unfortunately, even today, Parks Canada uses the terms "alpha wolves," "a pack of wolves" and "leader of the pack," and the vast majority of people still imagine a group of individuals in a wolf pack who all demand a high degree of often misunderstood "dominance aggression" as they grow older and who are

Leading female Faith, like Delinda, was a key decision maker in the Pipestone wolf family, debunking the age-old myth of the alpha male concept.

45

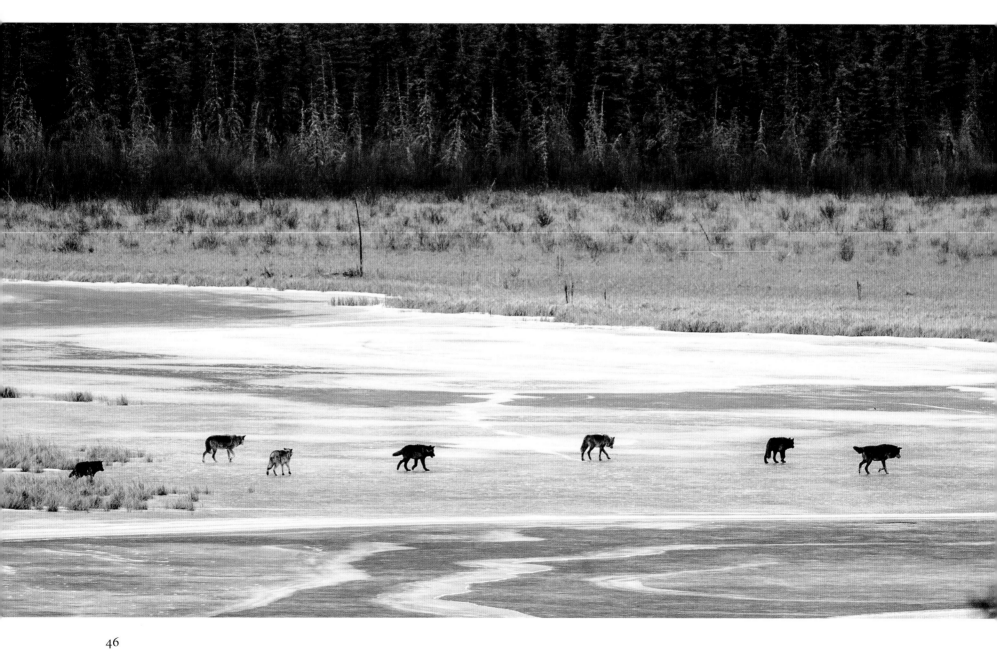

basically completely controlled by the alpha male. It's easy to find Facebook posts discussing what the alpha wolf is doing and how one can easily recognize an alpha by his coat colour (which is not true) and, of course, by his "dominant" controlling attitude and nature.

But dominance is not a behavioural characteristic – it needs to be tested and evaluated continuously. For example, if you fight a person and win the fight, you are only temporarily dominant over that person. Two days later, you may have to fight and test the dominance again or the dominance over that person may be gone. Even a lot of dog trainers in Germany (as well as in North America) are still referring to the alpha concept when advising pet owners. But since our extraordinary experience with real "alpha wolves" like Betty and Stoney, we now know that a typical wolf family (not pack) in the wild consists of a group-oriented social society that is led by different individuals according to their fundamental biological needs (reproduction, food and other resources and avoiding hazards). In a normal situation, an average wild wolf family is made up of two to three generations.

During the course of our work in Banff, we rarely saw a wolf family that was not socially organized as a parent–offspring formal dominance system. We did occasionally observe patchwork families or single mothers or fathers raising their young, but that was not the norm. Observing a wolf family in the wild, you normally don't see a congregation of adult animals but rather a well-organized social group that as a rule consists of a reproducing parent pair that are the main decision makers and their offspring from the last two years. However, there can always be exceptions to this rule: under certain circumstances (e.g., the death of a breeding individual with a high social status), animals that are strangers to a pack are occasionally included in a wolf society, sometimes even as a replacement for an old, disempowered individual. For example, this has been observed several times by my colleague Elli Radinger in Yellowstone National Park in the United States. These strangers then sometimes stay to breed with an adult wolf that remains with the group. Research by Douglas Smith in Yellowstone shows that in the wild, two or three females in a family may reproduce relatively regularly (not just the breeding female).

Our own surveys have occasionally documented similar breeding behaviour in Banff National Park. In the summer of 1995, breeding female Aster and her daughter "Black" cooperatively raised two litters of pups at the same den site. Astonishingly enough, mother and daughter not only got along well but we even witnessed Aster regurgitating food to all eight pups – Aster's five pups were approximately ten to 14 days older than Black's were. And then, in the spring of 1999, a heavily pregnant female from the "Panther" wolf family was killed in a prescribed burn that went out of control near the family's den site. Meanwhile, ten-year-old breeding female Betty of the same family still succeeded in raising her only pup, a grayish-coloured female. So Betty's pup was the only one raised by the Panther family that year.

The world (and the socio-emotional lives) of wild wolves often seems to be unfathomable, but cases like these, where two or more females may bring up their pups together by acting cooperatively, are proof of their ability

Wolf families in the wild typically consist of several generations of wolves. In this November 2011 shot, the Pipestones walk across the ice in the Backswamp wetland, led by Spirit, the leading male, followed by Yuma (seven-month-old pup), Blizzard (2.5-year-old female), Djingo and Jenny (seven-month-old pups), Faith (the leading female) and Kimi (seven-month-old pup).

A small herd of
bull elk in Hillsdale
Meadows along
the Bow Valley
Parkway in
December 2007.

to put the needs of the expanded family group before their own. Since two females can raise their pups together and a lower-ranking wolf can have the social status of a breeding female, the term "alpha" does not contain any precise information. According to Dave Mech, in the future the only use for the term "alpha wolf" would be for wolf packs consisting of more than three generations and multiple litters, thus justifying the term alpha wolf because in those circumstances there is usually a formal, dominant-behaving wolf mother at the den site (an "alpha female") that allows and tolerates a lower-ranking female to raise her own pups.

Why Is the Term "Alpha" Still Widely Used?

The short answer is that some people who believe the age-old myth of a social hierarchy from "alphas" to "omegas" are ignoring the fact that most information on the social organization of wolves has been collected in enclosures, and that the literature published that talks of typical hierarchies in wolf "packs" and that is full of descriptions referring to an "alpha male" and the "leader of the pack" is based on these captive wolf observations. But how can anyone figure out details on leadership behaviour in captive wolf "packs" when their movement is extremely restricted? The bottom line is that a clear linear pecking order is much less significant with wolf families that live in the wild than the results of research on captive wolf observations would suggest.

And therein lies the problem. In contrast to the research results from the wild, zoologists Rudolf Schen-

kel or Erik Zimen described the structure of the social ranking of a wolf pack in captivity more or less as that of a pecking order, dominated by an alpha male (alpha, beta and down to omega individuals). But wolves living in enclosures live in social societies with lots of generations and not one single wolf is able to leave the pack behind, especially during the socio-emotionally stressful breeding season. These captive wolves don't have the opportunity to disperse like wild wolves do, which puts the social structure of these captive packs at odds with what's really happening in the wild. Furthermore, captive wolves can't hunt and aren't able to use up a lot of energy. And last but not least, wolf packs that live in enclosures seem to have little to do, so to speak. Life is likely pretty boring, resulting in big arguments among individuals over all kinds of resources on a daily basis. All of this was wonderfully described by Mech in 1999.

So if the term "alpha" stems from these captive wolf observations and all of our arguments today are so convincing, then why is it still used? Quite frankly, we don't know. At this point, it's probably become part of the human psyche when it comes to talking about wolves.

What Did the Wolves Consume?

In Banff, wolves' preferred prey species is elk. On average, a wolf family of five members will either kill or scavenge one adult elk every five to seven days. Although there can be up to a dozen other species, such as wild cats, bears, coyotes, red foxes, martens, weasels, ravens and magpies around an ungulate carcass, every wolf individual consumes an

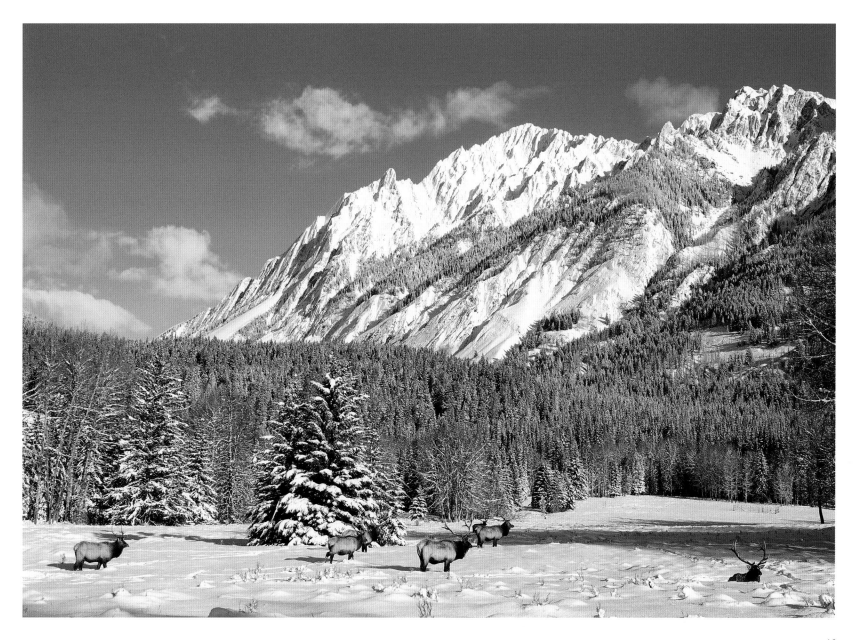

estimated two kilograms of meat per day. However, during a first feast at a kill, every wolf is easily capable of consuming up to eight kilograms of food, including all of the "green stuff" found in the elk's intestines, as well as meat, skin and fur, within a very short period of time. Higher-ranking wolf individuals are usually the ones that feed first on the energy-rich, high-quality meat like the heart and liver.

What we had learned in the past was that if there was an age difference of more than three or four years between the breeding male and female, the male generally tended to reserve the right to feed first. After the breeding season, pregnant wolf mothers similarly showed dominant behaviour at kills, and once they had pups, even showed aggression toward the breeding male. Usually, the wolf mother was the one in charge of sharing food among the pups.

During good times and in good weather, we learned that wolves often leave the valley bottoms where the kill is located to move uphill into sunny resting locations, which wolf researcher Erik Zimen suggested may aid in food digestion. As outlined in the book *Auge in Auge mit dem Wolf*, on average, older wolf individuals rested and/or slept 7 – 8 hours before going back to a carcass and feeding again, whereas lower-ranking adult and yearling wolves were observed feeding again at a carcass after just 3 – 4 hours of rest. However, juveniles were present in the vicinity of a carcass the most often, sometimes only resting two hours or less between "snacks." During bad times, especially through the summer season when there was the added socio-stress of feeding pups near the den site, some wolf individuals consumed large amounts of berries and other vegetarian fare. If there was no preferred prey species available, the wolves showed a high degree of behavioural flexibility and opportunism by chasing and killing every naive, vulnerable prey species that was available.

We had always wondered what wolves ate and how they got their energy to travel long distances between successful hunting expeditions, and we discovered that Banff wolves fed a lot on small prey species such as snowshoe hares, ground squirrels, voles and mice. Sometimes, single wolf individuals were observed searching for rodents and doing "the jump" for hours on end. It was also a habitat-specific trait for the wolves living in the Bow River Valley to do regular patrols along highways and railways in order to find either road or rail kills and scavenge those carcasses.

By the way, regarding energy cycles, apart from hunting and caring for pups, on an average day the wolves got up around one hour before sunrise and stopped being active at approximately 10 a.m. Afterwards, they rested for several hours. Adults usually remained inactive until late afternoon, whereas yearlings and juveniles were often observed getting active again earlier in the day. Temperature seemed to play a vital role in the activity level of the wolves – the colder it was, the more active they were. The wolves we observed definitely preferred to restrict their travel patterns as much as possible when it was very warm. During hot summer months, they were most active in the very early morning hours and/or late in the evening. However, since we did not have night-vision goggles, we did not conduct any fieldwork between the hours of dusk and dawn.

Blizzard doing "the jump" while mousing in Hillsdale Meadows.

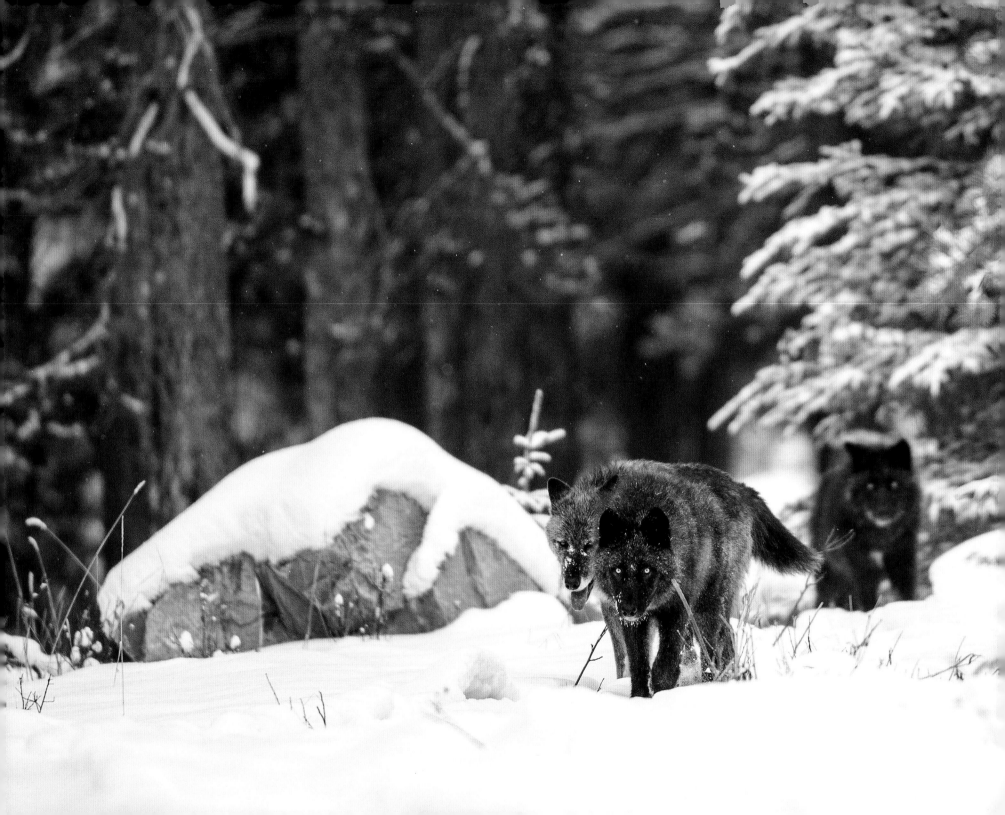

The "new" wolves, led by eight-month-old pup Blizzard, followed by her mother Faith and her sister Raven, make one of their first appearances east of Castle Mountain in the Bow Valley, December 2009.

The Rise of the Pipestone Wolf Family

The Bow River Valley is bordered to the northeast in part by the wild and remote Pipestone River Valley, which in turn connects to even more remote parts of the park, including the Red Deer River watershed. Wolves are believed to regularly disperse through these remote backcountry valleys into areas like the Bow Valley and vice versa, by travelling up and down the Pipestone River from the high alpine backcountry in the northern part of the park down to the Bow River near the village of Lake Louise.

In June 2008, a park visitor showed us a photo from the Pipestone Valley of what appeared to be a breeding female that was not part of the Bow Valley family. Soon afterwards, in late December 2008, a new wolf family appeared in the Bow River Valley, seemingly out of the blue, alongside the Bow Valley wolf family that had been ruling the valley for over a decade. The female leader of this new family looked like the wolf in the picture we had seen in June (a wolf Karin and I named Faith), and because it appeared like the wolf and her family had originated from the Pipestone Valley, we named her family the Pipestones. Within a year, these new wolves had not only begun to occupy parts of the Bow Valley but had established a dominance that would last for five years.

How It All Began

Before we actually met the Pipestone family, we suspected they were denning in the Baker Lake area of Banff National Park. Not only had we seen the photo of the breeding female from the neighbouring Pipestone Valley that June, but several independent people had heard pups howling in August and September of 2008 near Baker Lake. We trusted the information they were passing on to us because they were professional naturalists, not ordinary tourists. We didn't tell anyone and no one else knew about the wolves at Baker Lake, not even Parks Canada. We purposely chose to keep the information to ourselves because we did not want to draw any attention to the wolves in the media or on the Internet. At the end of the day, we wanted to make sure that nobody would come out and disturb the wolves. The problem was, though, that with the new wolves breeding in a remote location, we didn't have the whole story. It was frustrating to not be able to see things with our own eyes to confirm what was going on.

When we first started collecting basic data from what we had heard about this new wolf family during the summer months of 2008, while still observing the Bow Valley wolves, we were often approached by curious park visitors always asking us the same question: "Have you seen any wildlife?" We had been asked that same question for years, and because we were already sick of answering their questions and seeing them running amok, we changed tactics. We decided our new answer to their question would be, "Yes, of course, we're watching woodpeckers!" Nobody seemed that interested in woodpeckers, which almost instantly put an end to our being disrupted while quietly observing the animals.

Talking about observing animals, between 2008 and 2014, Karin and I spent 1,995 days in the study area observing wolves. Calculating an average of 10.5 hours per day in the field, we put in an astonishing total of 20,947 observation hours, which form the basis of this book. About one in three days over the course of the study would result in a sighting of at least one wolf, though more commonly than not, on those days we would often see the whole family, not just one individual.

The first time we actually saw the Pipestones (we had only seen tracks up until that point) was for a very brief encounter at the end of March 2009. We spotted the wolves using an underpass near Castle Mountain junction and within 30 seconds the encounter was over. We were

totally dumbfounded. We were so shocked to see wolves other than the Bow Valley family in the valley that we didn't even get a count on the new wolves. But soon afterwards our dog Jasper found some fresh tracks for us and we counted seven sets. The largest track measured 12.8 cm × 8.3 cm, a truly enormous paw print, which led us to believe that it belonged to a large, older male.

The same winter, there were some brief moments of a single wolf sighting here and there, but that was about it. Then, in June 2009, Karin and I got word about a darker, smoky-gray lactating female wolf carrying a deer leg in the Baker Creek area in the Bow Valley. A dark-gray breeding female? Immediately, we knew she did not belong to the Bow Valley family, because they were denning more than 30 kilometres away and we had regularly observed their light-gray breeding female, "Fluffy." We knew that highly pregnant Fluffy had approached the traditional den site on April 15, 2009, and had probably given birth to a litter of pups – in fact, on May 28, we observed five pups at the Bows' denning site: three black males, one black female and one brownish-gray female.

Interestingly enough, Fluffy had mated with her father, Nanuk, in early February 2009. Although inbreeding occurs very rarely in the wild, this was evidence that it can indeed happen. This particular case was explainable: Nanuk had lost his long-term partner Delinda (Fluffy's mother) in August 2008. During the breeding season of winter 2008 – 2009, he had desperately but unsuccessfully tried to find a new mate. It was the beginning of the end for the Bow Valley family. From Delinda's death onwards, their social structure fell apart. We never did find out

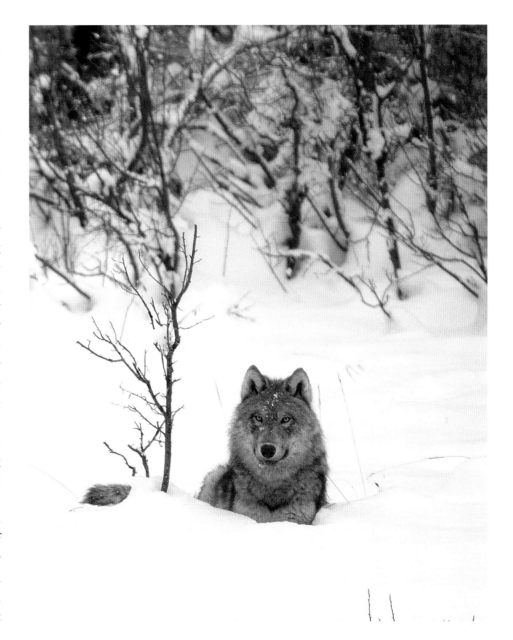

exactly what happened to Nanuk, but there were several final sightings of a limping black male wolf with a severely cut front leg and foot near Storm Mountain and later on near Lake Louise in March 2009.

The very high unnatural mortality within the Bows left their status in question. Their home range shrank, forcing Fluffy to give up a lot of familiar terrain in the western part of the Bow Valley. In June 2009, a new, black, approximately 2-year-old male wolf was observed at the old traditional den site of the Bows. We didn't know where this new wolf had come from that was suddenly seen travelling with Fluffy toward the den. At the same time, our observations revealed that Fluffy was struggling to cope with raising the pups on her own, and we could see that her movements and exploration behaviour were noticeably affected by the intense level of park visitor activity in her remaining territory. In July 2009, the new male was killed on the Trans-Canada Highway near Five Mile Bridge. Once again, that left 2-year-old Fluffy, a completely inexperienced new mother, alone fending for her pups in a much-reduced territory that was being hammered on both sides by extremely high traffic volumes (the Bow Valley Parkway on one side of the valley, the Trans-Canada on the other and Highway 93 to the south). We noticed the traffic having a negative impact on Fluffy's ability to hunt, and as visitation increased throughout the summer to unprecedented levels, she resorted to hunting rodents and feeding in desperation on canola seeds along the railway.

Through the end of July and the start of August, we were completely astonished and shocked to find dozens of adult wolf scats from the Bows made up of all kinds of berries to an extent we had never seen before. The summer was obviously a complete disaster for Fluffy, but it was about to get a lot worse. In late August, she got hit and killed by a truck on Highway 93 South, leaving her puppies totally unattended. By the end of the month, only one, the brownish-gray pup, was still living. As skinny as that poor pup looked, we didn't need a clairvoyant to suspect that her siblings had already starved to death. That pup was last observed in Moose Meadows in mid-September 2009, close to where a pair of red foxes was successfully denning and caring for three pups. This observation was relevant because Fluffy had known about the fox family and had been tolerating their presence.

As far as the dynasty of the Bows was concerned, this was the end. A new wolf family had arrived and had made itself more and more active and visible in the Bow River Valley.

"New" Wolves and Their Adaptive Behaviour Strategies

We were eager to find out more about the "new" wolves and started frequenting the area where the food-carrying female had been observed. A few weeks later, we saw a huge male and two yearlings. Then, in fall 2009, we were finally able to sporadically film the complete Pipestone family, not only in the western part of the Bow River Valley near Baker Creek but also in the east near the den site of the Bows. From there, they travelled back to their rendezvous site in the west, and from then on they moved up and down the valley nearly every week. Fortunately,

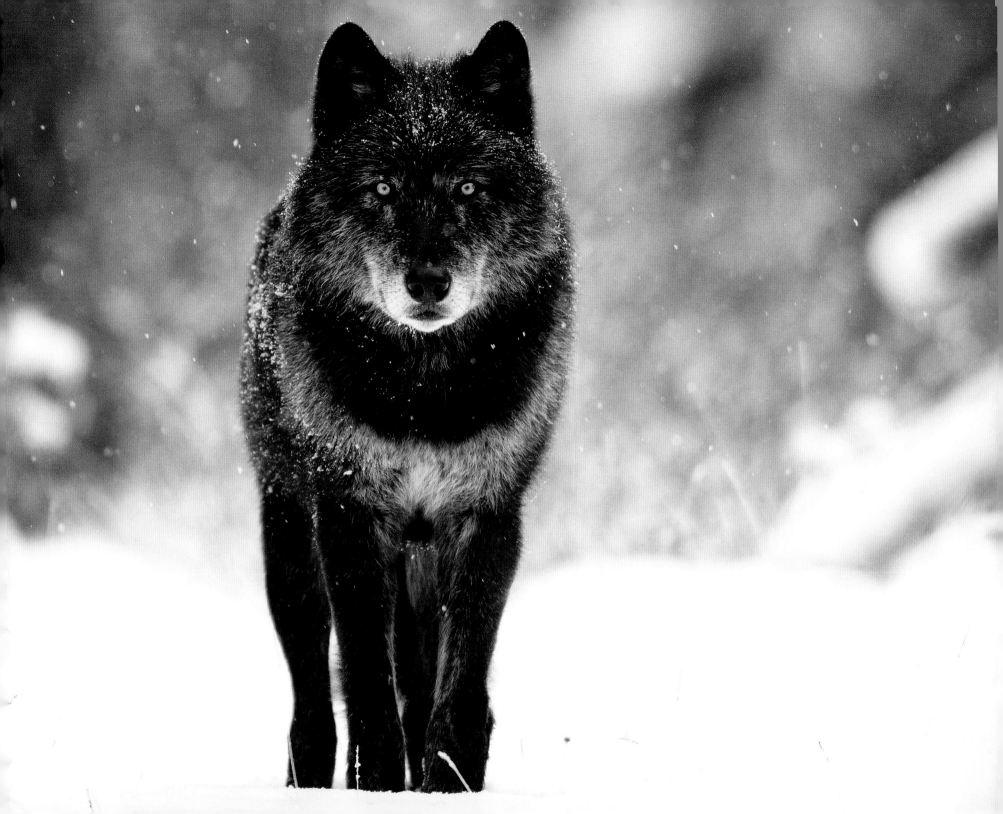

nobody else knew how visible this new family was becoming at this time.

Something was in the air. Our dog Timber could smell it and we could feel it. And then once in awhile we were able to watch them, two to three wolves resting in their favourite meadow with dozens of vehicles passing by without having a clue what was going on.

It didn't take long for the Pipestones to adapt to living in a man-made environment. And considering where they came from, we thought this was remarkable. They had been living in the backcountry and side valleys of the park, where human use is far less frequent compared to the Bow Valley with its vehicles and trains and mass-scale tourism. It is impossible to fathom why the wolves didn't just stay where they were, but they didn't.

Blizzard resting on the side of the Bow Valley Parkway, December 2009.

Instead, they surprised us by taking over the busy Bow Valley in breathtaking fashion. How and why did they do it? As usual, there is no easy answer. But our past research from the valley indicates that wolves living in the Bow Valley are able to conserve energy by using roads and other human infrastructure that isn't available in the backcountry. This way they are able to travel long distances in a short time. But that wasn't the only reason for these new wolves to want to move into the busy valley – ungulates there get killed on the railway tracks by the dozens, which translates into quick biomass for wolves. So even wolves that are new to this noise-and-human-filled habitat learn quickly that sometimes they can collect these easy pickings and don't even need to hunt. And, as a whole, valley bottoms like the Bow Valley tend to favour prey species like elk and deer because winters are milder and there is more vegetation available to them than at higher elevations in the side valleys and backcountry. More deer, moose and elk means more food for the wolves.

In addition, the Bow River Valley has a number of relatively undisturbed den sites with water nearby that are perfect for raising pups. This means adult wolves can easily sneak in and out of their denning areas to hunt and patrol their territory. The valley also has a number of good, secluded rendezvous sites where adults can "park" their pups and do extended tours along the railway to find food.

What else do wolves need to perfectly adapt to a convincing landscape? Don't they prefer natural surroundings and pristine wilderness? There is, of course, an argument that we have heard hundreds of times that wolves are an indicator species for intact wilderness. But for many

Europeans like us, this doesn't carry any steam. In Germany, there is no wilderness to be found, yet over 280 wolves live there in the middle of human-dominated landscapes. And it's not just wolves; deer and wild boars are found across most of the country, too. We call these animal species, which also include marten, red fox and pigeons, *Kulturfolger*. There is no word for it in English, but *Kulturfolger* denotes highly adapted animals of all kinds of species that have been living among people for a long time (in other words, they are animals that thrive in a cultured landscape and actively engage with our human habitat). It might be somewhat speculative, but Rocky Mountain wolves are apparently also convinced that a landscape with an energy-saving infrastructure and a railway system that is providing them "free meals" is a good habitat.

Last but not least, wolves living in mountainous terrain need valley bottoms, especially in the winter, so that they can follow ungulates down from the higher elevations when the snow flies.

In 2009, the Pipestones had just started getting used to their new, human-dominated world. As far as the Pipestones were concerned, it was readily apparent that they preferred travelling along the Bow Valley Parkway and the CP railway to going up and down slopes in the backcountry and using up a lot of energy. It helped that most of their prey species in the valley, such as deer and moose, spent their time grazing along right-of-ways, along the roads and rails, especially in spring and early summer when the adult wolves had to feed their new pups at regular intervals (irregular feeding is bad for their immune system). As wolves tend to travel in early summer in singles or small groups, we weren't able to immediately determine the social composition of the Pipestones, or their ages and sex ratios.

It was surprising how fast the Pipestones seemed to have become familiar with all angles of the Bow Valley. How did they do this? Well, we have a hypothesis that new wolves often occupy the territories of a previous wolf family quickly and efficiently in part because they can smell the established path systems used by the preceding family. They quickly adapt to travelling on and within this path system and we believe they can immediately determine whether or not there are other wolves still there. If they do not detect other wolves, new wolves seem to become quickly confident in occupying the entire path system and the territory that comes with it.

Introducing the Pipestones

Our more intensive behaviour work began in late fall of 2009, after the Pipestones had expanded their territory within the Bow River Valley to the east as far as Five Mile Bridge at the eastern entrance to the BVP. As the wolves began to travel together in full force, we started to determine the sex, social status, colour, individual personality and character of each adult and juvenile wolf just as we had for all of the other Banff wolf families since 1992. Character-based behaviour is just one dynamic component of a family-structured wolf society and is only part of understanding social rank order and their whole social organization. In order to determine the breeding pair of the Pipestones, we watched scent-marking behaviour for

Clockwise,
from top left:
Spirit and Faith in
early December
2009 during
John's first photo
encounter with the
new family.

Two of the three
youngsters, Raven
and Blizzard,
investigating a
chunk of elk fur in
December 2009.

Spirit scent
marking along a
trail near Castle
Mountain.

territorial maintenance and social bonding: we knew that individuals with high social status scent mark and over-mark, whereas yearling wolves and juveniles do not. That's how even a field research rookie can determine the breeding pair from the subordinate individuals in a wolf family pretty easily!

Our initial six months of observations found that besides the lactating female, the big male, one black yearling and one gray yearling, there were five pups at the family's rendezvous spot: four black and one gray. Unfortunately, one black pup and the gray pup did not survive. It must be noted that we never did learn what had happened to the three additional individuals that we tracked in March before the 2009 pups were born (we had tracked seven individuals that day). Were they killed as a result of human infrastructure and never reported by Parks Canada?

On September 2, 2009, several adult wolves and the three remaining 5-month-old pups left the rendezvous site permanently and from that point onwards we began to see the wolves together. Observing their scent-marking behaviour led us to the conclusion that one wolf that marked prominent points like rocks or tree stumps with a raised hind leg was obviously the breeding male, while another adult that marked over the same spot by squatting with a raised leg was the breeding female.

As I mentioned previously, we named that bonding pair Spirit and Faith. We guessed that Spirit was 4 years old at the time and that Faith was 3 years old. Spirit was not a tall wolf like Nanuk before him, of the Bow Valley family, but he was still a large, compact wolf with a dark charcoal coat fringed with gray. His mate Faith was an average-sized, dark-gray female, neither very big nor long-legged. However, one thing was certain: Faith was a very strong-minded, leading type of female. She soon became the family's main decision maker.

The Pipestones' subordinate adult sons, who urinated standing up, were named "Chesley" and "Rogue." Long-legged Chesley was classic gray wolf, big, bold and powerful looking, while his black brother Rogue was smaller and much more timid.

And following in the footsteps of these four adults were three carefree youngsters who behaved like jumped-up busybodies, sticking their noses into everything and anything without having any clue about the "real" wolf world. How did we know they were juveniles even though they were already quite big? Because we've seen a lot of juveniles in the past and all have "the look" about them that very quickly distinguishes them from adult wolves. John named the young male "Skoki," and we named his two sisters "Blizzard" and "Raven." Skoki showed urination behaviour much more often than his sisters did.

Scent-Marking Behaviour

We like Devra Kleiman's simple definition of scent marking, which she came up with an astonishing 50 years ago. As far as we recall, Kleiman described scent marking as some kind of deposition of odour by urination, defecation or the release of glandular secretions. We knew that observing the scent-marking behaviour of *canidae* was going to be a very challenging undertaking, not only because you have to be able to find and watch the wolves regularly

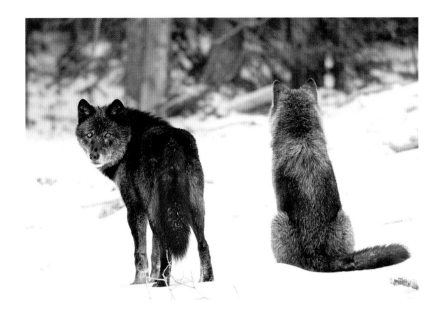
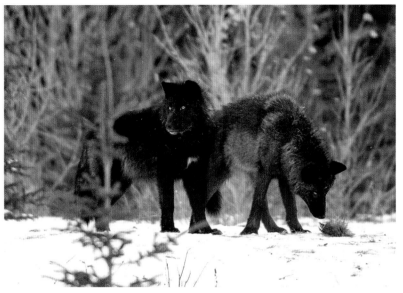
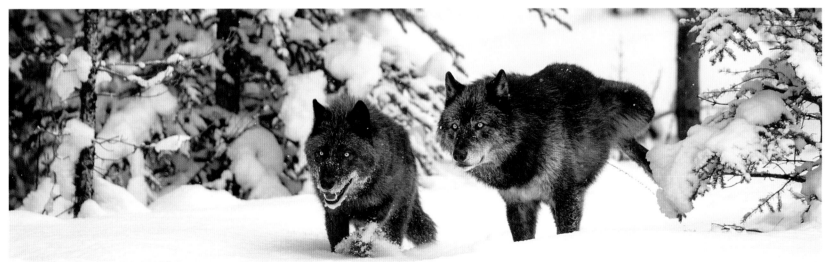

but also because scent marking can have several different behavioural emphases.

In wolf society, scent marking communicates a lot of information between animals, both from urine and scats. This information includes sex and reproductive states, social status, age and individual personality, as well as the makeup (composition) of a wolf family.

There have been theories put out there of alpha males always scent marking more frequently than alpha females do and that those high-ranking males more often direct their urine at specific targets than high-ranking females do. Additionally, the hypothesis has been put forward of males dominating females by overmarking their scent-marking efforts. However, we do not believe in either of these theories, because we have never witnessed a scent-marking "wolf father" directing threatening or agonistic body language toward a "wolf mother." To us, it always appeared as if breeding males and females were demonstrating strong pair-bonding behaviour and that both were scent marking for mutual territorial defense. Spirit and Faith scent marked and overmarked more often at crossroads and trail junctions within their territory than they did along the boundaries of their territory. Since both Spirit and Faith were observed leaving urine and scats strategically at tree stumps, rocks and snow piles, we are convinced that they were trying to leave not only olfactory messages behind but also visual messages: "Hey everyone, we (a strongly bonded reproductive pair) were here!"

By the end of our first year observing the Pipestones in 2009, a total of 680 scent markings were documented. Through 288 direct observations, we were able to document a nearly equal amount of urine marking and overmarking by both Spirit and Faith. Inner-territorial defense messages were placed 182 times, whereas outer-territorial defense messages were only placed 106 times. Spirit was observed scent marking within the territory 92 times, Faith 90 times. At the periphery of their territory, Spirit was observed scent marking 55 times and Faith 51 times. In this context, the theory that females primarily scent mark in the interior territory and males more at the periphery of a territory did not hold true.

What we generally found, though, were strong indicators for the theory that scent marking played a vital role in olfactory and visual communications between breeding male Spirit and female Faith (the bonding pair).

Another mutual act they performed together was their frequent scent marking at carcasses and things like bones or pieces of fur of prey species. Spirit scent marked carcasses 139 times, Faith 131 times. On the other "prey items," Spirit was observed scent marking 62 times, Faith 60 times. Interestingly, neither the adults Chesley or Rogue nor the juveniles Blizzard, Skoki or Raven scent marked any of the food resources. It seemed as if any urination behaviour shown by the subordinate siblings did not play any fundamental communicative role, because younger wolves and their standing (male) and squatting (female) body postures seemed to be showing "a normal release of urine only" with no essential reason behind it. Our findings were consistent with the hypothesis that high-ranking wolf individuals are more likely to communicate scent marking, whereas subordinate members of a wolf family mostly display simple urination behaviour.

Our observational-based results showed that the scent marking of wild wolves not only communicates olfactory and visual delimitation of territorial boundaries and important intersections within a regularly used and established path system but also marks resources like food. Although the marking behaviour on carcasses and bones was restricted to both wolf parents, we did not view it as a demonstration of dominance because we often witnessed one of the lower-ranking group members take away a food item that had just been marked with urine by Spirit and/or Faith. We will probably never know all of the details about what the marking of objects and resources with urine mean. According to dog researcher S.K. Pal and his colleagues, who were quoted in a scientific paper published by the Italian field biologist Simona Cafazzo and her colleagues, "it may be hypothesized that scent marking may facilitate relocation of food resources…"[2] Is that true for wolves, too? We don't know – yet!

Figure 2.1 shows all 680 observations of scent marking divided into scent marking inside the territory.

Colouration

The information collected on the Pipestone wolves' coat colouration showed that there was a lot of variation. However, all three juveniles were black, which is not unusual in Rocky Mountain timber wolves (Rockies wolves have the highest percentage, 35 per cent being black individuals within the population worldwide). Through genetic work, it's been discovered that the black colouration in wolves originates from interbreeding with

Scent marking by Spirit along the Bow Valley Parkway.

FIGURE 2.1 Scent-Marking Behaviour Shown by the Pipestone Wolves.

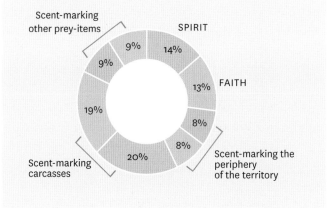

Scent-marking other prey-items 9%
9%
SPIRIT 14%
FAITH 13%
8%
19%
Scent-marking carcasses 20%
8%
Scent-marking the periphery of the territory

2 Simona Cafazzo, Eugenia Natoli and Paola Valsecchi, "Scent-Marking Behaviour in a Pack of Free-Ranging Domestic Dogs," *Ethology* 118, no. 10 (2012): 964.

Right: Raven in January 2010, just a week before she was killed by a vehicle on the Bow Valley Parkway.

Facing page: "Group inactive": Skoki (with the GPS radio collar around his neck), Faith (right) and Blizzard (left) nap in the sunshine near Ranger Creek.

domestic dogs in the past. Besides Faith and her smoky-gray coat colour, all of the other members of the family were black, which technically includes pitch black, brownish black, black with gray grizzling and a number of other subtle coat variations. Interestingly enough, during our work with the Pipestones, all of the neighbouring wolf families, such as the Fairholmes (living in the Bow Valley between Banff and Canmore to the north and south of the Trans-Canada) and the Kootenays (living in Kootenay National Park) were primarily classic gray in colour.

Sad News

In January 2010, a vehicle on the Bow Valley Parkway killed the beautiful little female Raven at just 9 months of age. Both John and Karin and I were extremely upset at this news. At the same time, we started seeing Skoki depart from his family for a day or two, though he would always return. He was the typical headstrong, though shy, type of wolf, while his sister Raven had been one of the most discreet individuals we had ever seen. In contrast, bold Blizzard was almost always visible and busy doing something. Mouse hunting was one of her favourite hobbies.

The impression we gained that first year was that the Pipestones were full of different characters and personalities (all of which we will describe in more detail later in the book). One thing was definitely clear very early on: Spirit was often not the one in the lead when they were moving around. Rather, it was Faith that seemed to be taking the lead the most often, which immediately reminded us of Delinda of the Bow Valley wolf family.

Always Expect the Unexpected

For behaviour observers like us, watching wild wolves meant we had to accept that we did not really know anything! However, because we knew the members of the Pipestones "personally," it made it easier for us to position ourselves in our car at certain locations along their wolf "highways" (the traditional network of trails). Sometimes we waited for the wolves for hours and hours in vain, while other times we got lucky. Many times we would find them and see them resting, but they wouldn't actually be doing anything. Our behaviour sheets, upon which we made notations every 15 minutes, soon became filled with the sensational statement "Group inactive." But that's the life of a field researcher. On the other hand, it was delightful to once in awhile see some active wolf pups play-running, play-wrestling or pretending to be the "king of the castle."

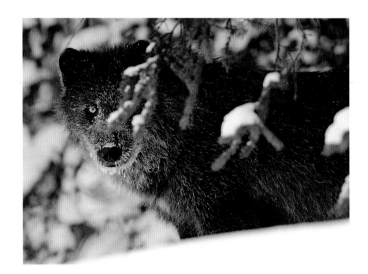

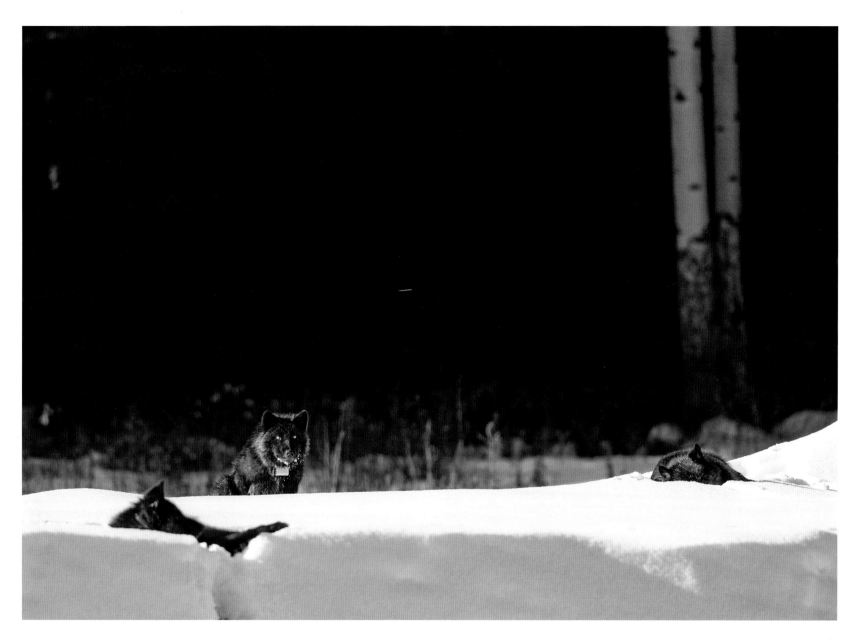

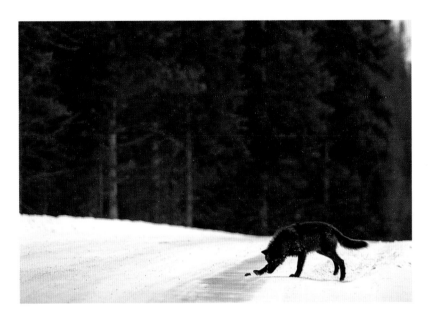
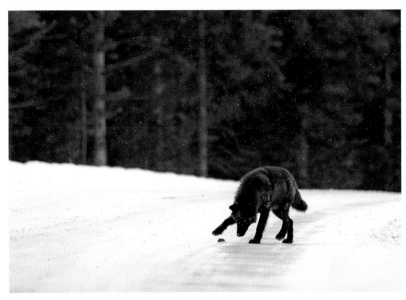
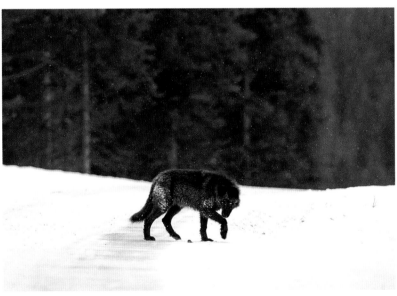
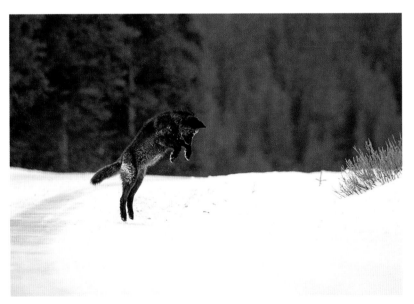

The "Mouse Story"

One of our most memorable encounters with the Pipestones happened on January 14, 2010, on a beautiful, but extremely cold, sunny morning after a heavy snowfall the night before. We encountered the family resting in a small stand of trees, and after awhile Faith decided it was time to move on. She got up and stretched, yawned and then started trotting to the east. Everybody followed her, except for Blizzard, who had heard a mouse under the snow nearby. We were fortunate enough to witness this beautiful juvenile female "playing" with her mouse both on the side of the road and in the middle of it for almost ten minutes. In typical wolf style, Blizzard tilted her head from left to right and back again, then launched herself into the air and dove into the snow on the side of the road face-first (interestingly, Paul Paquet used a computer simulation years ago to determine that young, inexperienced canids jump and jump to catch prey until they learn to attain a successful 90-degree angle).

At first, John and I were wondering what Blizzard was doing, because we watched her catch the mouse but not kill it. Instead, she carried it to the open road, laid down and deliberately let the mouse go. Of course, the mouse immediately ran away, which caused Blizzard to start "dancing" from her left to right foot, forward, backwards, sideways and all around the mouse, all without actually catching it. Sometimes her behaviour reminded us of the Texas Two-step. A few minutes later, she grabbed the mouse and we thought, "Ok, this is it, she's finally going to eat it." But she didn't! She didn't even injure the poor little critter but instead just let it go again. The mouse tried to escape, and once again Blizzard danced around it. I was so delighted to be able to film all of it. I stammered to John, "You got the photos? Got the photos?" But John was so concentrated on the action that I didn't get an answer. I certainly hoped he got the photos!

Unbelievably, the incident still wasn't over. Blizzard carefully grabbed the confused mouse and carried it back to the spot where she had caught it. And, instead of eating it, she let it go again. Then she jumped into the snowbank over and over again after the mouse. It must have been a dozen times or so. Afterwards, she grabbed the mouse and headed back to the road again. And, of course, at this point you know what happened next, right? Blizzard started the dance all over again, then suddenly grabbed the mouse and charged off down the road as fast as she could to catch up with her family. Did she eat the mouse? We never did find out.

The moral of the story is this: never get out of your car and run after wolves. Always take your time and be patient if you want to experience once-in-a-lifetime stories like this. Because of our patience and etiquette, I was able to get incredibly unique film footage that has become one of the highlights of my talks and seminars. People love "personal stories" about wildlife and we've found that nothing gets humans more attached to wolves than when we share anecdotes like the "mouse story."

Blizzard playing with a mouse on the Bow Valley Parkway. Unfortunately for John, the shots were not as sharp as he had hoped, due to having to shoot through the heat waves over the hood of his vehicle.

The "Recycle Story"

As the mouse story demonstrates, Blizzard was a very special wolf. One of her hobbies while travelling with her family along the parkway or Sunshine Road was to quickly jump out of line and grab a plastic bottle or pop can out of the ditch. At first we wrote this off as typical juvenile behaviour, but it turned out this wasn't the case. Even after Blizzard had grown out of her juvenile stage into a yearling, it was normal for her to carry around "recycled goods." Eventually, after months and years of this, it became old hat to see Blizzard carrying around a plastic bottle or can in her mouth.

Blizzard always looked like she was proud of what she was doing, even as an adult. She quickly became our favourite Pipestone wolf, always doing the unexpected. Behavioural traits that were normal for other wolves in the family were not so for her. The concept of "classic pack behaviour" did not apply to Blizzard, and it is indeed difficult to explain why certain individuals of a wild wolf group carry around plastic bottles and others don't!

Any wolf can leave the family whenever they want to and go do "unexpected stuff," but Blizzard's antics were so unique that she was light years away from reducing wolf behaviour to an alpha concept with a strict pecking order. So what was the purpose of Blizzard's habit of carrying around empty bottles and cans? Honestly, we don't know, but we certainly always retained the passion and hope that we would get to watch more of her behavioural nuances that we had never seen before in a wolf.

That was one of the reasons that Karin and I went out every single day, even on Christmas. We were astonished when people around us would repeatedly ask, "Don't you have anything else to do in your lives?" Well, after awhile those people knew what was coming, because we took their same old question and gave the straightforward, standard answer: "No, because we love to do what we're doing." For us, observing animal behaviour has never been a "have to," or something we have thought of as work. For us, watching animals and trying to figure out why they're doing what they're doing has always been – and always will be – ten times more exciting than any crime drama on TV.

The "Underwear Story"

On January 6, 2011, Karin, John and I were sitting in our cars parked side by side and discussing the world of wolves. All of us loved to argue about why wolves do what they do. Sometimes we felt like reporters in a W5-type investigative TV show, always asking the same basic and methodical questions: Who (is that wolf)? What (is it doing)? When (is it doing it)? Where (is it doing it)? Why (is it doing it)? For behaviour observers, the "why" always is and always will be the most complex and difficult question to answer.

Once we were done talking, John left for a quick drive to see if anything was moving about yet (we knew the wolves were in the area), when suddenly the complete Pipestone family came around the corner and walked past our car just ten metres from us. We could not believe what happened next: Blizzard found a pair of men's boxer shorts on the side of the road and started rolling in them,

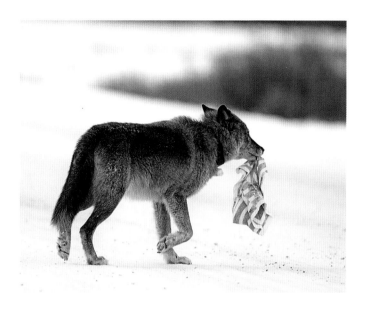

then threw them in the air and rolled on them again. Then she got up and approached Faith, who grabbed the boxers from Blizzard, gave them a violent "prey shake" and crossed the road with them in her mouth. Don't ask us how a pair of men's boxer shorts got there in the first place, but Faith walked into a meadow with the boxers held high, with Blizzard and two juveniles hot on her tail. She dropped the boxers halfway across the meadow, at which point "Chester" (a juvenile born in 2010) grabbed them and started chewing on them. He attempted to bury them under the snow, but Blizzard kept trying to snatch them out of his grasp, so Chester headed into the woods away from the other wolves and started to dig a hole to discreetly hide the shorts. Of course, everybody in the wolf family knew what was going on – Chester wasn't out-

smarting any of them. Spirit seemed to be the only wolf not interested in the boxers.

While the digging operation was going on, Blizzard suddenly found a mouse and raced away across the meadow with it. The boxers were quickly forgotten and all of the juveniles took off after their big sister.

Blizzard eventually tossed the mouse in the air and sprinted off to other, more important tasks. This left us once again without answers to the most important questions of all: Why had the wolves done what they had done? Was it just for pleasure or was there a different reason?

Do Wolves Have Emotions?

All of the incredible direct behavioural observations we've described above are, of course, rare to witness. There is very little known in the scientific community about how much influence emotions have on the behaviour of individual wolves. In this book, while we are eager to share these extraordinary observations we have had, and while we will outline our views on the socio-emotional lives of wild wolves, we are well aware that assigning emotions to wild animals is a wide-ranging and controversial topic.

We hope that our observations will provide a different perspective on wolf behaviour. We have had over 30 years of first-hand experiences with a number of different animals in Canada, as well as in several European countries. Some of our colleagues told us years ago that we should stop wasting our time, because neither dogs nor wolves could be emotional beings or display "fair play" or ethical sentiments.

Faith trots across the road with the boxers in her mouth.

But if that's the case, then why did the males Chesley and Rogue start howling so differently than their usual howls and sound so "melancholy" after their new wolf friend "Sundance" was killed right before their eyes on the Trans-Canada? Why did these wolves return to that exact location for several days in a row and howl over and over again? The truth once again is that we don't know why they stood and howled repeatedly from the trees near the spot where Sundance was killed. Like we have already pointed out, sometimes the toughest question to answer is "why."

Nevertheless, we feel similarly to wolf biologist Dale Peterson in that we believe, like he does, that the moral lives of nonhuman animals, and particularly the socio-emotional lives of wolves, are a gift of biological evolution. Wolves are far removed from only dictating alpha positions and social ranks and can negotiate inherent serious conflict between themselves and others, even with other species such as ravens. There always is conflict and choice. To Karin and me, all those naysayers about animals' emotions are slowly finding themselves in a growing minority. We are convinced that research on animal feelings is essential. For wolves, if kept in impoverished conditions, socio-emotional and otherwise, they are unable to express their full behavioural mood and repertoire and we get a false picture of what wolves are capable of doing. As Richard and Bernice Lazarus argued faithfully with an open mind in their book *Passion and Reason,* emotional reactions, among other factors, seem to reflect the wisdom of the ages.

How Do Wild Wolves Express Emotions?

Wolves express emotions through their body language. Our behaviour descriptions and our interpretations of wolf social behaviour venture beyond the conventional considerations and into an area that some scientists and most wildlife managers are reluctant to explore: wolves as feeling creatures. But, as Paul Paquet wrote in the preface to our German wolf book *Auge in Auge mit dem Wolf* in 2009, "As Günther skillfully and empathetically explains, the Bow Valley wolves often showed clear emotions such as joy, sorrow, grief, and altruism. Injured family members were never left alone, but were cared for by relatives via social support and supplementation of food."

Indeed, over the years we have learned again and again that social animals such as wolves care for one another by displaying compassion and empathy and by putting others before themselves.

It is important to note that socio-emotional, friendly behaviour is definitely not the same as "being nice." Niceness seems to be dependent upon character: sociable personality types tend to behave more "nicely" with other family members than headstrong characters do. But make no mistake: wolves do compete and on occasion are capable of harming one another, even within their family. However, this type of behaviour is rare compared to pro-social interactions and cooperation, because fighting each other can be very dangerous for all family members involved. Even breeding individuals may win a fight but at the same time lose in the long run because they are injured and not fit enough to reproduce. Most aggression

70

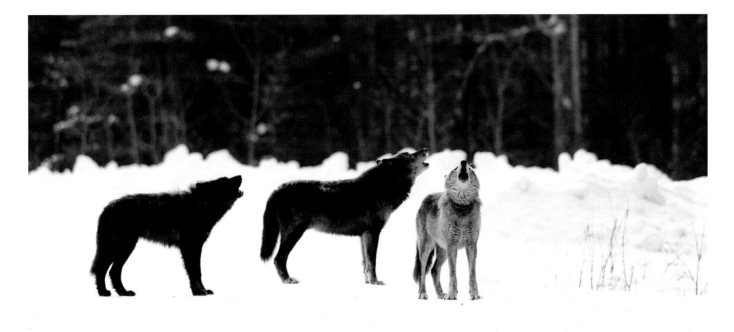

Chorus howling is intense enough that we would not hesitate to describe it as being emotional.

displayed by wolves and most violence is directed at wolves that are strangers, where there is no good reason for behaving "morally." An inhibition of agonistic (combative) behaviour within the social family group seems to be one of the several functions of "wolfish ethics."

To us, there is no doubt that emotions combine with the will to cooperate, personality, individual character and experience, along with cognitive assessment of a momentary situation, to prepare the wolf for an optimal behaviour response.

Put simply, emotions are an unlearned response system.

Viewing emotions as bodily and mental states that adapt behaviour appropriately to social environmental challenges is one thing, while understanding the structure of socio-emotional behaviour patterns is another. What we need is more open-minded, and therefore uncontroversial, behaviour descriptions of the body language shown in certain contexts. Body postures of wolves, for example, showing mixed inclinations between curiosity and fear, can be described relatively precisely. Greetings, rallies/meetings of wolf individuals and chorus howling are intense enough that we would not hesitate to describe

71

3 Frans de Waal, "What Is an Animal Emotion?" *Annals of the New York Academy of Sciences* 1224 (2011): 194.

these activities as being emotional, because in our view they come along with a functional label and sense. In other words, wolves should be seen as emotional animals in the functional sense in that they benefit others at a cost to themselves.

What does a "functional label and sense" mean? It means there are motivations behind behaviour that fall outside of the usual explanations in behavioural biology, and just because some scientists declare certain unanswered biological questions as taboo or nonexistent doesn't mean that they do not exist. For example, they may say that animals can't have emotions because we can't prove that they do. But we can't prove that we all have souls as humans, and some would argue humans have no souls, so does that mean we don't have souls? Nobody knows for sure, but we think they do. Just because we can't functionally label something doesn't mean it doesn't exist. In fact, we'd like to turn the question around and ask those same scientists for the scientific proof that animal emotions *don't* exist!

Renowned behaviour scientist Frans de Waal explains animal emotions as a

> temporary state brought about by biologically relevant external stimuli, whether aversive or attractive. The emotion is marked by specific changes in the organism's body and mind – brain, hormones, muscles, viscera, heart, etcetera. Which emotion is triggered is often predictable by the situation in which the organism finds itself, and can further be inferred from behavioral changes and evolved communication signals. There exists no one-on-one relation between

an emotion and ensuing behavior, however. Emotions combine with individual experience and cognitive assessment of the situation to prepare the organism for an optimal response.[3]

What a wonderful explanation for the emotional howling scenes we experienced after one of the wolves had died.

The Last Stand for the Bows

After Delinda and Nanuk and the original Bow Valley family dissolved, there was only one adult individual left from the Bows in the Bow Valley by the end of 2009: a young black female named Sundance. Meanwhile, the Pipestones by this point more or less occupied the entire territory that Sundance had grown up in (the Bows' territory).

In December 2009, the wolf breeding season started and hormones began to run wild. Sundance came into heat but did not approach the Pipestone family, because she was a reproducing competitor to their leading female, Faith. If she had, Faith would have beaten the crap out of Sundance for daring to approach "her" males. As both females were coming into heat in the third week of December 2009, Parks Canada radio collared Faith with a conventional VHF radio collar and Skoki was fitted with a GPS collar. We were not fans of this radio collaring, for several reasons. We felt it was some kind of cruel "Christmas gift" to the wolves, but more importantly, we did not agree with Parks' reasoning that they urgently needed to collar the wolves to collect "current telemetry data" to figure out whether the wolves were using areas such as the Pipestone

Valley, where Parks wanted to reintroduce caribou. We didn't see the need for this current data – we already knew the wolves were occasionally travelling up and down the Pipestone Valley into the backcountry.

Meanwhile, Sundance figured out a mating strategy to skirt the wrath of Faith. Instead of aiming for Spirit, she tried to lure out Chesley and Rogue, the young adult males. Of course, the boys knew exactly what was going on. One day we observed the yearling males following Sundance for seven kilometres away from Spirit and Faith and the rest of the Pipestones. She had obviously figured out a way to keep the interested males with her and away they went.

Unfortunately, as previously mentioned, Sundance was run over by a vehicle in late January 2010 on the Trans-Canada near the Banff warden office and died. The two males were totally devastated. As we have already described, they stayed in the area for three days and howled every night. Anyone who says animals don't express feelings did not see the heartbreak that we saw. From that day on, we only saw Chesley and Rogue occasionally. There were rumours, though, that they were the founders of a new wolf family in the Spray Lake area. And as a result of the two yearling males' departure and the death of Raven, the Pipestone family was down to just four individuals occupying the Bow Valley territory. Spirit and Faith did finally mate in February 2010, without any disturbance from competitors.

The fact that wolf parents typically start "showing" their entire established territory to their new pups by early fall in the year the pups are born presented a perfect opportunity for collecting precise information on leadership

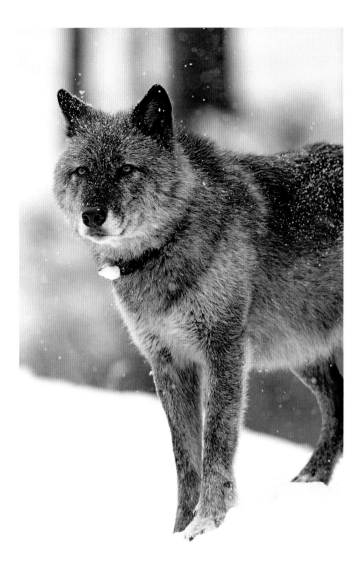

Faith shortly after she was collared in December 2009.

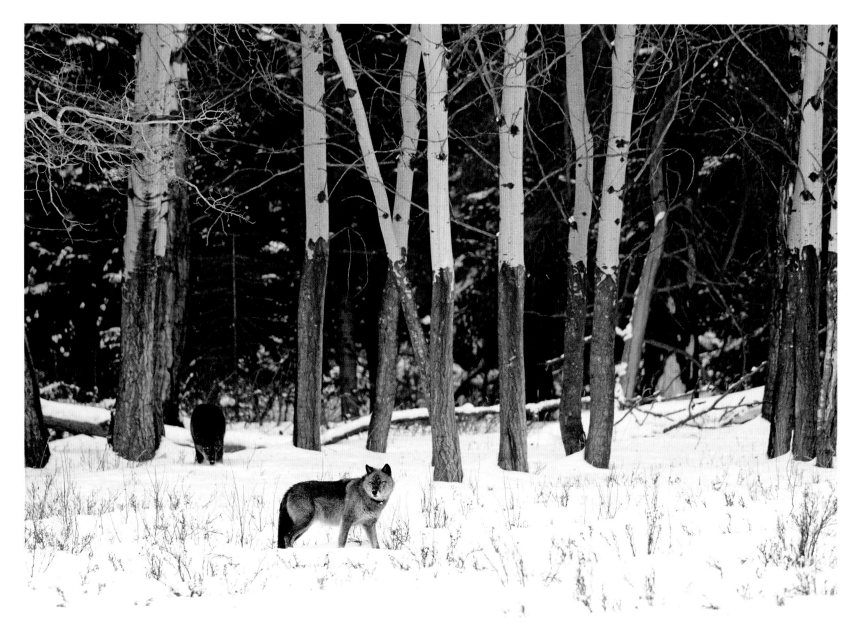

behaviour. So that was exactly what we did all winter long.

Are Wolf Families Exclusively Led by an "Alpha Male?"

Our observations for the winter of 2009 – 2010 unequivocally answered this question for us once again. As we had already discovered with our research in the past, the leadership of the Pipestone family wasn't strictly organized and formal decision making was not related to the sex of the individual. "Alpha male" Spirit was not always functioning as the "leader of the pack." In fact, more commonly it was his mate Faith that was the leader. We observed that leadership behaviour was extremely flexible, and related to age, experience, social status and the energy budget of individual family members. As we had been investigating since 1998, leadership behaviour (and all of the different motivations behind it that might play a role in which wolf leads) was expressed by breeding males and females, subordinates and juveniles. All wolf families that had lived in the Bow River Valley travelled and hunted on roads and railways during winter more than in summer. The frequency of wolves travelling on these different modes of human infrastructure was negatively related to the traffic volume and amount of human activity. Both the BVP and the CP railway interrupted movements (travelling and hunting) and caused wolves to leave the Bow Valley regularly. However, individual wolves responded differently to roads, railway and wildlife-crossing structures. These behavioural responses were developed through different experiences of social bonding with their parents, through their own early experiences with human infrastructure and through their individual temperament and character.

The leadership position when travelling (the wolf in front making the decisions) did switch within the family, not only seasonally but also between core and peripheral territory. Spirit usually seemed to have the highest motivation to travel first in unknown terrain, whereas within the intimately known inner territory it did not seem to matter much who led the family. We concluded that the job of avoiding potential hazardous situations was the responsibility of the highest-ranking male and that the youngsters within a wolf family can more or less run around carefree when the family knows where they are.

We also observed leadership behaviour being influenced by the ecological surroundings. For instance, youngsters were "not allowed" to lead when crossing a highway or secondary highway (Trans-Canada, Highway 93N or S or Lake Louise Drive). That seemed to be the job of either Faith or Spirit. By contrast, when crossing or walking on the more familiar (and less dangerous) BVP, Spirit and Faith did not always position themselves in front of the travelling family group.

During the winter of 2009 – 2010, we documented a total of 142 road crossings via direct observations, 72 of which were made while the Pipestones were crossing one of the above-mentioned highways and 70 were registered when the wolves were crossing the BVP.

Figure 2.2 shows leadership behaviour during road crossings.

Faith made many of the decisions in the family and was often the leader of the pack.

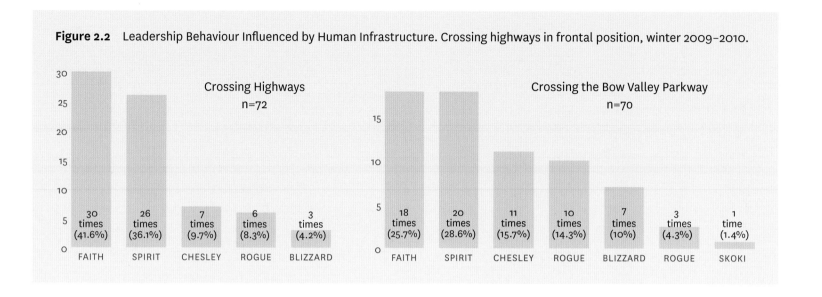

Figure 2.2 Leadership Behaviour Influenced by Human Infrastructure. Crossing highways in frontal position, winter 2009–2010.

Human Infrastructure and Extreme Adaptive Behaviour Strategies

Except for Raven, the family members all survived the winter of 2009 – 2010. They had figured out ways to coexist with people. But how, was the question. Getting answers to that complex question wasn't easy, especially since individual wolves are unique in their behaviour, and the habits and actions of wolf families reflect the collective interactions of these unique individuals.

We continued observing the behaviour responses and adaptations to human activity during the summer months of 2010. These responses and adaptations varied greatly among individual wolves but were important to us as they helped us create a knowledge bank of baseline behavioural tendencies and aided in understanding changes in their behavioural responses. The extreme volumes of traffic in that summer's high season definitely had a major influence on the size, stability and the persistence (of using infrastructure) of the Pipestones, as well as on their hunting. The mountainous terrain surrounding their core territory magnified the effects of heavy road traffic and led to a lot of interrupted hunting efforts. The traffic also drove the wolves more often toward the railway and other types of danger, such as navigating steep slopes or high waters. Up until our observation research, no single study based on direct observations had investigated the influence of complex human infrastructure (roads, highways, railways and settlements) on the movement patterns and adaptive strategies of wolves.

Because wolves live mostly in social family groups, the heavily used Bow Valley Parkway and the CP railway line caused a filtering effect on the movement patterns of the Pipestones and influenced their hunting behaviour (and, by consequence, likely negatively influenced their energy budget). For example, we documented changes in highway crossing frequency by individual members of the Pipestones that had an adverse effect on their movements because some of them did not use wildlife-crossing structures.

After Delinda died, we not only documented changes in group numbers and social stability but also drastic changes in reproduction behaviour in the Bows (the first evidence of inbreeding). And we already had knowledge of the filtering effect of human infrastructure during the Bows' family hunts. The Pipestones, like the Bows before them, adapted to having humans around and were even more tolerant toward people than the Bows were. But instead of developing a strict management plan for people that reduced or even eliminated the main problems the Pipestones faced, wildlife managers chose to carry on a useless discussion about how "habituated" the Pipestones were becoming. Instead of accepting the assistance of animal-behaviour-based knowledge, decision makers in Banff chose to base their management approach around further encouragement of mass-scale tourism. As far as the emphasis on improving habitat security for the Pipestones and other sensitive species was concerned, the Banff National Park management plan failed to ensure a reduction in the number of wildlife that die from unnatural causes. The result was that the wolves' preferred prey species, elk, got killed on highways and railways by the hundreds during the course of our project. Coupled with countless unnatural deaths of moose, deer and bighorn, one could clearly see the effects of reduced hunting/food availability on the Pipestones' social structure.

The end outcome in the Bow Valley was increased mortality and the decreased individual fitness of juvenile wolves. We observed some of the youngsters experiencing greater intra-family aggression and reduced access to food. All of these effects on behaviour combined to create a lot of socio-emotionally stressful and hazardous situations but also helped the wolves (juveniles, in particular) learn how to avoid direct encounters with humans and adapt to living in these high-volume traffic areas.

The Family Structure of the Pipestones in 2010

In June and July of 2010, a litter of four pups was observed: two black males and two black females. On July 31, six wolves (Spirit, Faith, Blizzard and three pups) left their rendezvous site for the first time. One pup had died, but the cause of death was unknown. At this stage, Skoki was rarely seen with the family (but he was a very shy wolf and could have been around more often than we thought). One thing was clear: Blizzard was an integral part of raising the pups and played the key role of being the "social worker." This once again gave evidence to the fact that young females operate as "babysitters" much more often than yearling male wolves do.

By the end of the summer, one of the juvenile males had

developed a large white patch on his chest, so of course we named him "Chester." His two black-coloured sisters were named "Meadow" and "Lillian." All three pups, raised by Spirit, Faith, Blizzard and occasionally Skoki, were brought up in the traditional and cultural environment of their parents. So it wasn't a surprise that they each emulated established patterns of highly adapted behaviour. Without complicating everything, the social skills wolf parents use to teach their young traditional behaviours like humans do is the reason we continue to describe wolf parents as "fathers" and "mothers." Interestingly enough, the dominant wolves of the Pipestones were once again not always the first to feed at kills but often gave way to the youngsters Chester, Meadow and Lillian (debunking the "alpha" concept yet again).

Regardless of who the parent wolves are, there are a lot of interesting theories regarding ranking and social status

Six-month-old Chester in October 2010.

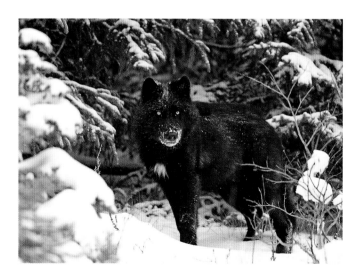

in wolf offspring. So-called little alphas, which are usually the highest-ranking yearlings, develop from the group of juveniles by holding their own against their siblings. Decades ago, canid researchers like Michael Fox claimed, argumentatively, that lower-ranking individual wolves don't ever get to mate. What a fallacy! His opinion hinted that rank is built up very early and that only individuals high in rank are destined to develop into leader personalities, whereas low-ranking individuals are not capable of doing so. In the wild, however, it's a different story. In particular, lower-ranking individuals tend to disperse very early on and often find a partner with whom they mate. Thus, the future parents automatically gain a kind of alpha status with their offspring. That means that submissive types leave their former group and often quickly become parents with a high rank. Of course, there is considerable variation in wolves leaving their family, according to age, sex and distance.

Sooner or later, nearly all wolves try to find a new mate in the wild with whom to rear offspring. After Sundance had died in January 2010, the brothers Chesley and Rogue were last observed travelling together in April 2010 in Spray Lakes Provincial Park, likely in search of potential mates. Similarly, in late December 2010, 18-month-old Skoki left the Pipestones for good and dispersed into Peter Lougheed Provincial Park in Kananaskis Country, where he found a gray-coloured female to mate with. In early July 2011, his new family included at least three pups that were observed running around and jumping up at their father, who seemed to be in a playful mood. It was like a Hollywood story.

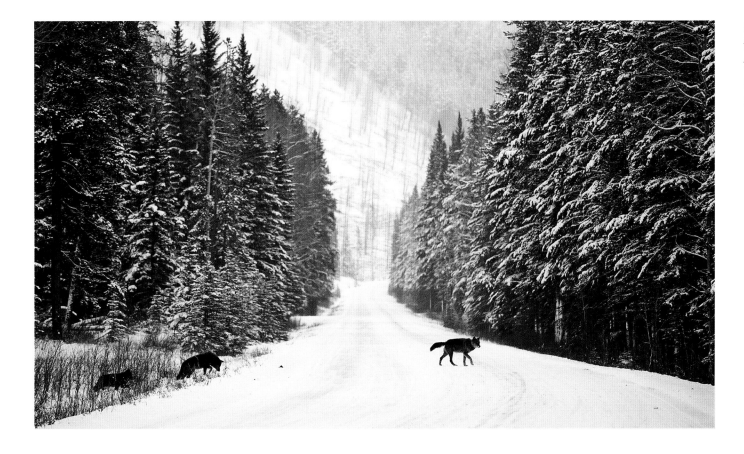

Faith leads the family across the Bow Valley Parkway in November 2010.

Travel Disruptions on the Bow Valley Parkway

Between November 2010 and March 2011, we recorded a total of 49 disruptions of the Pipestones' travel behaviour due to traffic on the BVP. Two typical behaviour patterns were observed in these instances and listed on our special behaviour sheets: avoidance behaviour and displacement behaviour. A wolf flattening its ears and lowering its body and tail position typified avoidance behaviour. Leading wolves avoiding traffic, for example, typically freeze their position for several seconds, then turn away from the traffic and move into cover. Freezing behaviour can also be included in displacement behaviour, which typically consists of stress-related yawning or sniffing the ground for no apparent biological reason. Such an individual is in a

conflict of different drives or motor patterns and is uncertain of what to do next. Displacement behaviour may also include stress-related urination or scratching behind the ears. This behaviour occurs when a wolf is experiencing mutually exclusive motor patterns and sometimes are out of context with a current situation.

For instance, a wolf approaching the BVP might experience two mutually exclusive drives that are in conflict if it is interrupted; it may want to approach and avoid the road at the same time.

Figure 2.3 demonstrates the number of times Spirit or Faith showed either avoidance behaviour or displacement behaviour while leading other family members toward the Bow Valley Parkway and attempting to cross that road.

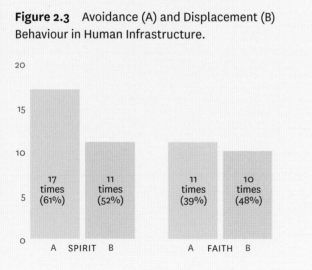

Figure 2.3 Avoidance (A) and Displacement (B) Behaviour in Human Infrastructure.

The End of Traditional Elk Hunting

For decades, elk were the preferred prey species for wolves in the Bow River Valley. That all changed in the late 1990s when Parks Canada moved more than 200 elk from the Banff town environs between 1999 and 2002 and relocated these so-called town elk outside the national park boundaries. These extremely questionable actions were strongly criticized in several newspapers and books by a lot of concerned people, including us in *Timberwolf Yukon & Co.* and Peter Dettling in *The Will of the Land*. We all came to the conclusion that as a direct result of having roughly 40 per cent of their food resources removed, the Fairholmes, a wolf family living between Banff and Canmore in the lower Bow Valley that had preyed heavily on (and depended on) this town elk population, broke apart. From that point onwards, the elk population and food base for wolves and other large carnivores was severely reduced in the Bow Valley. This management decision failed to respect the functional predator–prey relationship between the Fairholme wolves and elk.

Additionally, according to local newspapers such as the *Rocky Mountain Outlook*, sometimes there were exceptionally bad days when up to five elk were killed per day by trains on the CP rail tracks between the townsites of Banff and Lake Louise. In fact, these steel killing machines were a disaster for not only elk but deer and moose as well. Smaller ungulates and rodents don't even get reported to the media. No one has ever read about white-tailed deer, mule deer, bighorn sheep, snowshoe hare or beavers getting killed on the tracks, because no one ever reports

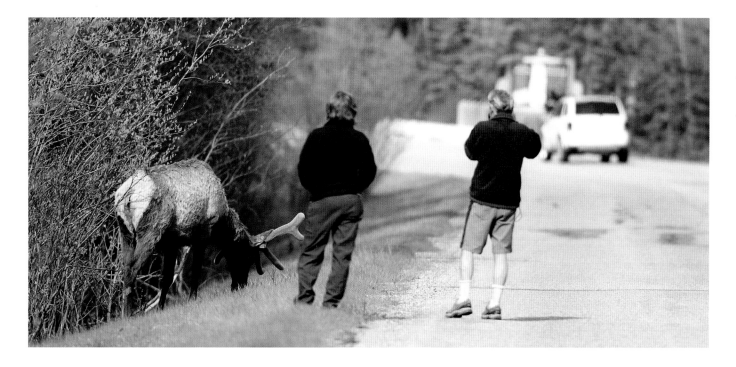

Elk have become increasingly rare in many parts of the Bow Valley, particularly along the Bow Valley Parkway.

it to the newspapers. Yet we've seen it all and documented hundreds of dead bodies or body parts – it's just everyday life in the Bow Valley.

When the Pipestones started to establish territory in our observation area, they immediately faced a shortage of vulnerable elk to hunt. This reduced food availability resulted in increased (longer) movement patterns, a decreased energy budget and greater interspecific aggression. Later on, we also became aware of the fact that reduced hunting opportunity resulted in an increased mortality risk and led to some individual wolves, of which we call "sociable types," being displaced out of the territory.

In response to the shortage of elk, the Pipestones began to function as a very flexible hunting group. In the winter of 2010 – 2011, Faith, Spirit and Blizzard searched for and chased moose, deer and even occasionally bighorn sheep and, according to Parks Canada statements in local newspapers, mountain goat. Meanwhile, the youngsters Chester, Meadow and Lillian, because of their lack of experience, really didn't become an integral part of the family hunting unit until the end of the winter, when they were 10 or 11 months old. We often watched Spirit and Faith start a hunt along the BVP or Bow River, and within minutes the youngsters had been left behind. The

Faith and Blizzard feed on an elk carcass, January 2010.

juveniles tried to hunt small prey in the absence of the adults, but their hunting success was very low. In fact, on their own, they were only able to very occasionally bring down young, female, white-tailed deer and snowshoe hare, which represented just a fraction of the family's hunting success on small prey species. As we have documented in our previous work in 2002, young wolves do not usually attack large prey species until they're at least 10 months old.

Most of the time, the wolves had the highest hunting success rate in the vicinity of the Bow River. During warmer seasons, when the river was free of ice, the wolves chased prey into the river, where the prey would stand there and hope. In winter, when the river was frozen, the wolves would chase deer and elk onto thin spots in the ice where the ungulates would break in and become easy prey.

Spirit and Blizzard shared duties and chased and tried to attack moose more often than ever before. Meanwhile, the juveniles were quite often without interference or supervision from one of the adults. Within the core area of the Pipestone territory including their rendezvous site, the juveniles Chester, Meadow and Lillian left the resting adults often, especially since the adults were often completely exhausted from unsuccessful hunts. At times, the youngsters were chasing mice and other rodents for over an hour. Small prey can make up as much as 15 per cent of a wolf's diet, so mouse hunting does actually matter. Nevertheless, mouse hunting can't replace real group hunting, which is regularly needed in order to survive.

Wolf parents and most 1- to 2-year-old adults are the ones that show inexperienced youngsters where to find prey (for example, within traditionally used calving grounds), what to hunt and how to hunt. It was always interesting to note the fact that parents such as Faith and Spirit knew a lot about prey that their offspring simply couldn't know without being taught. For instance, what to do when elk were not abundant was one of the very important things Chester & Co. had to learn: visiting more side valleys, travelling uphill more often and smartly giving chase to the most vulnerable bighorn sheep, for example.

Well-established adult and breeding wolves do hunt and kill specific prey animals very traditionally. The role of juvenile and inexperienced wolf individuals in the Pipestone family's hunting strategy now depended on imitating the extremely flexible hunting strategies of Faith and Spirit to which the three juveniles were most closely bonded. Yet, for the parent wolves, hunting with no elk around meant more and more that the only alternative was to hunt fighting-spirited moose or nimble climbers such as bighorn sheep and mountain goats.

The bad news was that Faith and Spirit took more risks in order to successfully bring down prey in tough and tricky, dangerous, mountainous terrain. The good news, though, was that both parents were still young (Faith was approximately 4.5 years old, Spirit 5.5), powerful and clever enough to persistently pursue ungulates for hours if necessary. Based on information we received from different sources, as well as from our own backtracking, we became aware that Faith and Spirit had followed and chased a female moose in March 2011 for almost 29 kilometres. We noted that the wolves had been zigzagging across the

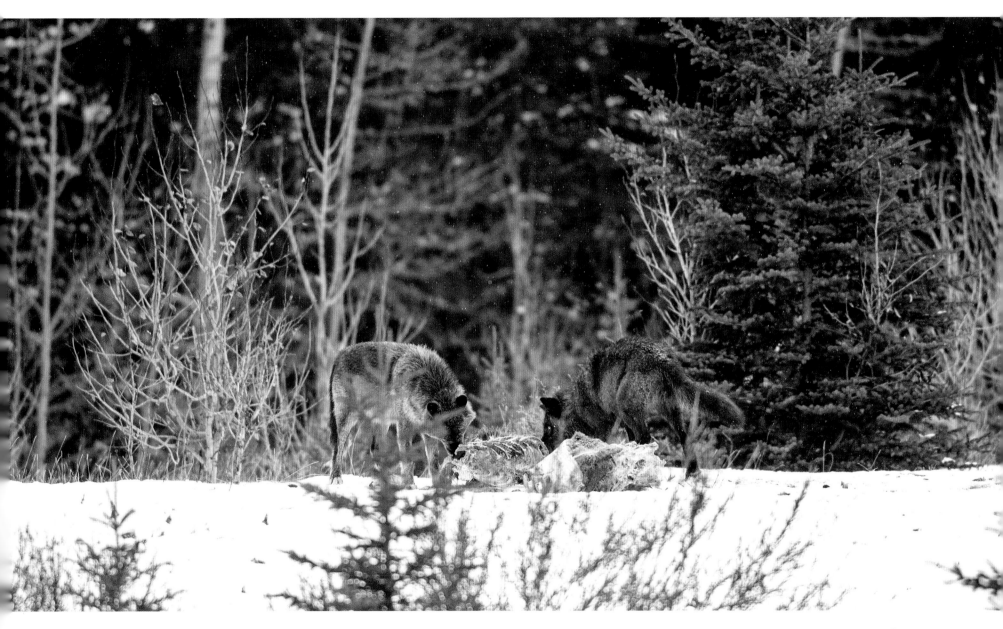

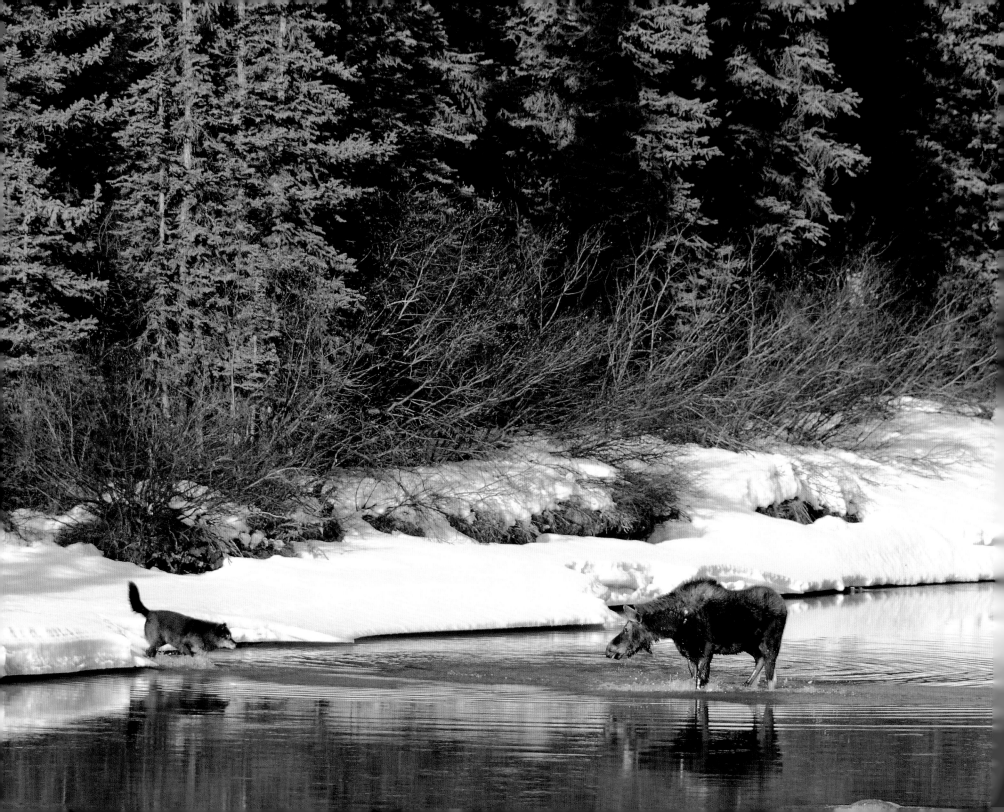

Bow River at least five times, had driven the moose right through an underpass near Castle Mountain and had eventually killed it on the opposite side of the Trans-Canada Highway.

Figure 2.4 compares the Pipestones' hunting and scavenging success in the summer and fall seasons of 2009 and 2010.

During the winter seasons of 2009 – 2010 and 2010 – 2011, there were a total of 29 kills (n = 29): four were moose, one having been killed on the CP railway line (13.8 per cent); twenty were white-tailed deer, five having been killed on the CP line (68.9 per cent); four were elk, three having been killed on the CP line (13.8 per cent); and one was a sheep (3.4 per cent).

It was interesting to note that out of the 28 ungulates consumed by the Pipestones during the summer/ fall seasons in 2009 and 2010, approximately 18 per cent were scavenged along the CP railway line compared to just over 31 per cent during the two winter seasons. By distinguishing between the seasons, our direct observations also suggested that the wolves were more likely to patrol the railway tracks in winter than in summer.

As a general rule, we'd learnt that the wolves were not "bloodthirsty murderers" but rather family-oriented animals that needed to feed their kids. We only documented surplus killing once in our entire project. In 2001, the Fairholme wolf family killed a cow elk, but were then disturbed by tourists, so they killed another cow elk half an hour later. They were disturbed once again and finally killed a third elk, a calf, which they consumed. Surplus killing does occasionally happen, particularly when one or both

experienced wolf parents have been killed by humans or when a wolf family gets disturbed while hunting. In order to promote a better understanding of how and what wild wolves hunt and kill, one of the worst things humans can do is to shoot wolf parents. Why? Because eliminating parent wolves removes the hunting and habitat knowledge and social wisdom from the family. Confused "teenagers" get left behind that have no clue where to go, what to hunt, how to avoid hazardous situations and how to deal with humans. It's for exactly this reason that we urge ranchers and wildlife managers and others to leave wolf parents alone if they are peacefully co-existing with livestock or humans.

Spirit charges into the Bow River to test a cow moose near Lake Louise.

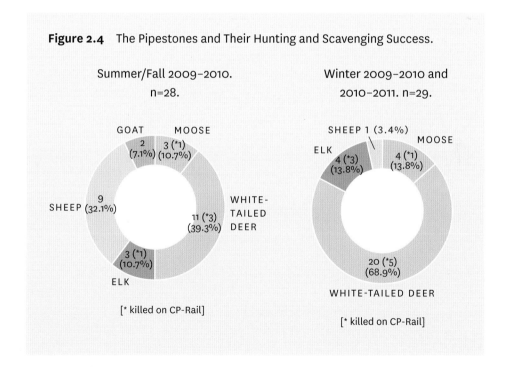

Figure 2.4 The Pipestones and Their Hunting and Scavenging Success.

Summer/Fall 2009–2010. n=28.

GOAT 2 (7.1%)
MOOSE 3 (*1) (10.7%)
WHITE-TAILED DEER 11 (*3) (39.3%)
ELK 3 (*1) (10.7%)
SHEEP 9 (32.1%)

[* killed on CP-Rail]

Winter 2009–2010 and 2010–2011. n=29.

SHEEP 1 (3.4%)
MOOSE 4 (*1) (13.8%)
ELK 4 (*3) (13.8%)
WHITE-TAILED DEER 20 (*5) (68.9%)

[* killed on CP-Rail]

Formal Dominance versus Momentary Dominance

One of the key purposes of wolf fathers and mothers is to teach their young enough so that they can become independent in the future and eventually become parents themselves. The better they are taught and the more experienced they are when these young, but reproductive-aged, wolves hit the "market," the higher the probability that the gene flow will continue. When offspring grow up and know how life works, they have a higher likelihood of passing on their genes to the next generation of wolves.

But we're getting ahead of ourselves. First, young wolves learn to imitate the behaviour of the older wolves rather than being told what to do. The primary jobs for parent wolves are to arrange protection and safety on a daily basis, to teach their offspring how to become valuable members of a socio-emotional society and to teach them when and how to cooperate with each other. Taking the initiative and actively converting the important decisions in life is what we call formal dominance. Adult wolves take care of things. It's as simple as that.

However, the generalized term "dominance" often gets wrongly connected with a strictly functionalist approach in which behavioural motivations barely count. This strictly functionalist approach ignores important functions of behaviour and doesn't look at patterns of what happened before or after, doesn't look at interactions with the environment or other animals and doesn't look at body language.

Yet these are all very important in explaining domi-

nance. In order to form stable social groups, agonistic social rank order correlates with age and status. Importantly, though, submissive behaviour and its typical formal communication signalling fulfills the criteria of stabilizing "dominant" social positions. Formal dominance (which, if necessary or needed, is underlaid by body language showing high, erect postures) is fundamentally related to age, yet older, high-ranking wolves often do not need to show dominance aggression. Rather, they simply ignore certain things. Our findings contradict the notion that within a wolf family there is generally an exclusive male agonistic dominance in each age class. Additionally, we do not agree with the argument that wolf societies are socially organized in a consistent linear rank order system. Sometimes females dominate males and other times males dominate females. However, the question of dominance in relation to sex, social status and age, as well as character type, will be discussed in the next chapter.

With dominance, what we often saw was that a lot of long-term social bonds within wild wolf families exist sexually independently. We have observed decades of communicative rituals (stabilizing behaviours) during play-runs, play-wrestling and social play in general. For that, wild wolves seem to use regularly organized family gatherings (rallying, chorus howling and play sessions) to test and establish their individual place within the existing family structure.

Such initiatives, organized by one of the formal dominant parents, seemed to establish very stable social relationships with their subordinate group members. Furthermore, play among parent wolves, who are usually

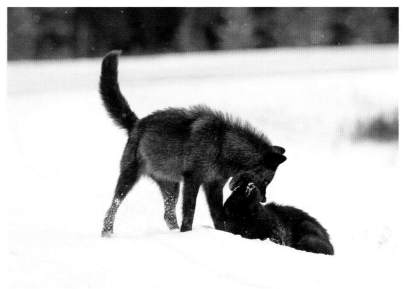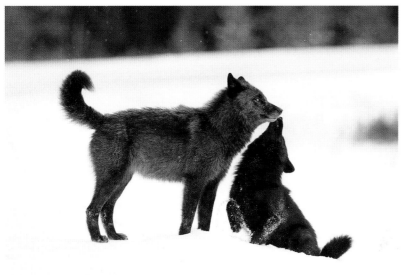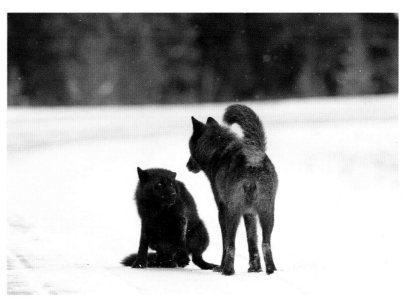

monogamous, strongly reflects their partner reference (pair bonding) and formal dominance structure outside of play. During social play, formal dominance relationships among littermates form over time, and all play during the juvenile period seems to aid step-by-step in making their interactions more similar to that of adult wolves.

Formal dominance should be defined as a nonviolent (it is seldom aggressive) and intraspecific key component of active decision making, rather than meaninglessly "beating up" other family members. Unfortunately, formal dominance seems to still exist in the minds of a lot of dog people as an act of violence. Some dog experts even love to argue that we should tell our dogs what to do, because wolves do the same. But they don't. In reality, one of the main differences between wolves and dogs is that wolves

get taught to be completely independent, while humans at least try to convince dogs not to become too independent but rather to have a "good time" under the wings of their social, two-legged companions. That's where humans fail the most with their dogs. But that's a different story, to be tackled by a different book altogether.

Nonetheless, what humans can learn from wolves is that knowledge is power, not muscles. Formal dominance in the absence of food and other resources was observed in five different contexts of decision making:

1. when actively initiating the family's collective group resting;

2. when actively initiating the family's collective group departure;

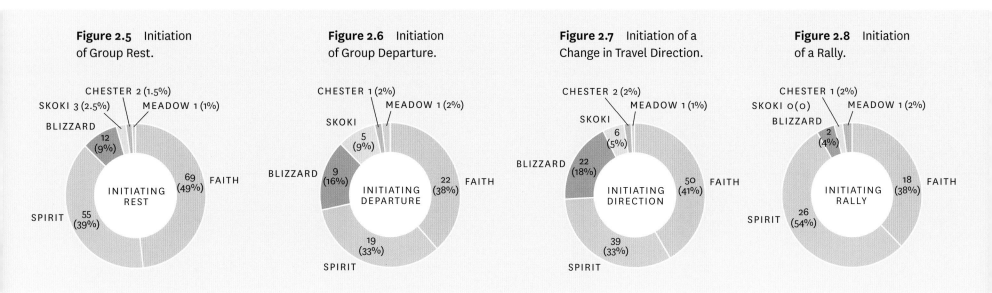

Figure 2.5 Initiation of Group Rest.

Figure 2.6 Initiation of Group Departure.

Figure 2.7 Initiation of a Change in Travel Direction.

Figure 2.8 Initiation of a Rally.

3. when actively changing the family's travel direction during common expeditions;

4. when actively initiating collective group rallying;

5. when actively initiating collective group howling.

Based on a total of 396 direct observations made between January 1 and December 31, 2010, Figures 2.5 through 2.9 show how many times each wolf individual had been the decision maker in the different situations listed above.

Without explaining every detail of the results, we do want to point out that Faith, the breeding female, was typically the main decision maker when initiating three out of the five family events (rest, departure and travel direction), while Spirit was the main decision maker for two events (group rallying and howling).

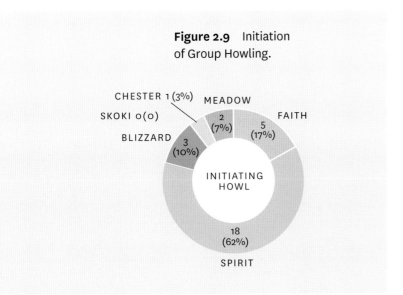

Figure 2.9 Initiation of Group Howling.

CHESTER 1 (3%) MEADOW
SKOKI 0 (0) 2
 (7%)
BLIZZARD 3 5
 (10%) (17%) FAITH

INITIATING
HOWL

18
(62%)

SPIRIT

Faith had been functioning as the central figure within the Pipestones right from the beginning. Wolf individuals that actively initiate a lot of daily routines are formally dominant. Furthermore, our observation results suggest that many of the jobs and behaviour patterns that in theory are "typically" the domain of the alpha males are actually carried out by a high-ranking female in the real wolf world.

In fact, initiating actions may function to communicate formal dominance status of decision-making females to the other group members. Moreover, based on our results, the dominance hypothesis of a macho world ruled by alpha males is dubious at best. We had already questioned it years ago when our "turbo queen" Delinda ruled almost all facets of the Bow Valley wolf family. She was not *a* decision maker, she was *the* decision maker. And our findings suggest that wolf parents do not function as strict dictators but rather have the courage and tolerance to leave occasional decision making up to subordinates or even juvenile family members.

There is a lot of what we can transfer to our lives from wild wolf parents, for instance how they switch genially back and forth between formal and situational or momentary dominance while handling their youngsters. As far as formal dominance is concerned, wolf fathers and mothers take action and responsibility by simply doing what young wolves do not like to do or can't do. Situational dominance, for example, involves things like who eats first or who controls the different kinds of resources. Interestingly enough, it is usually the wolf mothers, and not the fathers, who distribute food to the pups. Another example of situational

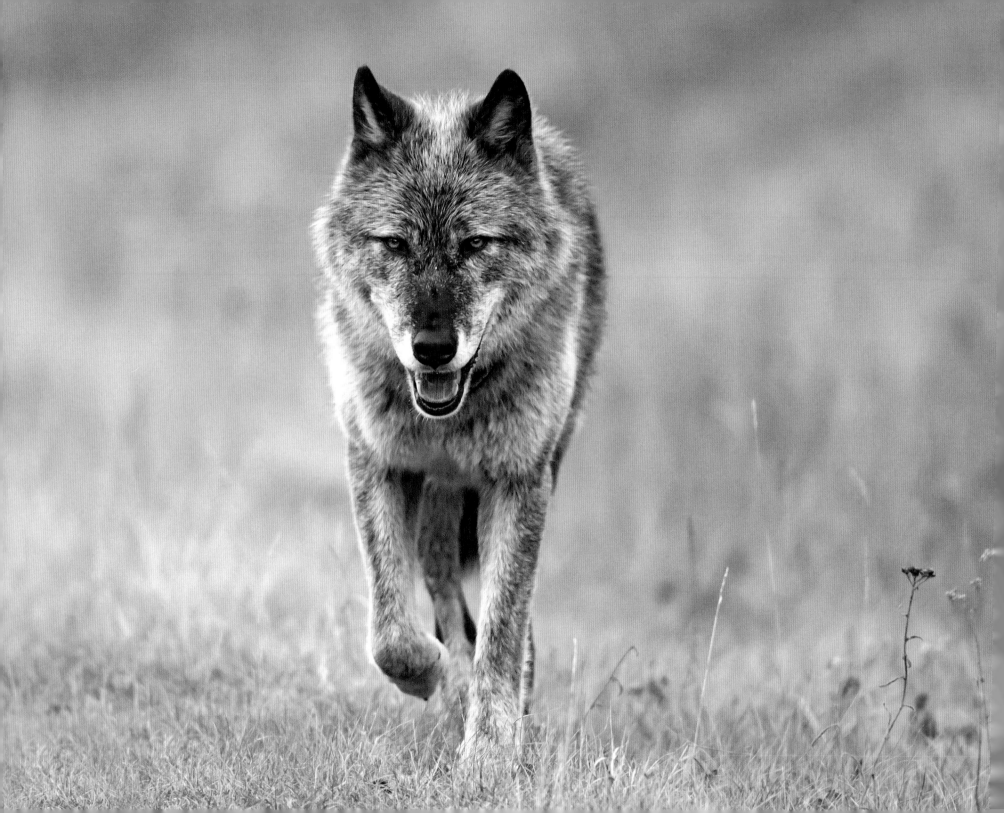

dominance would be a wolf parent positioning itself in front of the offspring while attacking a potential enemy such as a bear and doing everything they can to control the situation.

Nonetheless, there is a misconception with the issue of controlling, because a lot of people think that a high-ranking position is equal to being in control of every-thing, everywhere and at all times. But that is not the case. Individuals with a high social status can gain access to resources prior to other subordinate group members in competitive situations whenever they want, but they don't always do that. For instance, wolf parents have first pri-ority when accessing food, but they don't necessarily pull rank and dominate all the time. Real alphas don't have any reason to do that.

On the contrary, if it comes down to resources, they very often momentarily ignore "rebellious, snotty little kids" or quickly teach them an agonistic lesson. In 2010, biologist Simona Cafazzo and her colleagues from Italy wonderfully defined agonistic dominance: "Dogs interact agonistically. An aggression may be followed by a sub-mission, by another aggression, or may be ignored. In the last 2 cases, the interaction may not express a mutually acknowledged dominance relationship. Submissive inter-actions are considered as better indicators of a dominance relationship, and they show a higher level of linearity aggressive behaviors."[4] And that is exactly how it works. According to our own findings, for approximately 80 per cent of the time, high-ranking wolves control the resources but usually do so passively (not aggressively). From their body language and their stare, one can see that they can control whatever they want to, whenever they want to. Every youngster reacts to this immediately without asking any further questions.

Contrary to dogs, where all individuals can show self-assured scent marking at a young age, wolf parents do show specific scent-marking behaviour, as has been explained before, including scratching on the ground (something young wolves don't do). Showing all of the specific body postures (high and low) with tails raised or down is a classic indicator for a perfectly functioning wolf family structure. Extremely conspicuous is the strong pair bonding shown by wolf parents, which can be observed even outside the mating season, when they show a lot of socio-friendly greeting behaviour while walking together side by side. However, there is also parent and offspring bonding, sibling bonding, group bonding, habitat bonding and even a strong bonding to preferred objects such as specific antlers, bones or pieces of fur used during play sessions over and over again.

When it comes to alpha wolves and dominance, wild wolves don't always operate as a unit. The term "pack dom-inance" is popular when explaining so-called typical wolf behaviour in books and on the Internet, and one of the most common misunderstandings is the belief that wolves are constantly operating in "packs." They are not. Wild wolves rarely form family hunting units in the summer months while taking care of pups.

Instead, the Pipestones often operated in one of two ways during the summer: 1) individual wolves left the den location to find food as soon as possible (feeding pups at regular intervals was their first priority), and 2) small

Faith was typically the main decision maker when initiating three out of the five different family events (rest, departure and travel direction).

4 Simona Cafazzo et al., "Dominance in Relation to Age, Sex, and Competitive Contexts in a Group of Free-Ranging Domestic Dogs," *Behavioral Ecology* 21, no. 3 (2010): 444.

family units of one or two wolves on average were observed patrolling the CP railway line for carcasses daily (the latter, of course, is Bow Valley-specific). In summer, pack gatherings are the exception, not the rule. Considering the fact that from May through August the members of a wild wolf family are scattered all over the place for long periods of time, and that therefore higher-ranking and lower-ranking individuals meet less frequently, the whole idea of "constant dominance" should definitely be evaluated in more detail, as we have tried to do in this book.

If the Pipestones were gathering around a dead elk or moose, breeding female Faith was momentarily dominant over all the other group members, including "alpha" Spirit. Nobody wanted to argue with this highly motivated mother of the pups when she was feeding first on a carcass and aggressively defending it. Having a closer look at the feeding behaviour of the Pipestones throughout the year,

we concluded, just like we had in the past with previous Bow Valley wolf families, that there is no such thing as a strict feeding dominance order with wolves living in the wild. Rather, it's usually just a very flexible feeding system. However, all feeding behaviour habits shown by the parent wolves Faith and Spirit, as well as by adults like Blizzard, were extremely variable depending on whether the wolves were consuming a moose, an elk or a deer.

One general rule seemed to be that the more biomass present, the less agonistic behaviour (including aggressive communication) we observed. At bigger carcasses, the wolf parents Spirit and Faith were usually not the first ones to feed, instead allowing their low-ranking offspring to confiscate a dead moose or elk. However, their "general kindness" toward their subordinate daughter Blizzard, as well as toward their juvenile offspring Chester and Lillian, ended relatively quickly when consuming a small white-tailed deer instead. In winter 2010 – 2011, some comparison work of the feeding behaviour of the Pipestones at two carcasses each (of moose, elk and white-tailed deer) showed how flexible momentary dominance is expressed in a wolf family, known in biological terms as the "egalitarian feeding system."

Based on a total of 336 direct observations, Table 2.1 shows which members and different group constellations of the Pipestone family were observed feeding individually, in small units or together with all five family members.

Table 2.1 Pipestone Feeding Behaviour at Ungulate Carcasses.

Frequencies of Wolves at Carcass	Moose	Elk	Deer
individually separate	18	22	5
Faith & Spirit	21	28	11
Faith, Spirit & Blizzard	29	19	2
Faith, Blizzard & Chester	22	23	2
Faith, Blizzard & Meadow	38	21	2
Faith, Blizzard, Chester & Meadow	21	24	0
all five family members together	17	11	0
Totals	166	148	22

The Shy and Bold Model

We hope that slowly but surely you have started to realize how important direct observations on wild wolves are

Chester and Lillian at an elk carcass.

for figuring out the intimate details of their social lives. Any decision making in wildlife and human management should always be based on basic behaviour knowledge. Otherwise, animals' reactions toward humans are most likely going to be misjudged. The assessment of wolves living in human-dominated landscapes should presuppose basic knowledge about different personalities. The same is true for bears and other wildlife species.

So far, wildlife managers have failed to even consider basic behaviour work as part of any decision making.

Instead, there is a lot of talk about aversive conditioning efforts (using rubber bullets and noise deterrents to move animals away from humans and human infrastructure) when dealing with so-called problematically habituated animals. What is at issue here?

Any effort being made concerning aversive conditioning and long-term "behaviour-shaping" of wild animals is extremely difficult and time-consuming. It requires specially trained personnel and is just not that easy to do successfully. And one thing is certain: shooting a couple

93

of rounds of rubber bullets or firecrackers toward a wolf or bear without any competent knowledge in the field of animal psychology simply doesn't cut it. Such momentary actions not only have a high potential of confusing an animal but also increase its mortality risk. Besides, such unsystematic efforts don't really have anything to do with aversive conditioning at all. Conditioning has to be consistent to work; in order to modify the behaviour of a habituated animal, it is necessary to systematically confront it with aversive stimuli repeatedly and consistently (in other words, dozens of times at different locations out of different vehicles and/or by different people).

Although the general concept of what is called the "shy and bold model" is widely known, Parks Canada did not make any noticeable effort to recall this biologically relevant concept and apply it in its management actions. In Banff, we were the first ones to start distinguishing between two basic types of wolf characters, expressing two basic behaviour tendencies and reactions (Types A and B).

There is the Type A personality, whose behaviour reaction toward unknown stimuli is spontaneous. A Type A personality is explorative, daring and controlling. Applied to wolves, Type As are the ones that are visible, because they show up on roads (often first) and curiously investigate all kinds of objects, including parked vehicles. However, it's important to note that showing up often on roads does not necessarily mean a wolf is a Type A, because wolves can also learn to adapt to the presence of vehicles and roads.

By contrast, there is the Type B personality, who always waits and behaves more cautiously and is more reserved in decision making. This personality does not spontaneously approach unknown stimuli but rather behaves discreetly and is shy. Type B wolves often take detours around any obstacles, such as vehicles. With that knowledge in mind, we always kept our car at a distance when the wolves were actively travelling on the Bow Valley Parkway so it would not be in the way and cause Type Bs to move into the forest to go around us. In that context, one can see why we were constantly annoyed when uninformed park visitors, or ignorant local photographers who should know better, drove right into the middle of the Pipestones, displacing them off of the road and disrupting their movement patterns. Furthermore, it is important to note that A has nothing to do with "alpha" or B with "beta," because even low-ranking individuals often behave in an extroverted manner.

Of course, both personalities can only show us tenden-

cies in behaviour, which is why we generally differentiated wolf behaviour on a scale of zero to ten in terms of two elements: time and space (time was measured by a stopwatch, space by a tape measure). We did this so we could differentiate between shy versus very shy, for example.

Several tests were carried out to be able to distinguish between extroverted Type As and introverted Type Bs. In order to figure out the different personality types of the Pipestone wolves, we developed two different tests. But before we get into the tests, you might be wondering why it's important that we break down behaviour details like this. The reason is that the movement patterns of wolves are widely influenced by shy or bold individuals: some wolves may suddenly whip across a road in a split second (shy Type Bs), while others might stand on a road for some time without hesitating much (bold Type Bs). Wolves living in the Bow River Valley, in particular, need to cross roads and railways and use wildlife-crossing structures, as well as travel on human infrastructure, in order to conserve their energy budget.

Chasing wolves away from roads and other human infrastructure by hazing or aversive conditioning only resulted in a filtering effect on wolf family movements, because some individual wolves refused to cross roads and even wildlife-crossing structures. The effects of this splitting up of the family may increase individual mortality risks from automobile and train collisions, as we observed in the case of Raven.

Regardless, the Pipestones surprised us by taking over the busy Bow River Valley in rapid succession. And because the wolves started using the BVP regularly, we

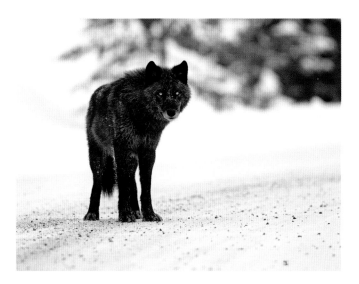

Blizzard was a classic example of a bold Type A wolf.

were pretty sure we would be successful in attempting to accurately classify the different types of wolf characters in the family. Their travelling in the open on the road gave us an excellent opportunity to follow them for long distances and carry out behaviour tests. Meanwhile, the Pipestones' territory also included small parts of Yoho and Kootenay national parks and by the end of winter 2010 – 2011 covered an estimated area of about 1100 km², which gave us a lot of opportunities to test our shy and bold model findings in a variety of different landscapes and circumstances.

In our opinion, the testing of basic character types has to be done on wild animals because otherwise we're left with huge gaps in our knowledge base. One of the key reasons we wanted to accomplish this work was to show the difference between adaptive behaviour (for instance, reactions to parked cars) and habituation to humans.

Leading male Spirit (right) was a strong Type B personality, while leading female Faith (facing page) had an explorative Type A personality.

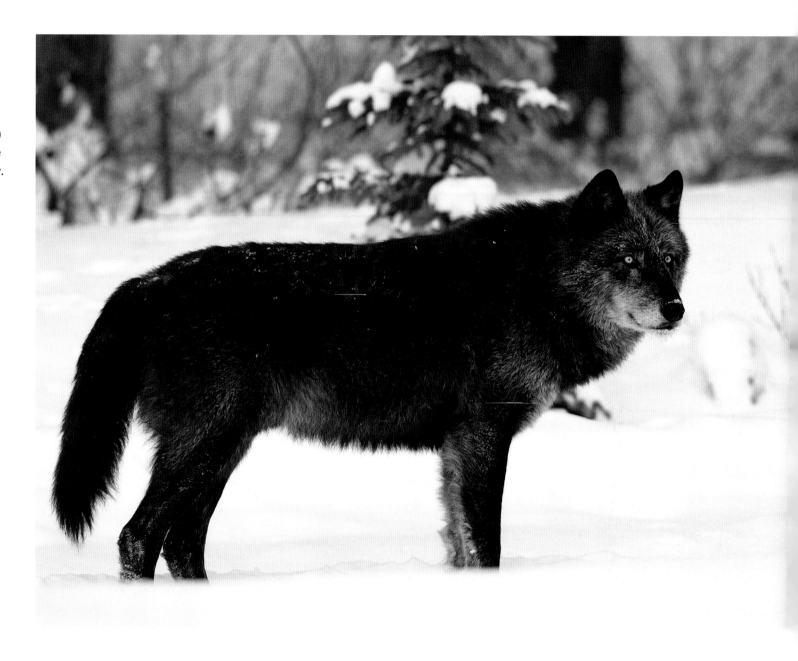

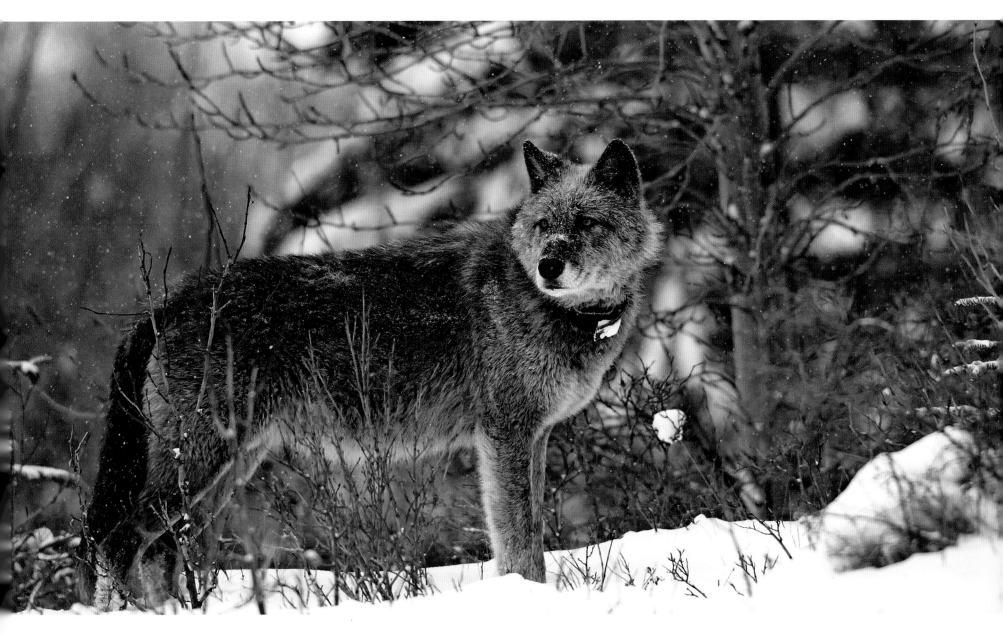

We also wondered if "curious" wolf individuals (Type As) that did not hesitate to travel on roads had a higher mortality risk than shy wolf individuals (Type Bs) that did have some hesitation.

This information was urgently needed because we saw representatives of Parks Canada and other agencies trying to create a link between adaptation and wolves being a potential danger to humans. One of the arguments we heard repeatedly from a lot of wildlife managers was that they didn't want wolves on the road because they become habituated and potentially dangerous. Fortunately, this theory has never been proven. In fact, according to our own findings, regardless of character type, there has never been a single wolf in the Bow Valley that has behaved dangerously toward humans.

We feel the whole wolves-as-a-threat-to-humans debate from agencies like Parks Canada is just an attempt to change the subject to justify mass tourism. The real issue was and continues to be uncontrolled park visitors. Wolves in the Bow River Valley were already known to be susceptible to human impacts due to their low density, the fragmentation and loss of their habitat and the decline of their elk prey base. But instead of arranging for more protection of these animals (e.g., a reduced and strongly enforced speed limit for vehicle traffic, a CP declaration to voluntarily limit the speed of all its trains in the Bow Valley and a strict fine system for visitors found harassing wildlife), Parks Canada has focused on drawing even more tourists to Banff and has stood idly by as transportation traffic (i.e., trains and semi-transport trucks) has increased considerably. As a result, ungulates, particularly deer, continue to get killed unnaturally in high numbers throughout the mountain parks.

Instead of listening to theoretical talk from wildlife managers about wolves posing a danger to humans, we were finally able to prove via our practical wolf character tests that neither wolves of a Type A or B personality were a threat to park visitors.

So what were our tests to determine shy and bold wolf character types once the Pipestones had adapted to their surroundings and started to appear on the Bow Valley Parkway (after having been almost invisible their first year)?

Test 1

While the wolves were in the forest but travelling toward a known crossing spot, we would place a fake, plastic banana skin (an object we were sure the wolves had never come across before in their lives) on the road at that crossing location, drive back 500 metres and then sit patiently in our car to observe. Sometimes one of the wolves would discover the banana skin as different constellations of wolf groups were crossing and, just like that, they would be gone. But other times, if they noticed the banana skin, then we recorded how long it took – within a time frame of a maximum of three minutes – for a wolf individual to approach the banana skin. Individuals that approached it quickly were characterized as Type As, while individuals who approached very slowly or not at all were characterized as Type Bs. In other words, we tried to figure out how long it took for them to react to an object.

Test 2

Test 2 involved similar circumstances to Test 1, except with this test we replaced the fake banana skin with a tripod with a camera on it. Types As approached it quickly and curiously and fit into the basic character type tendencies of running into action without thinking it through. Type Bs, on the other hand, were skeptical of the tripod and camera and would cautiously sit and wait to see what was going to happen next. They often did not like to approach it and sometimes even made a huge detour around the object.

Documenting the exploration behaviour of animals, and particularly their reactions toward unknown objects, should be considered a key component of characterizing and assigning Type A and B personalities. Instead of carrying out these tests via direct observations, photo traps could be used instead.

Pipestone Personalities, 2009 – 2010

It wasn't surprising that the Pipestones' breeding pair each represented a combination of the two character types. As we had learned in the past, the Type A and B model seemed to resemble the Chinese philosophical concept of *yin-yang* – a balance between the elements. Leading male Spirit had a strong Type B personality, like his sons Skoki and Rogue and his daughter Raven. Faith, on the other hand, had an explorative Type A personality and was daring and curious like her son Chesley and her juvenile daughter Blizzard. In order to understand the behaviour differences between the two types, it is important to note

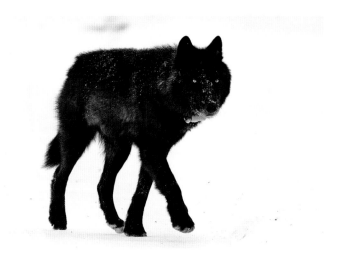

Skoki was an extremely private Type B wolf. This was the only decent shot John got of him once Skoki was full-grown.

that the first reaction to an unknown situation or object is what was being tested, not general adaptation.

It was astonishing how different the individual personalities of the Pipestone wolves were when they were on the move. Type Bs were hesitant when travelling on roads, while Type As felt more than comfortable doing so. Although wildlife managers might think that shy wolves are better for the system, because they would avoid travelling on roads and not get run over by vehicles, we proved the opposite. Type Bs were actually killed along infrastructure more often than Type As (see Appendix E).

We had already studied feral dog families in Italy for three years during our Tuscany Dog Project (2005 – 2007), so we were familiar with the shy and bold screening process and the basic character types, which at that time we classified as "introverted" and "extroverted." We had also already carried out similar personality tests on two

other wolf families in Banff: the Fairholmes (2000 – 2003) and the Bows (2000 – 2008).

Without exception, all of the test results indicated that the highest-ranking male and female (the breeding pair) within the Fairholme and Bow Valley families were never both classified as being either Type A characters or Type B characters. Instead, the "executive floor" of both wolf families was always a combination of one Type A and one Type B. These findings coincided with the fact that the Pipestones' leaders, Faith and Spirit, each represented one of the two fundamental personalities, too. Note that because the two tests only checked the spontaneous behaviour reaction toward an unknown object or situation, there could never have been a mix of Type A and B characters in one wolf. However, individual Type B wolves, for instance, may have had varying spontaneous behaviour, ranging from very shy to shy, just as Type As could range from bold to very bold (on a scale from zero to ten).

As far as the youngsters of the family were concerned, we classified Chester and Lillian as moderately bold Type As and Meadow as a very shy Type B. As we have mentioned before, adult male Skoki discreetly left the Pipestones and dispersed out of the home territory to the east. He was an extremely private Type B and was therefore a good example for our assumption at the time that shy wolf characters, in particular, were strongly affected by high traffic volume on the BVP (we had previously discussed this assumption in our 2002 paper, "The Influence of Highway Traffic on Movement Patterns of the Bow Valley Wolf Pack on the Bow Valley Parkway of BNP"). It didn't take a degree in rocket science to predict that human activities were going to have a greater impact on all wildlife species as more and more people were encouraged to use the "scenic" Bow Valley Parkway.

Blizzard: A Type A Wolf Meets a Coyote

A late December 2010 survey of several old Bow Valley wolf rendezvous sites showed a lot of wolf activity. Tracks were all over the place and our dog Timber was in his element. With great interest, Timber followed a single set of fresh wolf tracks for awhile and after his final examination, turned around and looked at us as if to say, "You have to be kidding me. You don't know what's going on here? What kind of species are you? Use your nose!"

As certain as Timber was that there were wolves nearby, we couldn't actually see anything (and, of course, we couldn't smell anything). We checked the tracks a bit more religiously and it looked like the family had departed the night before, leaving one wolf behind. So we snowshoed back to the car and waited. Sure enough, a few minutes later, we observed Blizzard on a little hill with a deer leg. Once again, Timber had been right – no surprise there!

Blizzard was staring at what turned out to be an adult coyote. Soon we discovered there were two coyotes, and one of them started barking at Blizzard from halfway down the hill, even after he had clearly recognized that Blizzard was staring at him. The coyote then scent marked a bush and even scratched the ground. "Wow," we thought, "what a self-confident coyote!" The coyote's brave approach toward Blizzard was a rare instance of an encounter between a coyote and a wolf where the coyote

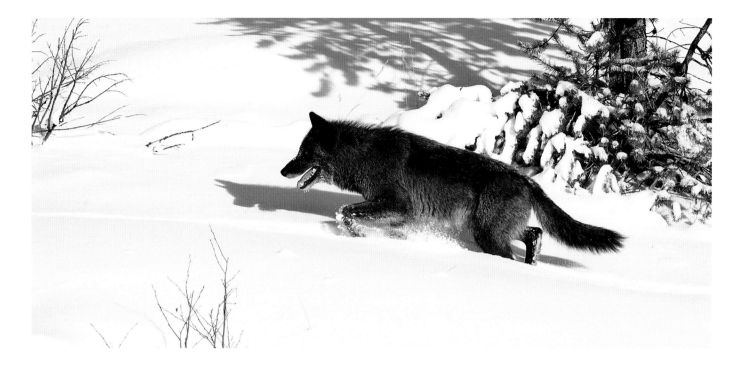

actually didn't try to avoid the wolf and instead stood its ground. Type A Blizzard didn't hesitate for a second: she took off toward the barking coyote as fast as she could. This was a clear example of Type A animals reacting without thinking, and it compared interestingly to similar encounters in similar situations we had witnessed in the past. Because of her rash decision, as Blizzard mindlessly chased the male coyote, we watched the female coyote grab the unattended deer leg and proudly carry away her "free meal." Five minutes later, Blizzard came back to the hilltop and realized immediately that the deer leg had been stolen. She sniffed the ground hectically but in the end had to deal with the consequences of not having "thought through" chasing the strongly bonded coyotes – she had fallen for their cleverly orchestrated trick.

And, yes, dear animal behaviourists, we hear you loud and clear: there was no "coyote plan" involved, so it must all have been driven by pure instinct. What else could it have been, right? Well, here is a "kicker." According to Frans de Waal, "the beauty of the emotional response system, over an instinctual one, is that it is not strictly pre-determined. The neurological and physiological changes it produces may be rapid and reflex-like, but the elicited behavior varies with situation and experience."[5]

5 De Waal, "What
Is an Animal
Emotion?" 193.

101

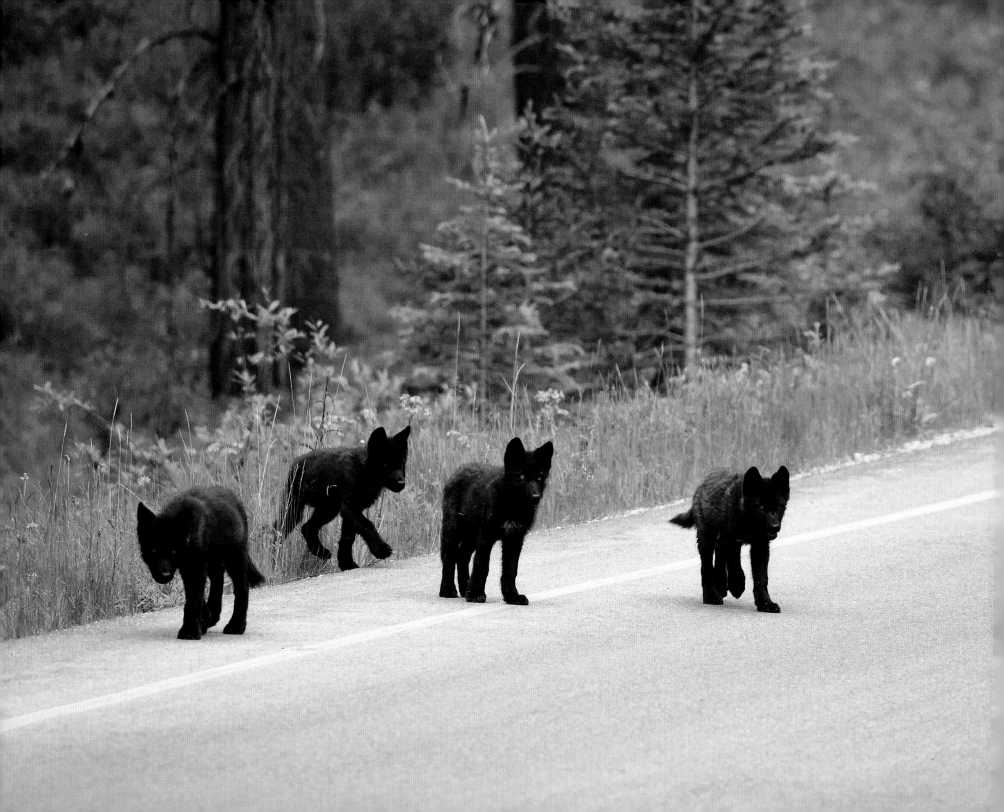

Six of the 2011 litter's seven pups on an evening walkabout.

3

The Golden Years of the Pipestones

The Bow Valley terrain magnifies the effects of higher concentrations of large carnivores and their prey in low elevation areas, particularly in the winter months. The valley overlaps spatially with roads and railways, as we've previously discussed, and by the golden years of the Pipestones' dominance in the Bow Valley, all of the wolves were observed travelling along the Bow Valley Parkway, often on a daily basis. Yet despite this proximity to human infrastructure, they did not lose their fear response to people, arising from frequent nonconsequential encounters with hikers, bikers, skiers etc., nor did they ever show any aggression toward people. In short, they were not habituated in the negative sense of the word.

Nine-month-old Lillian dispersed from the family for the first time in January 2011 and was on her own when this picture was taken in February of that year.

However, during the winter of 2010 – 2011, some of the family members did behave overly curiously with certain human elements in their landscape. It was usually the young Type A wolves, like Chester, who would forego chasing large prey species such as moose and taking part in other family activities in favour of checking out parked cars. Although she was already an adult and nearly 2 years old, Blizzard also seemed to be drawn to certain attractive stimuli and still loved to chase and jump after mice for hours in the middle of open meadows.

In mid-January 2011, 9-month-old Lillian dispersed for the first time and moved to a side valley in the southeastern part of the Pipestones' home range. Here, we were able to observe Lillian hunting snowshoe hare and marmots on her own. Initially, we were very surprised that Lillian left her parents so early. At first we wondered if her absence might have something to do with the mating season, but that argument wasn't convincing because any female under one year of age is definitely not a competitor for reproduction. Between February and April 2011, Lillian rejoined and left the family several times. We last observed her in June 2011. At that point, at 14 months old, it definitely made more sense for a very submissive wolf individual to disperse. The alternative – staying and becoming some sort of omega wolf – is an option that most sensitive wolves do not choose. We later got reports from our friend Hendrik Bösch that Lillian had wandered off toward Kananaskis Country.

We also observed two unusual aggressive encounters between the wolves and domestic dogs that winter (neither dog was in the immediate presence of humans). The

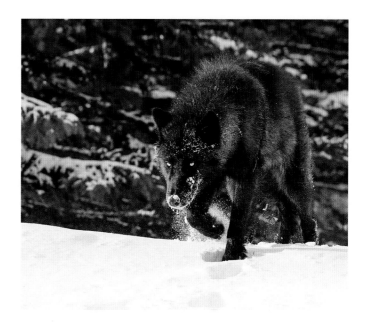

first encounter occurred in late December 2010, when a barking, off-leash, female terrier ran to within 50 metres of Blizzard. After a minute or two, Blizzard, who initially just stood there watching the dog, had had enough. She bluff-charged the terrier for 50 metres back toward its owner, who promptly grabbed the dog, threw it in the back of his car and drove off.

The second incident took place in early 2011 at the start of the BVP. It was still breeding season and an off-leash and uncontrolled border collie mix tried to follow Faith into the woods. Fortunately for the dog, he was smart enough to retreat after a quick sniff and after physically seeing Spirit (who did not outwardly show any aggressive body language but did display the first sequence of predatory

behaviour). By eye stalking, Spirit unequivocally communicated his intention and willingness to treat the male dog as a reproductive competitor. The border collie mix had no problem "understanding" Spirit's message, and immediately turned back and trotted over to its owner (who hadn't seen either wolf).

Chester and the Ravens

Even from a distance, Chester was an easily recognizable wolf because of the large white patch of fur planted squarely on his chest. For six days in January 2011, we had been watching the Pipestones eating a moose, and because it was late January, Faith and Spirit had started to engage in some courtship behaviour, including parallel walking together for hundreds of metres. On January 21, 2011, we watched the breeding pair disappear over a hill out of sight. That afternoon, we saw Chester come around the corner for some leftovers from the big moose feast. In his company was a flock of ravens flying only about three metres above his head. Chester didn't care at all; his focus was on having free access to the remains of the moose. There were two hind legs laying there, the untouched head and skeleton, as well as lots of bones and pieces of fur with some meat still on them.

He ran right into the scene, grabbed one of the legs, laid down and started chewing on it. At the same time, the ravens were landing all around Chester, one of them just 25 centimetres in front of the wolf's face. But nothing happened. Don't wolves kill ravens? Yes, sometimes they do. There are wolf individuals that seem to hate ravens

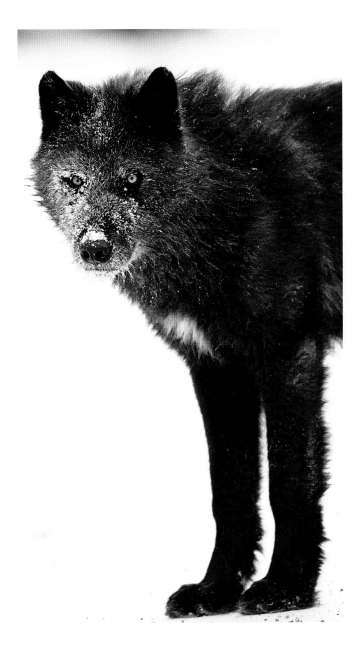

Chester and some of the other family members were often extremely curious during the winter of 2010 – 2011 and would approach parked cars to check them out.

and will attempt to kill them given the chance, while there are others that seem to form mutualistic relationships with the ravens. Some of those relationships are limited by time, whereas others can be long-lasting (the pups of the Bow Valley family regularly socialized with the same ravens at their traditional den site).

Renowned raven expert Bernd Heinrich suggested in an article published in a German dog magazine that ravens evolved with wolves in a mutualism that is millions of years old, so much so that they have innate behaviours that link them to wolves, making them uncomfortable without their presence. Even today, some First Nations people refer to ravens as the "eyes of the wolves." Indeed, we found that ravens vocalize special alarm sounds to warn wolves at rendezvous sites and kill sites if strangers are approaching. According to Heinrich, ravens are using their "kek-kek-kek" alarm calls not only for communicating with each other but also with wolves. And that is absolutely what we have witnessed in the Bow Valley for years. The funny thing is there are people out there who believe they can sneak up on wolves for close-up photos without knowing a thing about how the whole wolf–raven relationship works. If the ravens can see you, then the wolves already know you're there!

Wolves and ravens have an ancient evolutionary history. In Norse mythology, Odin, the god of war, was always accompanied by his two ravens, Hugin and Munin, as well as by his two wolves, Geri and Freki. It seems that only modern humans – ignorant as we often are – have not paid attention to the real extent of the biological reasons behind wolf–raven bonding and relationships. But, of

course, this omission is neither the fault of the wolves nor ravens.

Meanwhile, back to Chester: After a full hour of directly observing up to a hundred interactions between the Pipestone wolf and the ravens, we noticed that one particular raven was clearly getting closer than the others and was even contacting the young wolf. We guessed this raven was likely a bold, extroverted, Type A character just like Chester was. As we continued to observe the pair, we were stunned when the raven suddenly landed behind Chester's shoulders and sat on his back for a minute! Chester barely responded, behaving as if everything was totally cool. He didn't take any kind of self-defense action and he didn't try to shake the raven off. He just sat there.

New Den and Rendezvous Locations within the Pipestone Territory

An immature bald eagle circles over a kill site accompanied by three ravens.

In February 2011, we discovered for the first time that the Pipestones had decided to change den locations, much to our surprise. Since the vast majority of our observations were carried out from our car, we only slowly started to realize that Faith had begun to take over the old den sites of the Bows. This area was strategically located at the heart of the human-dominated Bow Valley, yet it was unique in that there was nearly no human activity near the den location at all.

On March 17, 2011, the Pipestones had found a huge carcass right in the middle of their new inner territory close to the railway. Chester and Meadow were feeding on a hind leg. Watching through our binoculars, it became evident that the wolves were consuming a moose that had obviously been killed by a train. Shockingly, early the next morning, 11-month-old Meadow also got hit by a train and sustained life-ending injuries. The Pipestones were now down to Faith, Spirit, Blizzard and Chester.

On April 12, 2011, at 9:20 a.m., Faith, who could hardly move anymore because her belly was probably full of pups, approached the den location. From then on, we didn't see her for three weeks, which also meant that she was not taking part in any of the hunts and that the rest of the family had to search even harder for food in order to provide the number one female with energy.

By the way, most of the time we became aware that an ungulate had been killed on the railway by watching high concentrations of ravens and/or magpies gathering in the

It was one of the most amazing "wow" moments we've ever had in the field and shows just how far the individual relationship between a wolf and a raven can go.

Afterwards, Chester slowly trotted toward the nearby forest with that raven flying above him. We concluded that while the wolves and ravens were occasionally on their own, the two species were often intentionally hanging out together, partaking in mutual excursions. We concluded that such a relationship might help define one of the most valuable mixed symbiotic societies in the wild.

skies and the trees. We tallied the mortalities published by local newspapers from Parks Canada reports from October 15, 2009, to April 15, 2011, and discovered that a staggering 46 different large mammals had been killed by trains.

Figure 3.1 shows the different ungulate species and numbers of each ungulate species that were found along the CP railway line within the Bow River Valley (between Lake Louise and Five Mile Bridge), regardless of whether or not the wolves detected the carcasses. The four wolves documented by the bar graph were two unnamed wolves in 2009, which could have been two of the original seven Pipestones that we first tracked back in the winter of 2008, as well as the juvenile Raven in 2010 and the juvenile Meadow in 2011.

This high number of unnatural deaths of both ungulates and carnivores left us not only sad but also frustrated and angry. We asked ourselves the same question over and over again: Where was the moral compass of upper management within CP Rail and why weren't they enacting a voluntary speed limit for trains travelling through national parks? Unfortunately, discussions of this nature, in terms of moral and ethical issues in animal conservation, are only in their infancy, at best. Instead of functioning as an eye-opener, we were usually laughed off as "dreamers," disparaged as "bad characters habituating wolves" or labelled "tree huggers" or "crazy nut cases" in discussions with many park officials and CP Rail crew.

Rumours were flying about what we were up to at that time, but since they didn't have anything to do with the wolves, we avoided getting drawn into the politics.

Blizzard chewing on a bone near the Canadian Pacific railway tracks at Backswamp.

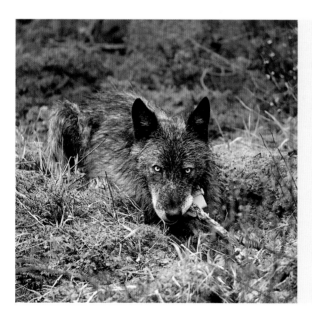

Figure 3.1 Ungulate Carcasses and Large Carnivore Carcasses Found in the Bow Valley along the CP Railway Line.

Moose	White-tailed Deer	Mule Deer	Elk	Bighorn Sheep	Wolves	Coyotes	Grizzlies	Black Bears
4 (9%)	14 (30%)	6 (13%)	7 (15%)	2 (4%)	4 (9%)	2 (4%)	3 (7%)	4 (9%)

We occasionally stepped over the line and were verbally abusive toward tourists and local photographers caught harassing the wolves (which we regret and apologize for), but at the same time we continued to receive encouragement and positive reinforcement from biologists who believed we were doing the right thing. So we continued our first-hand observations and kept collaborating with those researchers who encouraged us to maintain our high ethical standards.

We continued to use our Type A male dog Timber in our work through 2011, and he found the wolves' new rendezvous site pretty easily and quickly by scent. That not only helped us considerably for our observations but also reassured us, after a few days of uncertainty, that the Pipestones had indeed become comfortable in their new core area. One of the best examples of this was Blizzard mouse hunting in the new rendezvous site on April 18, 2011. The astonishing part was that Blizzard did it in broad daylight, hunting for nearly a full hour in the sunshine until almost 10 a.m. without getting disturbed, before she finally trotted along the BVP in the direction of the new den site.

Why did they leave behind their old den, where Blizzard, Skoki, Raven, Chester, Meadow and Lillian were born? Quite frankly, we don't have a clue. The only thing we do know is that wolves don't usually give up well-established denning sites. Both the old and new den locations provided cover, some hills with an overview of the area, water and everything else that adult wolves like to have in order to successfully raise a litter of pups. On the other hand, the extremely low prey abundance in the western part of the Bow Valley might have forced their hand and caused the move to the new denning site, where more ungulates were available.

Nonetheless, the Pipestone family was still dependent on its flexible, adaptive behaviour patterns in order to survive. The elk population along the parkway had also shrunk to almost nothing in the eastern part of the valley, with just a few bulls left and no cows or elk calves in sight. As a result, maintaining their flexibility was the only thing the Pipestones could do. And, indeed, they were very good at what they did considering where they lived, so close to human activities and towns, yet without becoming habituated and without any serious conflict with people. One of their most successful adaptive strategies was to increase their activities in the crepuscular hours, right at dawn and dusk.

In the first days of July 2011, Blizzard took all seven pups for some walks away from the den site, sometimes in the morning and sometimes in the evening. The pups loved to be around their aunt because she behaved patiently and always remained calm and cool when they jumped all over her enthusiastically or were play-running around her.

Observing Blizzard and others in the bright summer light in the morning or during the early evening hours was not uncommon that summer. Being active through the night and around dawn and dusk were behavioural tendencies that probably followed thousands of positively reinforced experiences of the wolves (such as being successful during mouse hunts), which seem to be suggestive of a strong selection for flexibility. Approximately 35 per cent of our time spent in the core area of their

territory was taken up observing the wolves during the day in bright light conditions (2 – 3 hours after dawn and 2 – 3 hours before dusk) and 65 per cent of the time during the hours of dawn and dusk.

Parks Canada Advertises the Den Location

Year after year, the methodology of wolf parents raising new pups in the Bow Valley was to consistently use quiet den site locations in close vicinity to the BVP. After having completed our significant long-term monitoring analysis, we were able to document that between 1995 and 2010, not one wolf pup had been killed near those den sites. All of the wolf pups had learned to avoid humans and all of them had developed astonishing adaptive behaviour strategies from a very early age.

However, that all changed in the early summer of 2011 when Parks Canada decided to put huge signs out around the wolves' den site ("Area Closed" and "Speed Limit 30 km/h"). During the month of June, and especially on June 27, 28, 29 and 30, the wolf pups were out playing on the road during the early morning hours and unfortunately were seen by several park visitors. Karin and I instinctively knew that having these big visual signs combined with a new 30-km/h speed limit meant trouble. It was an open invitation to the public (and to every clueless photographer) to come and look for wolves (up until that point, it had just been John, Karin and I). Our fears were confirmed almost immediately on June 30. As we were waiting in our SUV shaking our heads, the very first car to pass us that morning stopped and a local photographer asked us straight up, "Have you seen any pups?" Indeed, we'd

The warden service's closure sign advertising the den location.

Jenny runs right by one of the many Parks Canada signs advertising the den location.

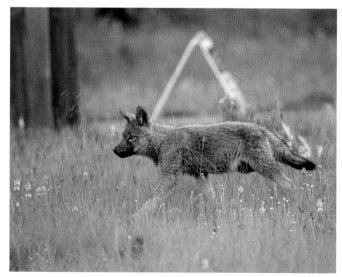

110

seen them almost every morning but, of course, had told nobody. But now, thanks to Parks Canada's "advertisement," we now found ourselves in the middle of a gong show. Wolf expert after so-called wolf expert showed up, explaining to us how to find the wolves and describing to us "the alpha thing."

It quickly became trendy to watch wolves. Performing responsibly by staying in the car and being patient was temporary at best for many. Unfortunately, a number of photographers did not behave patiently at all and were even following the wolves on foot. The experience became all about "getting the shot" and posting it online.

Some people seemed to be so addicted to receiving as many "Likes" as possible on Facebook that they were hanging out near the Pipestones' den site all day long. Whenever a pup or an adult wolf attempted to cross the road in broad daylight, like Blizzard did on July 3, 2011, at 5:12 p.m., for instance, the human followers were at the wolf's heels. Most of the time, we were the only ones (along with John and a select few others) who maintained a distance of 100 metres from a travelling Pipestone wolf like Blizzard. Meanwhile, locals and visitors would often pass us, intent on getting their shot at all costs. Unfortunately, each time we reported these instances to park officials, they either blamed us for not providing enough details to investigate further, or, even worse, accused us of just being "jealous." Instead of doing their jobs, park wildlife managers, wardens and even law enforcement crew never did look into this harassment any further. As a result, up to a dozen photographers were driving along the BVP on any given morning, hunting down wolves.

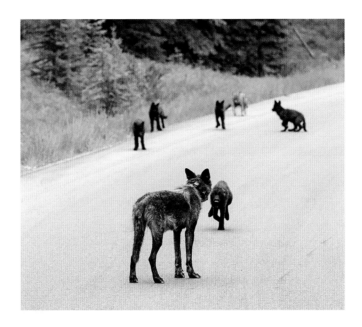

Blizzard leads the pups out for an evening stroll along the Bow Valley Parkway. Note the lead pup already displaying submissive body language as it approaches its older sister. The pup is not being forced into behaving submissively; it's actually normal behaviour for a lower-ranking wolf to approach a higher-ranking wolf in this manner.

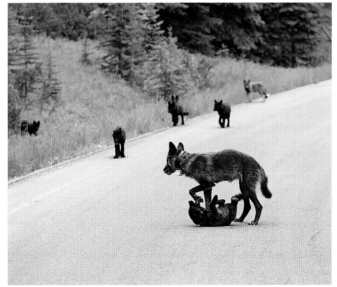

Another example of age-related dominance, though in this case Blizzard is ignoring the pup that's thrown itself at her feet in a submissive posture.

111

Blizzard and
one of the pups
chorus howling at
dawn in Hillsdale
Meadows.

Despite the buzz around the Pipestones' den site in early summer 2011, we had been able to document 188 direct observations, which were later tabulated and categorized, and all of the behaviours we had filmed were analyzed. We sorted behavioural information both by insights into character-related footage of wolf pups and social-structure-related footage of interactive behaviours of the pups with juvenile and adult group members. By summarizing these documented events, we had an excellent survey of when, where and how many times every individual wolf had been present or had left the den site. For instance, on July 4, 2011, Blizzard and the seven pups left the den and, along with the usual raven mother and her three youngsters, gathered at the new rendezvous site. At 7:16 a.m., the entire wolf unit chorus howled, initiated not by Blizzard (the oldest wolf at the site) but rather by a black pup. One day later, we documented another interesting event involving Blizzard: she had travelled east of the den and been confronted by a coyote that had showed up on the road. Blizzard ignored the coyote completely and continued moving along, displaying once again how variable the treatment of coyotes by wolves can be.

With the increase in traffic around the den site, the wolves were facing a slow, but inevitable, increase in social stress. At the same time, their prey base was in sharp decline. And worst of all, Parks Canada wasn't doing anything to stem the tide of human interference we were seeing on a daily basis. Instead, tourists were treated like "holy cows," and despite a sharp increase in park visitation numbers, the federal government levelled a series of absurd budget cuts throughout the national parks. Through it all, we continued to report park visitors who disrupted wolf hunts. Typically, the hunt would be interrupted when tourists or photographers would spot a wolf, after which they would stop their car, jump out and try to approach the wolf at close range.

On July 6, 2011, we documented an unusual event involving Faith and Spirit and the five pups. We watched the seven of them go steeply uphill in the distance into a nearby subalpine area to hunt bighorn sheep, which was likely a result of the disturbances they were experiencing in the valley bottom, although this is merely conjecture. By July 11, 2011, the pups were back at the rendezvous site in the valley bottom.

Hunting Behaviours

We recorded two different types of hunting behaviour near the Bow Valley Parkway that summer. The first was when wolves were hunting small prey species such as ground squirrels, where the wolf would typically eye stalk

the prey and then jump at it. Eye stalking occurs when a wolf stealthily approaches its prey with its head level with, or lower than, the top of its back. Its ears are pricked and directed forward and the wolf stares at its prey the entire time. The second type of hunting behaviour we observed was when wolves hunted deer, in which case they would mostly chase the prey or try to block its movements.

Between mid-April and mid-July in 2011, we recorded a total of 17 occasions of either park visitors or photographers harassing Spirit, Faith or Blizzard enough to disrupt them while they were hunting small prey or deer.

Figure 3.2 shows the number (and percentages) of disrupted hunts that occurred between mid-April and mid-July in 2011.

The "good" news in all 17 of these occurrences was that the people disrupting the hunts failed to get good pictures of the wolves, because in most cases it was our impression that the wolves were informed by the ravens that humans were approaching. As discussed previously, it's extremely common when wolves hunt for them to be accompanied by a large gathering of ravens. There are obvious benefits to this for the ravens: when the wolves make a kill, the ravens can scavenge an easy meal, and when the wolves find a carcass (off the railway, for instance), the wolves open up the thick skin of the elk or moose to enable ravens to get at the meat (ravens can't open the skin on their own). Raven expert Bernd Heinrich noted that ravens seem to recognize wolves as their guardians, particularly around carcasses, where ravens would often appear to be uncertain and would act skeptically when wolves were not around. We observed similar raven behaviour around carcasses for a long time; wolves regularly chased off coyotes, martens or foxes, yet often tolerated ravens in their midst.

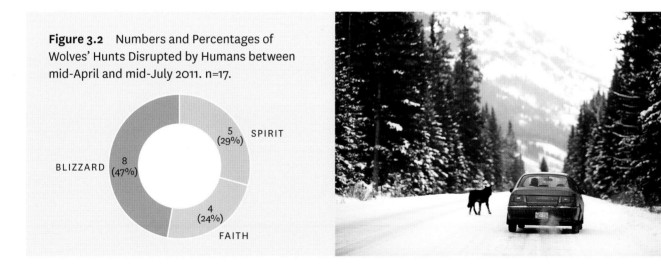

Figure 3.2 Numbers and Percentages of Wolves' Hunts Disrupted by Humans between mid-April and mid-July 2011. n=17.

5 (29%) SPIRIT

BLIZZARD 8 (47%)

4 (24%)

FAITH

Spirit getting disrupted during a hunt by an impatient local photographer.

Forced to Move Away out of Necessity?

On July 4, 2011, the Pipestone wolves left their den site and gathered in their rendezvous site (a nearby meadow) with all seven pups, probably for the first time. It was the earliest abandonment of a den site we had recorded for the Pipestones (compared to the Baker Creek den site). All of the wolves, including the pups, looked to be in decent shape. The next morning, we filmed all seven pups and were able to clearly distinguish between them: four were black-coloured males, two were black-coloured females and one was a beautiful grayish-brown female.

On July 27, 2011, Faith led the entire family to the south toward the Bow River and then, without hesitation, directed them west along the railway. Unfortunately, the next morning, one of the pups was killed on the railway. The following morning, we were extremely surprised to discover Faith, Blizzard and the pups at the Pipestones' old rendezvous site to the west. At 6:25 a.m., we watched Faith get greeted and surrounded by pups as she lay in the meadow at the old rendezvous.

On August 4, 2011, we witnessed several events that people like us are always hoping for. The first began when three of the pups came out on the road early that morning before disappearing into the woods. Just three minutes later, we watched a cinnamon-coloured black bear lead her little cinnamon cub along the road, right in front of the wolves' rendezvous site. Once more, we were left sitting in our car in awe; not a single wolf showed up to challenge the mother bear, which constantly "sniffed the air" and nervously, but determinedly, led her cub safely past the wolves. We knew the wolves were around, because half an hour later we watched Blizzard and Spirit cross the road in front of our car.

Later that evening, as if the wolves wanted to up the ante after the morning's spectacular event, we watched in amazement as Spirit, Blizzard and Faith tried to surround and attack a bull elk. The bull was fit and healthy and very clearly showed with its body language that it was willing and able to fight off the wolves. But while the adults were testing the elk, the pups showed up at the scene and it was their turn to look on in awe at the big defensive bull. The adults had seen enough – they turned around and trotted back to the rendezvous site with the somewhat disoriented pups in tow.

On August 8, Chester returned to the family after having been on his own for a brief period, and shortly after, we spotted him travelling with the pups on the road, the entire family (led by Faith) heading west toward Protection Mountain. But by August 23, the wolves had reversed course and walked right by their old rendezvous site all the way east to Castle Mountain and beyond. Either that night or very early the next morning, the family must have swum the Bow River, because at 6:41 a.m. on August 24, we discovered the family sleeping in the middle of an open meadow high up in the Sunshine Valley. Chester and one black pup were missing and our speculation at the time was that the pup might have drowned in the crossing of the Bow River.

At first we were quite surprised that the wolves would risk crossing the Bow with all of their small, relatively inexperienced pups. But Faith and Spirit were

excellent parents, and given the context and their background of risk taking, it suggested to us that they did not have much of a choice: finding food was the number one priority. And, in principle, 11-week-old wolf pups are relatively good swimmers, though tackling the unpredictable waters of the Bow in the summer right after the spring/summer flood would definitely have been tricky for them.

We had previously observed wolf parents leading their juvenile and subordinate offspring to specific crossing locations on the Bow River countless times. In fact, over the last 15 years we had used a transportable GPS device to record how predictably precise the "traditional" crossings were for wolf parent–offspring units on the Bow River. The results were astonishing: regardless of which wolf parents we were looking at, they all managed to lead their young dozens of times per year to the exact same crossing locations, with a maximum deviation in distance of just 1.5 metres. That's how good they are; that's how they put habitat intelligence into practice!

It seemed crystal clear to us that the Pipestones had to face the facts. Food availability had become extremely low in the Bow Valley. Faith and Spirit obviously had to come up with new solutions for their family to survive, and moving to the Sunshine Valley that August seemed to be their new strategy to find food. However, due to the density of bears in the Sunshine Valley and the increased probability that the wolves would encounter grizzlies (and black bears) in the valley bottom, protecting the pups was also a priority.

On August 25, at 7 a.m., Faith, Spirit, Blizzard and the pups arrived at a side valley off of Sunshine and we spotted them climbing up a steep slope. They went up and up and up, before Spirit started chasing bighorns. To our surprise, Faith and three pups were only 100 metres behind Spirit. Unfortunately, Spirit's short chase was not successful, so the wolves descended the hill and were soon back on Sunshine Road again. We were the only ones who knew the Pipestones were in the valley, and for hours we watched the family explore the valley and play in the middle of the road, demonstrating to us once again what adaptive behaviour looks like when undisturbed.

On August 27, the wolves showed us again how they had learned to cope with human infrastructure. Early that morning, we watched Faith and Spirit lead the group right past the empty Sunshine gondola building. There was not a soul around other than us in our vehicle, so the wolves travelled right by the building. Blizzard was the most curious, sniffing and exploring around the structure. But soon the wolves moved on and continued on their way, providing us with an excellent example of why they didn't need to be "hazed" or "conditioned." If people had been present that morning, Faith and the other adults would not have behaved the same way; they would have shown avoidance behaviour. It was a superb example of what undisturbed, practised, habitat intelligence is all about.

We suspect the Pipestones eventually travelled toward Healy Pass, an alpine zone where wild sheep and mountain goats were relatively plentiful (and people fairly scarce). Whether the pups faced life-threatening situations, such as taking part in risky hunts on tricky ground, was unknown to us. However, the distribution of sheep and goats in the Healy area, as well as a healthy population

of deer and a few moose, was reason enough for the adults to lead the pups into that area and stay there for a day or two. Heading up Sunshine and into Healy may have been better than the alternative of leaving the pups behind in the Bow Valley, where they might have starved to death.

On the afternoon of August 29, we observed three of the pups hanging around a carcass in the Sunshine Valley, carrying around some bones and leg parts. We could not see the carcass, but it was obvious where it was because of the ravens present. We also watched a mother grizzly and her two cubs come out of the area, but did not see any adult wolves. In fact, for several weeks we only occasionally observed the adults high up in the valley. In between sightings, we suspected the wolves had killed ungulates or found carcasses, because we saw several very high concentrations of ravens. As always, ravens were a safe indicator that there was a carcass around.

By the end of September 2011, the wolves had come back down to the Bow Valley, but two more of the pups were missing and had obviously died, although we never did find out the cause of their deaths. On September 27, at 9:15 a.m., we filmed Blizzard, Faith, Spirit and the four remaining juveniles testing a small group of elk in the Bow River. Unfortunately, the hunt wasn't successful and at 10:23 a.m. the wolves crossed the Bow Valley Parkway and – surprise, surprise – were spotted immediately by at least five different drivers who were all after them instantly. The Pipestone family was back in the stressful Bow Valley and once again faced constant hunting disruptions.

The greatest discrepancy in the Pipestones' hunting behaviour strategies was found by comparing all prey species consumed by the wolves before that summer with what they had consumed that summer (May – September). As was noted before, elk predation was very low due to a complete lack of elk available to prey on. Besides the fact that we saw the wolves testing a single elk bull here and there, or, on occasion, testing a small bachelor group of elk, we only found one elk killed by the wolves all summer long. That summer, according to our own direct observations, the wolves consumed 38 per cent fewer white-tailed deer but a stunning 45 per cent more bighorn sheep. Most of the sheep carcasses were found in the Sunshine Valley. Additionally, we became aware of at least two mountain goats (one in the Sunshine Valley and another one in the Bow Valley) that had been eaten by the wolves. Whether the wolves had actually killed the goats remained unknown.

During all of our observations carried out in the

117

Sunshine Valley, we rarely saw Chester, so we suspected he had likely dispersed in late September 2011 at the age of 1.5 years old. Chester was last seen in early December 2011 near Outlet Creek in the Lake Louise area by a friend of ours.

Composition of the Pipestones in Summer and Fall 2011

After careful monitoring through the summer of 2011 and into the fall, we started summarizing our observations on the sex and character ratio of the four remaining pups that had been born earlier that year in mid-April. After we had finished our personality tests, we concluded that we were able to determine only one extrovert, Type A individual in the surviving pups: a black female we named "Yuma." There were three different Type Bs, though: a shy black female with a small white patch called "Kimi"; her brother, "Djingo," a silver-black-coloured, introverted Type B; and a golden-gray female with a beautiful ochre-coloured face called "Jenny."

Throughout that summer and well into early fall, the main social partner and babysitter for the youngsters had been their older sister Blizzard. She did most of the supervising and playing with the pups while Faith and Spirit were off pursuing deer, sheep and goat in the subalpine zone. In the meantime, we watched these incredible wolf parents test different ungulate species in the upper slopes of the Sunshine Valley, where they had obviously learned how to bring down enough prey to support the family.

In October 2011, the three remaining adult wolves gathered in the valley bottom (often near the Bow River)

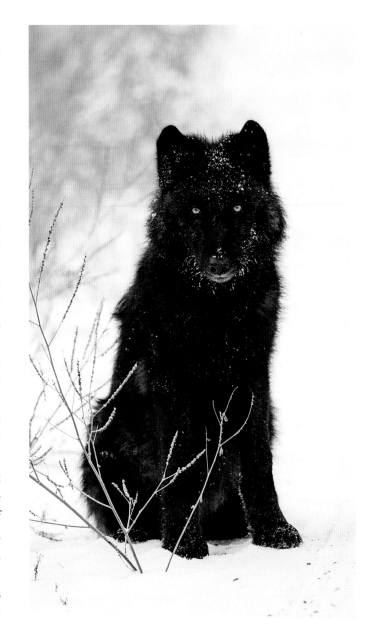

almost daily and regularly led the juveniles up and down the Bow Valley along the BVP. By the end of that month, the pups were approximately 6.5 months old.

The family was also using the railway system often for travelling up and down the valley. We always kept a close eye on the railway lines, which often gave us an excellent opportunity to have a closer look at who was leading the family unit and how often. During these observations, we aimed to test and confirm the general prediction that young wolves do not take over a frontal leading position until they're at least 5 months of age and, moreover, that wolf pups are heavily dependent on the orientation provided by their parents.

During late July and early September 2011, a total of 39 direct observations were made out of our SUV in order to distinguish which individual wolf had been leading the family unit along the road (including the pups). Figure 3.3 shows which wolves led the unit, and how often.

In the Middle of a Hunt!

Very early on in the morning of July 22, 2011, we watched from a distance as Spirit trotted so far uphill into the low-hanging clouds on a mountain pass that he appeared to disappear into the sky and we couldn't see him anymore. A minute later, we saw Faith and Blizzard position themselves behind some willow shrubs and lie down for what looked like a rest. At least, that was what we thought they were doing. How wrong we were! Despite the decades we had spent investigating and watching the relationship between wolves and different prey species in the Bow Valley, we had never seen wolves employ what is called the

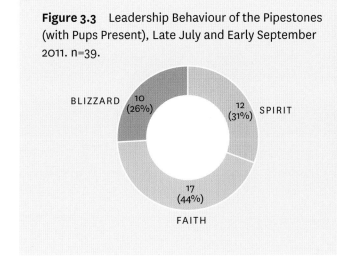

Figure 3.3 Leadership Behaviour of the Pipestones (with Pups Present), Late July and Early September 2011. n=39.

BLIZZARD 10 (26%)

SPIRIT 12 (31%)

FAITH 17 (44%)

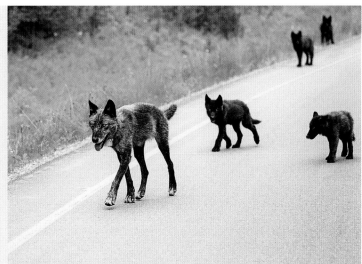

Blizzard leads the pups on an evening walk on the Bow Valley Parkway.

"ambush hunting strategy." But there we were, right smack dab in the middle of the action. Being at the right place at the right time when you're watching wolves is an unbeatable feeling, and to have first row seats for something we had very little knowledge of in Banff – how wolves hunt bighorn sheep – was a spectacular treat. While we had seen sheep wandering up and down in that area, we had rarely seen Nanuk and Delinda testing them.

Spirit showed up at the very top of a hill he had climbed and immediately began eye stalking a bighorn ewe grazing nearby, blissfully unaware of what was about to happen next. The wind direction must have been perfect, because Faith seemed to know the instant that Spirit had opened his downhill chase of the sheep, which panicked and tried zigzagging in a frenzy down the slope, with Spirit right on its tail. They raced down the mountainside and when they were just a few hundred metres away, Faith and Blizzard both got up and got ready for action. They jumped out from behind their cover and the sheep didn't have time to respond or react. Faith and Blizzard blocked the sheep's getaway route and stood there, waiting for Spirit to rush in. Seconds later, Spirit arrived at the scene and grabbed the sheep by the neck. As soon as he did, Faith and Blizzard joined in immediately and it looked like they had killed the sheep before it even hit the ground.

As if the youngsters wanted to give us a first-hand demonstration of the typical differences between Type A and B characters, 3.5-month-old Yuma was the only one that boldly ran into the kill site and dug in to the feast. In all likelihood, she was instinctively driven by her innate predatory motor patterns: eye-stalk-run-grab-bite.

Meanwhile, it took her reserved sisters Kimi and Jenny over a minute before they carefully approached the dead sheep. They appeared to not know what to do in that rapidly evolving situation, which was absolutely normal considering their age. And what did their brother Djingo do? He just sat and waited…and waited…and waited.

The scene had been so sensational that it had left us with mouths agape, stuttering out, "Wow, what a coordinated effort!" This ambush hunting strategy that Faith and Blizzard had pulled off together with Spirit, after his superb preparatory work, was evidence to us that wolves actively cooperate with each other while hunting. We don't buy the argument touted by some that wolves only hunt together "by coincidence."

Beauties and the Beast

In late fall 2011, Blizzard still hadn't separated from her family, despite the fact she was now over 2.5 years old. On October 26, 2011, at 7:13 a.m., we were left speechless when a park warden (who shall remain nameless) drove his park truck right into the middle of the travelling Pipestone family group. At the time, Blizzard was interacting with the juveniles at the edge of the Bow Valley Parkway and the entire family got disrupted from their activities by the warden's vehicle. Worse yet, the warden's actions suggested to the other drivers behind him that it was perfectly okay to behave that way around the wolves. We couldn't believe what we had just seen.

On November 3, we had just checked one of the Pipestones' traditional crossing locations on the BVP when

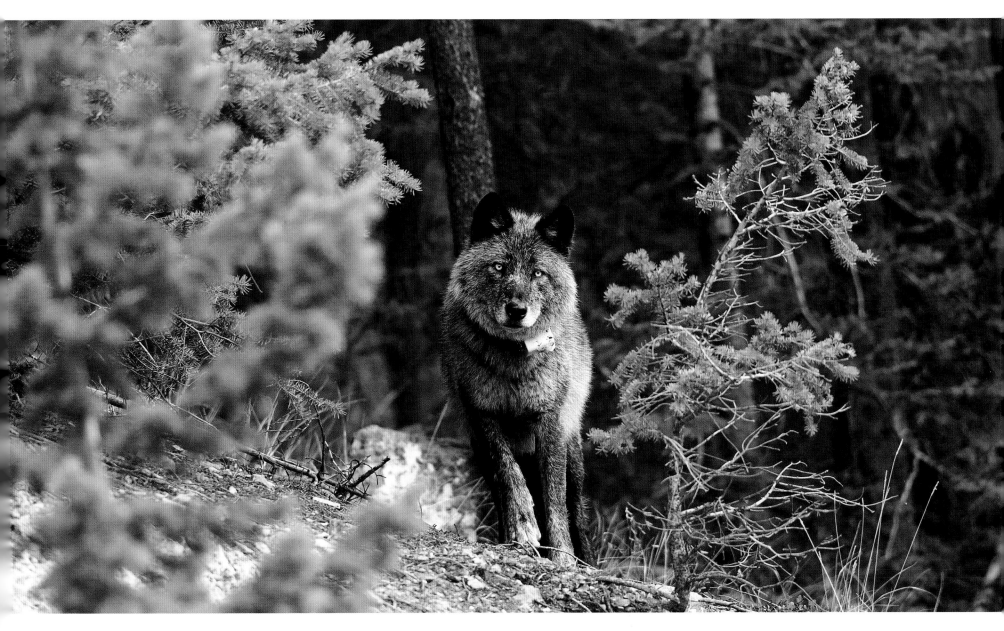

Faith and Blizzard
(behind) together
for one of the
last times, late
November 2011
near Lake Louise.

we spotted a giant, majestic bull moose travelling along the edge of the forest. As we filmed the moose, our dog Timber let us know there was a wolf there and, sure enough, Blizzard was seen approaching the moose from a distance. Unfortunately for Blizzard, the bad news was this was a healthy bull with no sign of any weaknesses, so this walking fortress was out of reach. We soon noted to our surprise that Faith was watching the moose, too, but that she was coming from the opposite direction to Blizzard. With wolves on both sides, the moose rapidly turned around and went after Faith. To our surprise, Blizzard sat there doing nothing while her mother got chased uphill into the thick forest, where Faith knew the big bull couldn't follow her. The bull quickly gave up the chase when the trees got too dense and turned his attention back to Blizzard, whom he then pursued for a short distance before she, too, raced away.

The moose had established momentary dominance over the two wolves and it was pretty obvious that he had the upper hand during this encounter, driving off the beauties Faith and Blizzard. The wolves didn't have a hope of getting this huge healthy beast nervous or on the run. In fact, he didn't display an ounce of panic – becoming a victim simply wasn't in the cards for this big guy. Faith and Blizzard joined back together and left the moose alone. Soon afterwards that morning, the wolves tested a group of four young bull elk but were disrupted by several cars. The wolves had no choice but to quit their hunt and cross the road, with shy Kimi being the last wolf to rush over the road like a rocket. A minute later, the wolves were gone – another day in "paradise" with nothing to feed on.

Mass Tourism, Low Prey Density and Social Behaviour

Let there be absolutely no doubt that wolves prefer to live a social life. But uncontrolled tourism and low prey density both seem to cause stresses on family stability and may also heavily influence wolves' social behaviour. For example, we documented changes in the social structure of the Bows due to these factors, and then in December 2011, we watched Faith force Blizzard out of the family. This was strange behaviour because Blizzard had an excellent relationship with her mother. She always showed the necessary respect, always approached and greeted Faith in a clearly submissive manner and never communicated any kind of aggression toward her mother. Blizzard also had strong social bonds to her juvenile sisters Kimi and Jenny, who looked up to their big sis and could often be found looking over her shoulder and imitating her extraordinary mouse-killing skills.

Djingo, too, seemed to be deeply impressed by his big sister, who most of the time was not only socially available to her younger siblings when Faith and Spirit were out hunting but also showed them much of the Pipestones' home range first-hand. It was often Blizzard that would take the initiative and lead all three youngsters to a killed ungulate on the railway to scavenge an easy meal.

Unfortunately, Faith chased off Blizzard three times within a two-week period. After realizing she was never going to become an integral part of the family again, Blizzard dispersed for good. Around Christmas of 2011, she passed the east park gate of Banff National Park, then

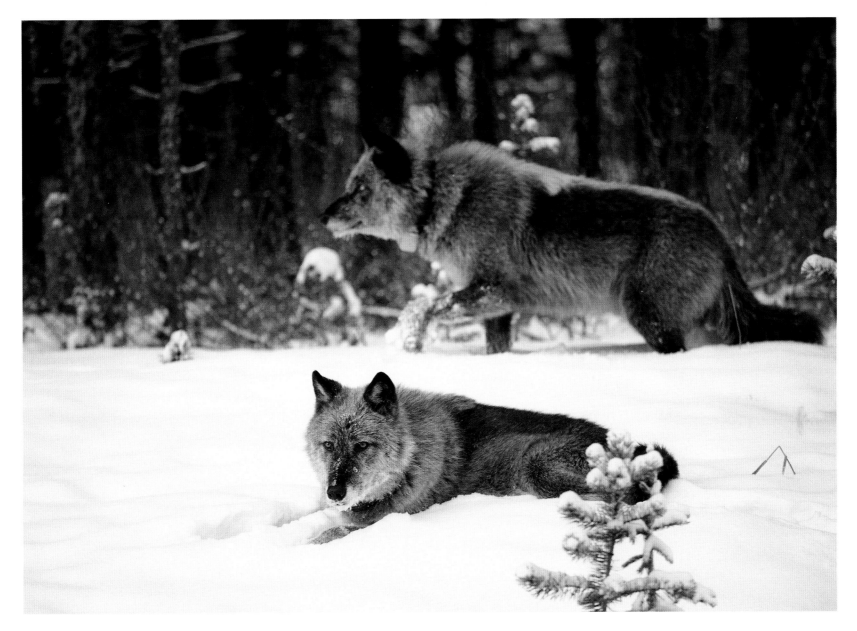

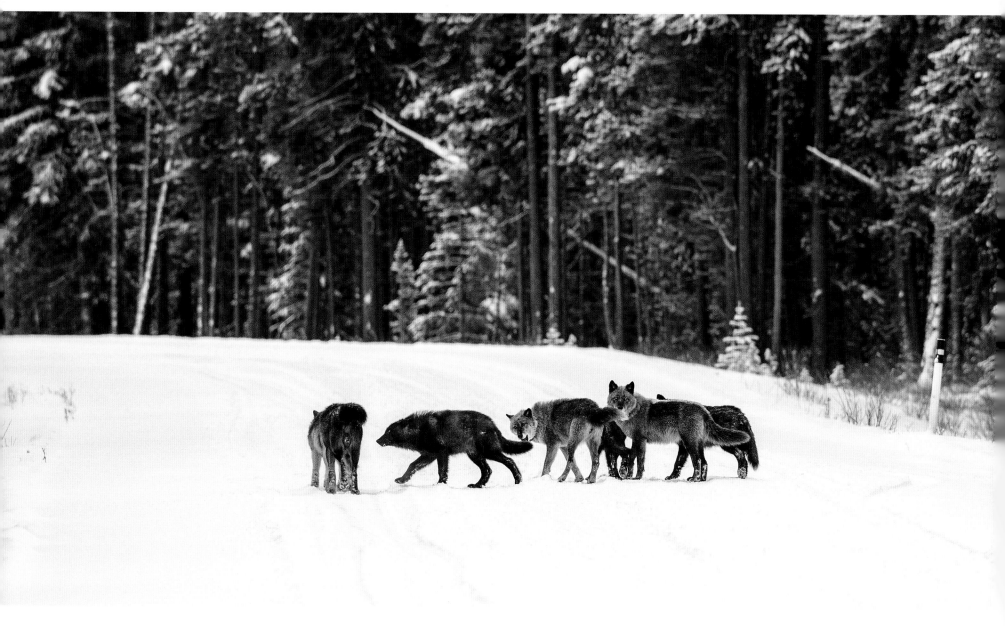

shortly after that, the town of Canmore. She continued to travel east toward Calgary and on December 29, 2011, she was killed on the Trans-Canada Highway near Lac des Arcs, Alberta.

We were devastated by the news. Blizzard had been one of our darlings in the wolf world, because she had taught us so much about social skills and about how wolves could behave in a kind and sociable manner. For us, it always seemed like she lived life to the fullest and was never too stressed or strained.

We're not going to lie, Blizzard's death left us "pretty pissed" at Parks Canada for its constant excuses justifying all of the negatives that accompanied mass tourism and the hordes of uncontrolled, selfish park visitors who never seemed to respect anything other than their own interests. Karin and I had gotten tired of asking the same simple question repeatedly of the people responsible for the chaos in the valley: If the wolves are not safe in a protected area like a national park, then where can they be safe?

Of course, the loss of Blizzard also left us with another strictly professional question: Why did we believe that the malfunctioning Bow Valley ecosystem was to blame for her dispersal and subsequent death? Isn't it normal biologically for a mother wolf to kick out her daughter after she becomes an adult and a reproductive competitor? Yes, that can indeed happen. But we believe what happened to Blizzard was part of a bigger picture, a problem inside the national park that has been going on for decades.

Wolf parents can be tolerant or intolerant of their adult offspring. Similarly, wolves can become more social or less social depending on external factors. So far in our study,

the Bow Valley had provided an exemplary opportunity to directly observe the long-term effect of mass tourism occurring at the same time as a sharp, human-caused decline in ungulate populations. It was no secret that low food availability does increase intra- and interspecific aggression. In fact, in 2002 we had already written and published a behaviour observation report for our German wolf sponsors and had additionally published a book in which we had described the increase of "pack aggression" in relation to a sharply decreasing elk population.

In Banff, we were able to directly observe several wolf families that responded to reduced food availability by expanding their territory, while at the same time we saw an increase in intraspecific aggression between family members.

From 1999 to 2002, after wildlife managers had relocated and culled hundreds of elk, the Fairholme wolf family responded to the dramatic reduction by trespassing for the first time deep into the territory of the Bows. And in 2008 – 2009, the Pipestones took over the home range of Nanuk and Delinda and their offspring after the elk population along the BVP had more or less completely collapsed.

Some wildlife managers likely consider our conclusion that reduced prey abundance in the Bow Valley resulted in an increase in aggressive interactions as pure fantasy, but, in fact, it has a long history. Dating back to when we were observing the Fairholmes in the early 2000s, we documented two juvenile wolves that faced an unusually high degree of intraspecific "pack aggression." Both youngsters were kicked out of the family at an early age and

One of the last photos John got of Blizzard with her family, November 29, 2011. She is the grayish wolf looking directly at the camera.

Günther's vehicle blocks the road to stop tourists from disrupting the wolves as Faith and one of the pups cross the Bow Valley Parkway near Moose Meadows.

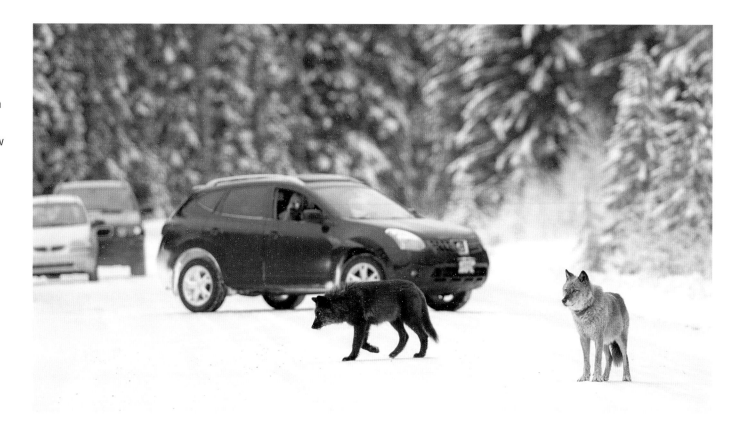

began to show up in areas with an extremely high density of humans. Shortly after that, "Dreamer" and "Sandy" showed up at a park campground and were shot by park personnel. Both young wolves were sociable character types, which our research showed were very unlikely to disperse at such a young age. These sociable types generally stayed with their wolf families for a much longer period than the reproduction-competitive, headstrong character types. Blizzard, too, had been a sociable character type that looked to have been pushed out before she wanted to be pushed out, because of a lack of food. After seeing all of these examples, the only reasonable conclusion we could come to was that Dreamer, Sandy and Blizzard were forced to move because of low food availability.

Regardless of this debate, there is another central argument to be made that mass tourism and its consequences can force wolves to deal with more hazardous situations because they get chased around by irresponsibly behaving

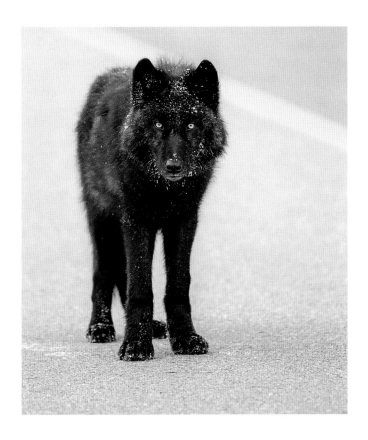

people, who would interrupt hunts and often separate Faith and Spirit from their offspring. The attitude of humans toward the Pipestones varied a lot: some photographers were respectful, as were some tourists, but the majority of tourists and photographers would follow the wolves for kilometres at close range, not giving them any room to breathe. We even reported several photographers harassing the wolves on the railway, forcing them to waste energy moving off into the deep snow and sometimes

splitting the family up in all directions. Unfortunately, as we've mentioned before, our complaints to Parks Canada were usually ignored or written off as being reported "too late to do anything about it," despite the fact that Parks Canada knew we did not own a cell phone and there was also little to no cell coverage on the BVP. There always seemed to be some excuse not to take action.

The fact of the matter is that even with experienced wolf parents like Faith and Spirit, the catastrophically low prey density was bound to cause problems like malnutrition in the young wolves. Combined with the negative effects of mass tourism and the "Wild West" behaviour we were seeing from park visitors harassing wildlife along the BVP, we were very concerned about what kind of future the younger wolves in the Pipestones were facing.

Interestingly, some of them did much better than others when dealing with these external influences. Even some of the shyer individuals were able to adapt. We watched a good example of that on the morning of December 20, 2011, when Faith crossed the Bow Valley Parkway as a car was driving by. Yuma was hot on her mother's heels, which was typical for a bold Type A wolf, and she was followed by Type B Jenny, who was using her sister as a bit of cover. The car stopped, and Djingo, who was on the road by this point, appeared to not know what to do.

Yet Djingo had already learned to watch cars before making any further decisions. Although he was a Type B and shy in principle, he would scrutinize every move the cars made. After he had checked cars out and was satisfied that they didn't pose a danger to him, he was not only willing to trot along roads and cross them without being

Djingo adapted quite quickly to being around vehicles despite being a shy Type B wolf.

Typically among pups, there is a high-ranking pup, a low-ranking pup and a number of sociable pups in the middle with no rank at all.

too scared but he even occasionally sniffed one parked car after another from up close. Just a few months earlier, the same Djingo would have shown a lot more hesitation being on a road with a car nearby. The other good news with Djingo's adaptation was that extremely shy, Type B Kimi felt much safer whenever her now "brave" brother was around.

The shy and bold model was, of course, one thing we were extremely interested in, but as our fieldwork went on, we also became fascinated with answering the question of whether or not juvenile wolves develop their personality by imitating the strategic and traditional behaviour sets of their parents and other adults in the family, or if the youngsters' personalities are driven primarily by some sort of early character strains. In other words, was there more to the story of social rank order and differentiating between extroverted and introverted characters?

The Three-Grade Rank Order Model

The old school of thought had wolf rankings defined as alpha to beta, gamma to omega. We have discarded that line of thinking and, instead, we were now looking at a kind of three-class society with three types of wolves. In general, all three types of wolves we'll be describing can be either extroverted Type As or introverted Type Bs, which means that showing a shy or bold behaviour tendency has nothing to do with the three-grade rank order model we'll explain next.

Over the years, we had noticed a distinguishable difference in social rank early on in young wolves. Within

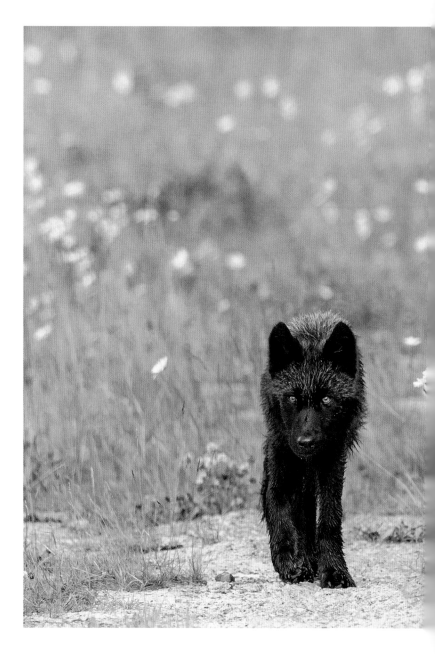

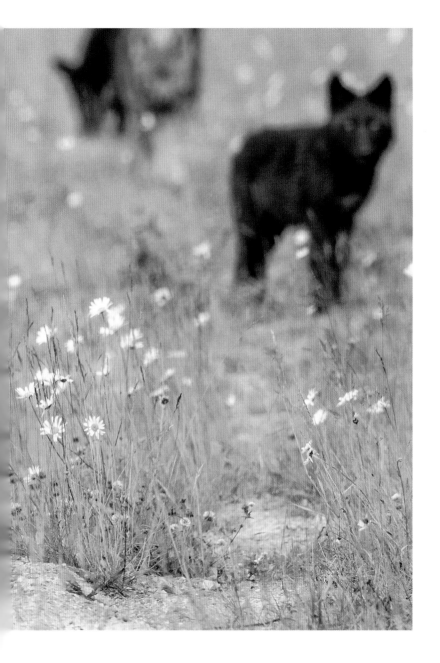

a litter of pups (this is also similar for coyotes and foxes), a social rank order had already developed by the time they were approximately 11 weeks old. On one hand, the observed social rank grades in pups seemed to be dependent on the development of their locomotive motor patterns, skills and movement abilities. On the other hand, social grades were definitely distinguishable by the pups' comfort behaviour and play behaviour, as well as their exploration habits. When the pups got close to 3 months of age, we were able to discern enough differences to assign each pup a three-grade rank order. Typically, there was a high-ranking pup, a low-ranking pup and a number of sociable pups in the middle with no rank at all. The latter were constantly busy trying to figure out new social behaviours related to social rank with their other siblings.

Because we have known all the wolf pups we've observed over the years individually, we have realized that the development of social play in wolf pups involves mimicking and imitating from an early age. This first stage of socialization was generally displayed in abundance by all pups. Typical play signals were similar to what a domestic dog puppy would exhibit, including stamping their paws on the ground and performing a bent-over bow. They would engage in classic tug-of-war games and pups would tear at sticks, bones or other pretend prey in a jerking manner.

This was all general "puppy stuff" that had already been described in 1971 in every imaginable detail in the book *Wölfe und Königspudel* (Wolves and Standard Poodles) by one of our unforgettable teachers, zoologist Erik Zimen. After a period of play-fighting, play-wrestling and biting

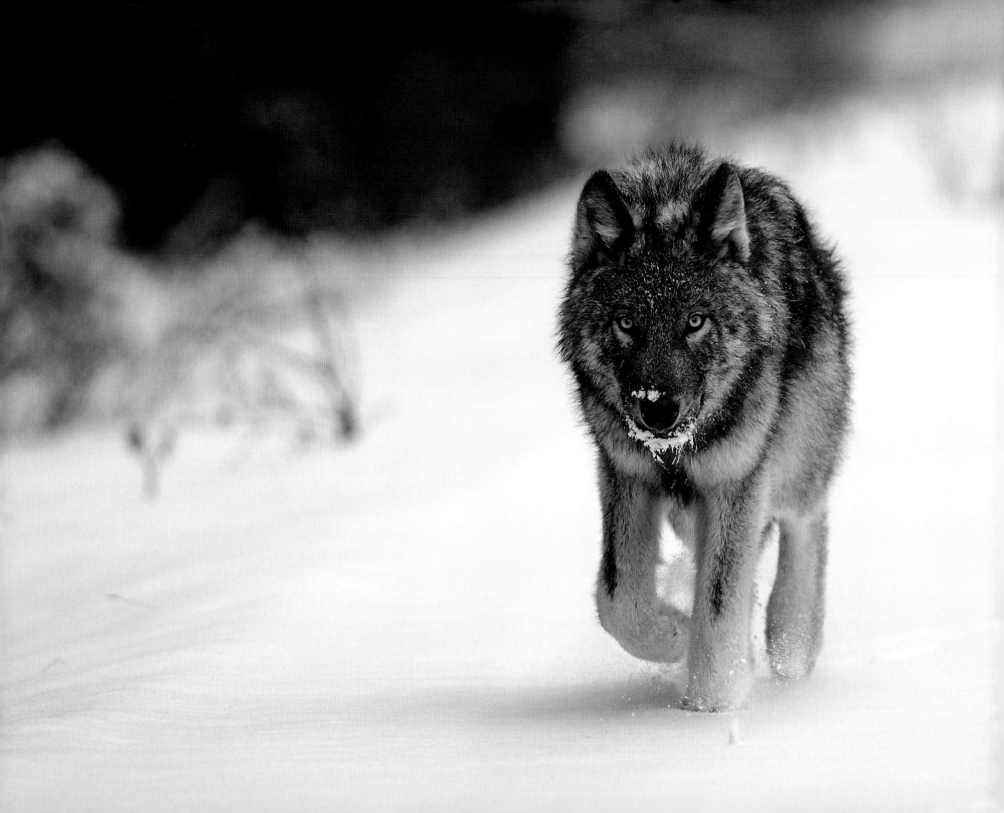

games – agonistic interactions in nonserious conflicts from a behaviour standpoint, which are perfectly summarized as "ritualized close-up confrontations" by German ethologist Dr. Dorit Feddersen-Petersen in her book *Hundepsychologie* (*Dog Psychology*) – we noted repeatedly, year after year, that we were seeing the same three different types of personalities. One type of social rank was especially easy to recognize: the highest-ranking individual. He or she typically would show a lot of solitary play with no intention of engaging a potential play partner.

Interestingly enough, such personalities would also seldom take part in a form of play most dog owners are familiar with, called "zoomers," where sociable pups dash around in circles or zigzag all over the place like they're crazy for a few minutes. We noted that high-ranking pups, which we labelled headstrong or strong-willed types, were special when it came to behaviour categories like comfort behaviour (e.g., grooming, resting together), contact behaviour (e.g., greeting initiatives) and play behaviour (e.g., solitary, in a group, with objects). Most of the time, these pups would bed down separately during inactive phases and did not like body contact with others when resting or sleeping. Furthermore, these characters were seldom willing to initiate any social play at all and, most importantly, distanced themselves from the den location three times faster than their siblings.

Later, we learned that headstrong wolves were the ones who left their parents very early on, often at just 16 – 18 months of age. These were strong-willed wolves that behaved very independently as yearlings. Strong-willed Skoki, for example, did not hesitate for a second when he wanted to disperse; he just left and didn't stop moving until he had found a mate (as we have already mentioned, he ended up settling in Kananaskis Country and establishing a family). Skoki became a proud father when he was only 22 months old.

However, we should note that it's not just these high-ranking, headstrong types that have the skills necessary for survival. The general rule seems to be that regardless of the character type, all young wolf pups seem to be equipped with a certain socio-emotional repertoire to be able to learn the social skills necessary for survival.

According to Jaak Panksepp, there are three emotional tools used in separate situations: play/joy, empathy/nurturing and panic/grief. However, observing the early independency and social dissociating displayed by high-ranking pups begged the question: Are the headstrong wolves that are generally not that socio-emotionally involved the ones that later on are more likely to become the "leaders" of a wolf family? We're still working on the answer to that question.

Here is what we do know: comparing the same three behaviour categories as mentioned above (comfort, contact and play), we noticed there was a very marked "sociable type" to be seen, a wolf that loved to rest and sleep in the midst of their brothers and sisters and always preferred body contact during inactive phases. Whenever and wherever there was a play scene to be discovered, sociable types such as Blizzard, Chester, Djingo, Jenny or Yuma could be found in the middle of the action. These sociable personalities did not like to wander around by themselves but seemed to love running around in a throng

Jenny was typical of the "social middle field" among pups that we described as being sociable types.

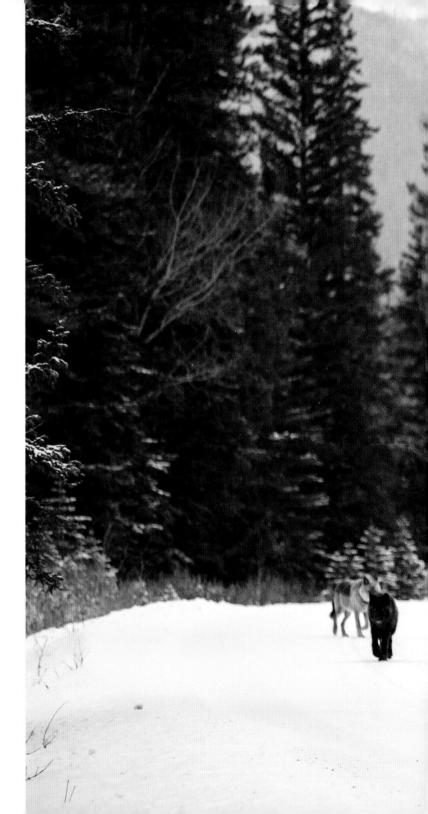

Sociable, Type A, 2.5-year-old Blizzard often led the family during its travels in the fall of 2011. From right to left: Spirit, Jenny, Djingo, Blizzard, Yuma and Faith. Shy Kimi is walking through the bush to the right, just out of sight.

with their siblings. These individuals are examples of what we describe as the "social middle field." As pups, these wolves demonstrated that for sociable character types, a lot still needed to be clarified down the road, including social status and rank. Most of the time, sociable individuals did not occupy any strict rank positions but became main caretakers for future pups.

The third social order type we were able to classify was the "mentally weak type." Always totally submissive, always cautious when approaching a sibling and almost always crawling on the ground in a low body posture when in the presence of others. Representatives of this type included Raven, Meadow, Lillian and Kimi, all wolves that didn't have the self-confidence to place themselves in a resting group. They rarely lay in body contact with their siblings during common inactive phases. Mentally weak types, formerly known as "omega" wolves, almost certainly would have loved to play with their siblings but either didn't have the nerve to do so or were completely ignored by their brothers and sisters. In German, these submissive juveniles are called *schmuddelkinder*. This word translates into "urchins" in English, though perhaps "weaklings" would be a better descriptor for these low-ranking wolves.

Through long-term observations, we confirmed that these mentally weak wolves, such as Meadow or Lillian, dispersed even earlier than the strong-willed individuals did, usually at just 10 – 12 months of age. Often, as was the case with Lillian, low-ranking individuals tried to eke out a living at the edge of their home territory where they hunted small prey like hare on their own or scavenged on

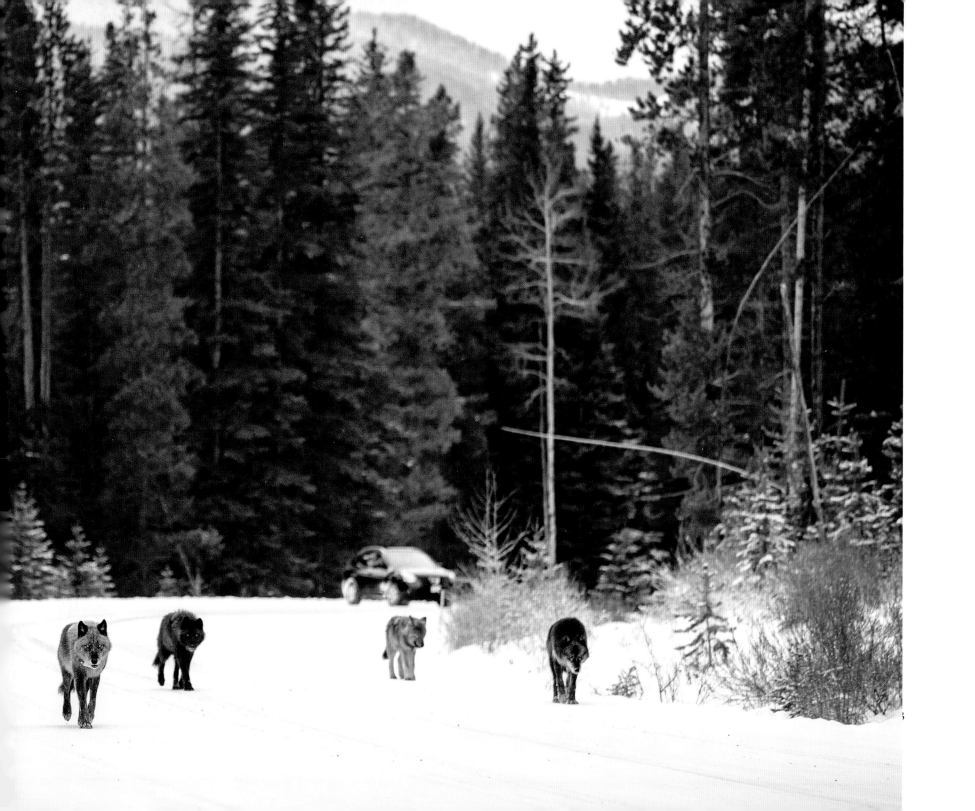

One of the young pups crossing the road near the den site.

carcasses. They were also often seen consuming "leftovers" from the family's kills after the family had departed. Our discovery that no long-term omega wolves were found in wild wolf families should be considered proof of a social structure system that is obviously fundamentally organized in a different way than in captive wolf societies, where the mobbing and bullying of the lowest-ranking individual is common practice.

Sociable, middle-ranking types, on the other hand, didn't become long-term mobbing victims at all. To the contrary, sometimes it appeared to us that playful personalities such as Blizzard were geniuses at recognizing whether they had gained the attention of other family members or not, which in our opinion was an indicator of a special ability of some wolves to put themselves in the "shoes" of other wolves. Against all odds, and in contrast to a lot of generalized comments in wolf literature, wolf observer Elli Radinger reported that some exceptionally playful wolves had stayed with their parents for their entire lives in Yellowstone National Park in the United

States. If that's not possible (for whatever reason), then sociable characters like the ones born in the Bow Valley to the Pipestones seem to become unusually attentive and enthusiastic "babysitters." Blizzard, and later on, Yuma, were perfect examples for our hypothesis that particularly sociable character types of the female gender were taking their job as social helpers very seriously and dispersed from the family as late as possible. Unfortunately, as has already been discussed, in Blizzard's case, Faith forced her out, almost certainly due to low food availability. Nonetheless, Blizzard was already nearly 2.75 years old when she was forced to leave her beloved family behind.

Irrespective of whether individual wolves have already been classified as either Type As or Type Bs, the three-grade rank order model is determined independently from the behaviour reaction types. That's the somewhat complicated thing about figuring out personalities – the headstrong ones, the sociable ones and even the mentally weak ones can be Type As or Type Bs, males or females, young or old. And while it may sound extremely difficult to define these complex wolf personalities, when one takes the time and appropriate observational action, it isn't.

When it came to the issue of individual dispersal behaviour and how wolves disperse to interconnected areas north, south, east and west of the Bow River Valley, with protected and unprotected wolf populations, we were not able to find this out during our project. This is where intensive telemetry and GPS work would have offered us a distinct advantage. It is because of this technology that we knew Skoki went to Kananaskis Country and that his sister Blizzard had been killed outside Banff National Park.

Leadership Behaviour in Relation to Social Status, Age and Character Types

Before Blizzard had left her wolf family, we explored the significance of age and personality in leadership behaviour in the Pipestone family while travelling along roads. Looking back at the information we had collected from early September 2011 to the end of December 2011, strong-willed Type A Faith was 5.5 years old, strong-willed Type B Spirit was 6.5 years old, sociable Type A Blizzard was 2.5 years old and Type A Chester was 1.5 years old. In addition, sociable Type A Yuma, sociable Type Bs Djingo and Jenny and mentally weak Type B Kimi were all 6 months old.

As far as the bold, Type A adults Blizzard and Chester were concerned, it was interesting to note that Chester led the family significantly less than Blizzard did. However, keep in mind that Chester was a yearling and was not with the family by the end of September.

The final statistical note we found interesting was focused on the leadership behaviour of the four juvenile members of the Pipestones. We wanted to know whether or not young wolves, during their first autumn of regular travels away from the den and rendezvous sites (at the age of 4.5 months or older), would ever take over the frontal leadership positions and, if they did, we wanted to know if the rate of juveniles leading a family group was influenced by character.

As indicated by Figure 3.4, Kimi was never observed in the front of the group and was therefore not included in the diagram. All three other juveniles were occasionally observed travelling in front, regardless of their character.

However, Yuma was observed in the front significantly more often than Djingo and Jenny.

Figure 3.5 shows all of the frontal positions of the Pipestone wolves related to character type.

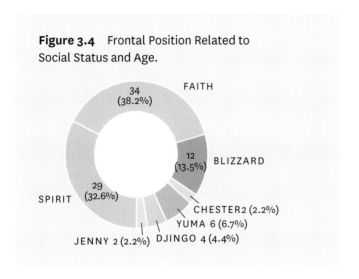

Figure 3.4　Frontal Position Related to Social Status and Age.

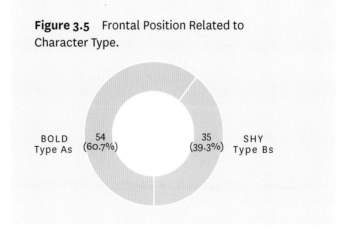

Figure 3.5　Frontal Position Related to Character Type.

Blizzard at
Hillsdale
Meadows six
months after
being radio
collared by
Parks Canada.

Wildlife Management and Animal Behaviour Knowledge

If you were to ask Karin and I whether or not all wildlife management should be based on animal behaviour knowledge, our answer would be simple: yes, of course it should. One of the main reasons we have outlined our detailed findings on wolf leadership in relation to personality types is to provide some important tools to better understand their adaptive behaviour strategies. When it comes to "managing" wolves (as well as bears), the importance of considering the shy and bold model cannot be overstated, because, otherwise, management actions such as hazing and/or aversive conditioning are nothing but arbitrary and cannot possibly work as they are intended to. This issue has already been discussed, but it will be explained a little bit more in detail here.

Wildlife managers tend to completely ignore the determination of basic character/personality types in wild animals, but it deserves to be taken very seriously. For instance, to begin with, there is no such thing as uniform wolf behaviour. Type A characters typically tend to get confused and panic when confronted with unknown stimuli and situations they can't control, whereas Type Bs tend to hide. To date, no one in Banff (or elsewhere) has come up with an aversive conditioning or radio-collaring program differentiated by or based on character types. So when the Pipestones were shot at with firecrackers or chased around by helicopters flown by Parks Canada personnel, no one had any clue as to how the different wolves would react based on their basic character traits. The

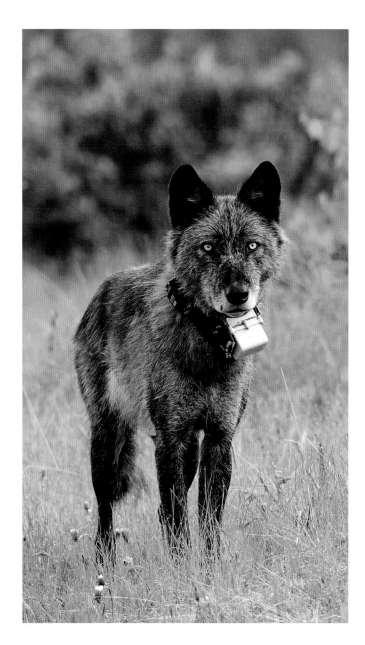

almost tragic result of this was that Blizzard nearly got run over by a train while being chased along the railway tracks by a helicopter when Parks Canada fitted her with a GPS radio collar. She ran around confused and panicked, as Type As do, when in the same situation a Type B wolf would have hidden instead.

We are of the opinion that all radio collaring should be carried out with a moral compass at hand. Wildlife conservation should always be based on respect for animals. Parks Canada felt we had overreacted and showed an exaggerated emotional response when we complained about how it had handled Blizzard when capturing her. But we had identified Blizzard as a Type A, so we knew what was coming. Thankfully, she wasn't injured or killed.

During another occasion of attempted "behaviour modification" (in other words, aversive conditioning to try to change the behaviour of the wolves), we watched in horror as Kimi ran directly onto the road in front of a speeding vehicle and narrowly missed being hit just seconds after she had firecrackers shot in her direction. In fact, over the years we have witnessed nearly a dozen such chaotic scenes where wolves (or bears) were put in danger by park personnel during hazing and/or aversive conditioning, but it would be too much to list them all in this book.

The bottom line is that in the absence of any functional behaviour definition, there is a high potential for management actions such as aversive conditioning to fail. Why isn't it mandatory for managers to take animal behaviour psychology classes before initiating aversive conditioning or radio collaring? Our motivation for repeatedly criticizing nonbehavioural-based management decisions has never been about pointing fingers but rather about offering practical suggestions for considering animal character types when effecting animal management. What the professional world of animal behaviour experts calls "a successfully achieved behaviour modification" is always based on individual juvenile (ontogenetic) character knowledge, but that was never the case in Banff. We know that ontogenetic behaviour development is a critical component that has to be factored into wildlife management decisions, which is why we believe that aversive conditioning without detailed knowledge about animal personalities should no longer be used as a management tool in Banff. As it is currently used, aversive conditioning is just too risky and/or a total waste of taxpayers' money.

Taking Field Notes at the Den Site, Late Spring 2012

Bold, extroverted, Type A wolves won't hesitate to walk right past parked cars, while shy, introverted, reserved Type Bs detour around them. Like we have already mentioned, it is important to note that shy Type Bs can adapt to a lot of environmental stimuli and influences, but their basic character always remains the same when confronted with new situations. In spring 2012, our hypothesis of being able to separate the character of a wolf into these two basic personality types was confirmed. In mid-April, at least six new wolf pups were born at the same den the Pipestones had used in 2011 (the traditional Bow Valley family den site). As usual, Faith had punctually

One of the
black pups in
late June 2012.

approached the den in mid-April and after April 14, we did not see her travelling with Spirit and the family for some time.

On June 5, at 7:07 p.m., the new pups showed up on the road for the first time. At first, there were only three individuals, two black and one gray. However, on June 7, at 6 a.m. sharp, the yearlings Jenny and Djingo accompanied five pups to the roadway. Parks Canada had advertised the den site again but this time posted a huge sign using one of John's pictures of Lillian on it (without his permission). Just as we had been in 2011, we were annoyed and alarmed to see this blatant announcement to every park visitor about where to find the headquarters of the Pipestone wolf family.

In moments of need, young wolf pups usually learn that their parents protect them and are there for them. That became evident on June 16, when we watched an adult fox show up near three pups and throw off their usual spirited behaviour. However, 15 minutes later, Spirit showed up and the pups started playing again, secure in the knowledge that their father was there to protect them. Unfortunately, for most of that month, Faith and Spirit were out desperately trying to kill an ungulate somewhere and Faith was only showing up at the den site sporadically. Meanwhile, the little wolf pups had soon grown to the stage that they were more or less physically capable of moving around further from the den. We got a huge surprise on June 20, at 7:01 a.m., when six pups appeared all of a sudden! We observed three black male pups, two black females and one gray male that morning.

From then on, two of the pups were running around on

the road significantly more often than the others, which helped us distinguish the pups' basic character types. Now it was 14-month-old Yuma that was often the only adult at the den site. Observing her professional actions as "baby-sitter" reminded us again of what young wolf pups really need: socio-emotional safety, bonding opportunities for creating long-term relationships and a feeling of security and group-oriented familiarity. During the first two weeks of June 2012, the two Type A pups were running around exploring the road, playing and living a relaxed life in social harmony. We even saw them nibbling on the wooden post of Parks Canada's wolf sign! It was really good to see that the pups were playing a lot. Otherwise it would have been alarming, as German canine expert Mechtild Käufer reminded us unequivocally: "Animals that are raised in social isolation, therefore having no or very little opportunity to play in their youth, suffer from a permanent

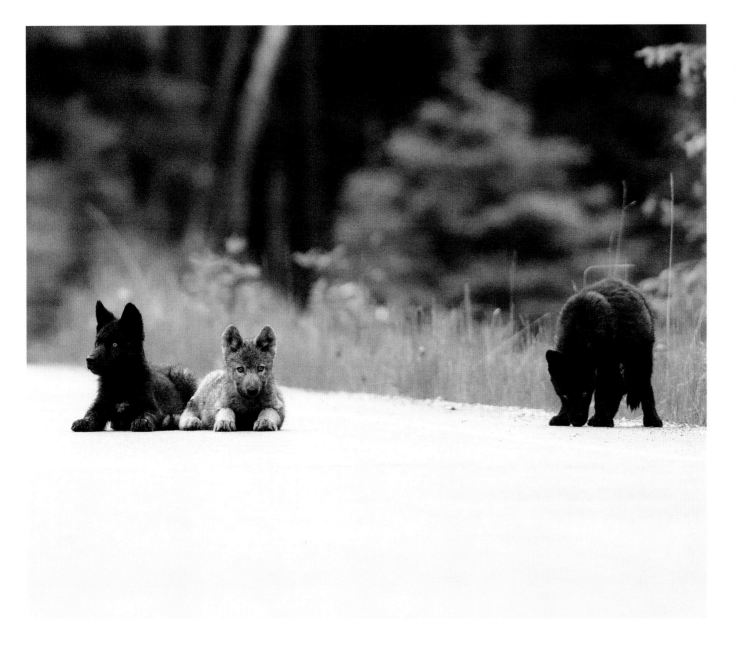

Two black pups and a gray one (later named Golden Boy) on the Bow Valley Parkway in early June 2012.

[6] Mechtild Käufer,
*Canine Play
Behavior: The
Science of Dogs at
Play* (Wenatchee,
WA: Dogwise
Publishing, 2014),
207.

reduction in their dopamine, noradrenaline and serotonin levels."[6] Yes, Mechtild, you are absolutely right!

On June 25, we had a great encounter at dawn, as we observed Faith standing at the edge of the road near the den site, where she started to howl. Three minutes later, all six pups showed up on the road in the usual socio-friendly manner, muzzle-licking and greeting their mother. Faith turned around and almost automatically the pups followed her and they soon disappeared into the forest.

Foxy Encounters

That June we kept seeing the same red fox show up each morning in the den area of the Pipestones. "Foxy" would sniff the air to determine if an adult wolf was around, and if the coast was clear, she would sneak in and steal food items, like bones or little pieces of fur with some flesh on them, from the wolf pups. The pups seemed to have no clue about how a predatory species like a wolf was supposed to deal with a cheeky, smart adult fox that knew exactly what it was doing. The shifty fox would eventually leave the area, triumphantly carrying a small piece of food in her mouth. For two weeks, she snuck in and out of the den area without getting caught once by any of the adult wolves. It was remarkable.

For that entire month of June, we never did see any other adult foxes. We suspected that was because something had happened to the male fox and it simply wasn't available to actively lend a helping hand. Later, we confirmed that Foxy had denned in the area and had given birth to at least two pups. We had one glorious morning when we got to watch the two pups play-running through an aspen forest near the wolf den site in early July.

For those who love to hear unusual animal stories, the following is a great one, although hard to explain in any rational way. On July 7, 2012, we were delighted to find Foxy in the middle of an open meadow hunting mice and doing "the jump" over and over again. As she was leaping about, two ravens showed up. Like the wolves, we knew these ravens "personally," too, because they nested just 200 metres away from the wolves' den site (ravens live monogamously like wolves do, and a wolf rendezvous site tends to become a raven family's favourite spot, too – it's there that they raise their young every spring and summer, where they know they can easily find the wolves). Of course, the ravens weren't watching wolves; they were watching Foxy, and likely speculating on the chances of scoring a free meal from Foxy's efforts.

While the ravens were watching, Foxy caught a mouse and started eating it. And then what happened next left us speechless: out of nowhere, Yuma showed up at the scene. She stood there, staring intensely at Foxy, and we were sure Foxy was in trouble. But to our shock (and joy), after a brief stare down, both canids started to hunt mice independently right beside each other! No threats from Yuma, no predatory behaviour toward Foxy, not even an argument! This was particularly astonishing considering that the wolves were dealing with a food crisis at the time and trying to raise six hungry pups.

Yuma continued to hunt mice for ten minutes without paying any further attention to Foxy, who slowly left the meadow and trotted into the woods. There never was any

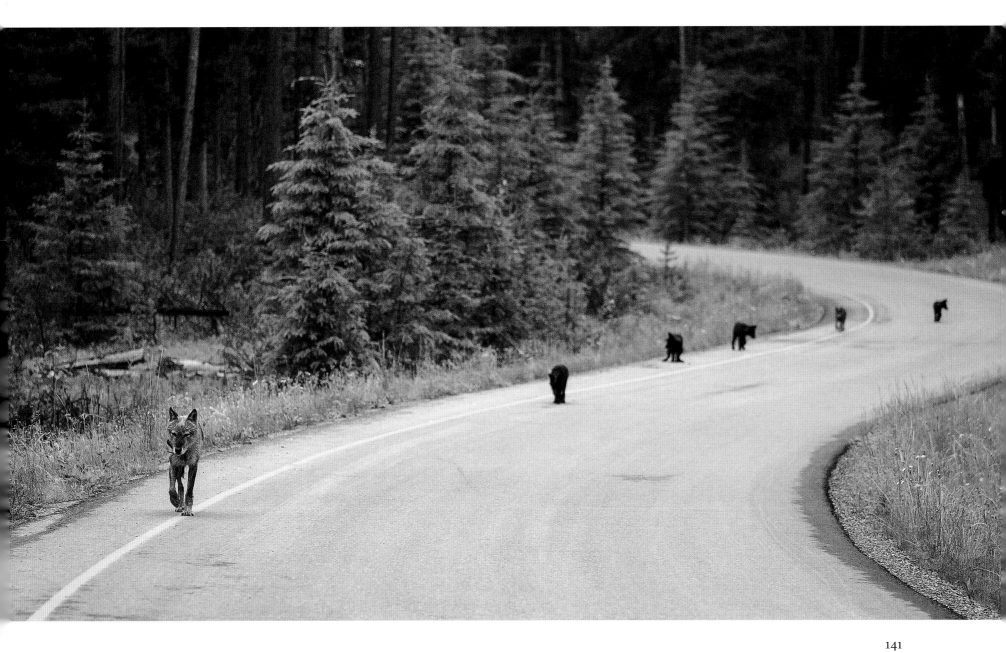

panic from Foxy and she didn't really even pay attention to Yuma. And, of course, in the middle of all of this were the two ravens hopping around, completely unmolested. It was mutual tolerance all over the place, a behaviour specialist's dream.

So is it possible that what looked like a mutual agreement of "cease fire" at that moment in time was actually something else? Of course, it could have been; we have no idea what was really going on. But like we mentioned before, sometimes animals can leave us observers speechless!

The Interactive World of Wolf Pups and Ravens

Before dawn on July 9, 2012, Yuma, Faith and all six pups joined in a group howl, initiated by Yuma, on the road near the den site. Later that same morning, we watched Spirit, Faith and Yuma travel toward the rendezvous site, past the huge wolf advertisement sign. A few minutes later, all six pups showed up under the wolf sign and ran into the meadow after the adults. It was soon obvious that the family had left the den site for more than just a short walk, because we saw them travelling all the way to the Sawback area, ten kilometres from the den site. On July 13, early in the morning, we saw Yuma, Spirit, Faith and the pups heading back toward the rendezvous site, zigzagging through at least six different cars lined up along the parkway. The wolves finally managed to reach their core territory safe and sound and the next day we watched the pups play-running deep in the rendezvous meadow. As

usual, the two resident adult ravens were also there, sitting on a thick branch of a big aspen tree. Fortunately, we were able to identify the ravens individually because one of them had an open gap between the feathers of its left wing and the other did not. Consequently, we called the ravens "Gap" and "Ngap." While watching the pups and ravens interacting over the course of two weeks, it became obvious that some kind of socialization process was going on between the two species and it was fascinating to watch.

We catalogued several interactive behaviours expressed by the ravens and wolf pups when interacting with each other in an ethogram (a methodical listing of behaviours observed), distinguishing between four behaviours, all of them initiated by the ravens: approach, tail-pulling, coat-pinching and play-running.

Table 3.1 shows all of the interactive play behaviours observed between the pups and Yuma and the ravens, initiated by one of the two ravens, between June 29 and July 14, 2012.

Risky Lives and Further Loss

The year 2012 was a tough one for the Pipestones. Faith and Spirit were out battling the odds trying to find enough food for the pups, and while they were doing that, tragedy seemed to follow the other members of the family. On July 19, 2012, at 4:41 a.m., we watched Faith leave both the den location and the rendezvous site for good with all six pups behind her. The entire core of the Pipestones' territory had been declared a "closed area" by Parks Canada and signs, including the big sign with John's wolf picture on it, had

Table 3.1 Symbiotic Related Interactions between Wolves and the Ravens Gap and Ngap, Summer 2012

Interaction	Approach	Tail-Pulling	Coat-Pinching	Play-Running
Gap >* pup(s)	7	3	6	2
Ngap > pup(s)	10	5	5	1
Gap > Yuma	3	1	1	0
Ngap > Yuma	5	0	1	0
Total	**25**	**9**	**13**	**3**

*The symbol ">" means "in the direction of" or "toward."

One of Gap and Ngap's youngsters in June 2012.

been placed all over the roadsides, but nobody seemed to care. Every day brought a constant throng of ignorant photographers and tourists buzzing around the den and/or rendezvous location to the point where the wolves had no choice; they had to move to get some peace and quiet. By 5:59 a.m. that morning, Faith and the pups had already reached the Bow River near a picnic area named Muleshoe after a long walk and travel along the parkway completely undisturbed by photographers. The photographers hadn't even noticed that the wolves were long gone and instead continued to drive their vehicles up and down alongside the den site.

By the following day, Faith had taken the pups across the Bow River to a well-hidden location near the Trans-Canada where Parks Canada often dropped roadkills so tourists wouldn't see them. Normally, we would have expected all of the yearling wolves to be part of such a long journey and to be on board caring for the pups, but other than Yuma, all of the others were missing. Unfortunately, we soon learned that all three yearling wolves had been killed on the Trans-Canada Highway: Djingo was struck by an SUV near Castle Mountain, Jenny was hit near Lake Louise and Kimi was killed at the Sunshine exit.

Parks Canada has often trumpeted the highway fencing on the Trans-Canada as having reduced wildlife mortality by 90 per cent, but in the case of wolves, this was definitely not true. We had been registering complaints for years regarding the shoddy fencing near the Sunshine interchange and in the Redearth Creek area, but the neglect reminded us daily that there was only money for tourist-related issues in Banff, not wildlife-related ones. All three youngsters were just 14 months of age. It was a terrible loss for the Pipestones and once again showed the world the shortcomings of Parks Canada's wildlife management in the park.

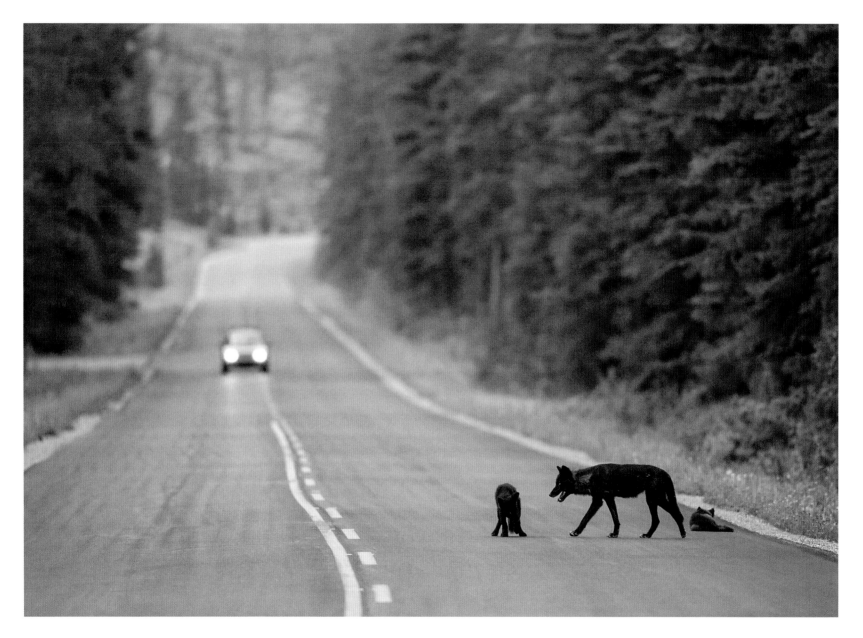

The Pipestones in 2012

By the end of the third week of July, a black female pup was missing. By now, so many family members of the Pipestones had died that just three adults and their offspring were left: Faith, Spirit, Yuma and five 3-month-old pups. Watching the remaining youngsters roam about made it possible for us to shed some light on their personalities. We already had information about their basic characters, but we took this opportunity to test the shy and bold model hypotheses again.

After the personality testing procedure had been completed, we characterized the only juvenile female left as a classic Type A. We called this sociable character "Sunshine" (in German, a person with the nickname *Sonnenschein* is someone who is always in a good mood), and we named her two brothers "Trickster" and "Golden Boy," or "G.B." Trickster was a long-legged, tall, black male with silver grizzling on his dark coat. He was a relatively shy but headstrong Type B who liked to behave discreetly in the background. Golden Boy, on the other hand, was given his name because of his unusual yellowish, golden-brown, ochre colouration. G.B. was a beautiful-looking male wolf that was easily recognizable as a curious Type A character and sociable personality. He often was observed initiating play-runs. The other two black male pups were both extroverted Type As and very playful. "Big Foot," named for obvious reasons, was playful but nevertheless a headstrong, very powerful-acting male, while the fifth pup was a bit more reserved. Although his behaviour tendency was that of a Type A, we weren't 100 per cent sure what exact personality type he was, so he got dubbed "No Name."

On July 26, 2012, Faith, Yuma and four pups were exploring the road in the Sunshine Valley. No Name had been missing since Faith had taken the pups across the Bow River a week earlier. Whether he had drowned or had been killed by another cause remained a mystery. From now on the wolves stayed more or less in the same areas of the upper Sunshine Valley where they had been hanging around in late August and early September 2011. A day later, on the 27th, Faith, Yuma and the pups passed the Sunshine gondola building early in the morning on a beautiful sunny day and headed toward Healy Pass undetected by tourists or local photographers. Spirit showed up later that day and trotted off in the same direction. The wolves remained out of sight in the Healy Pass area for a few weeks, before returning to Sunshine Road again on August 11. For the next four days, we were able to observe the Pipestones nearly all day long. By the end of August

Yuma with several of the pups in July 2012 near the Sawback prescribed burn after the Pipestones had abandoned their core area for good on July 19.

Sunshine was a sociable Type A pup with a faint white stripe on her chest.

2012, the pups had grown up nicely under the tutelage of Yuma, who was the adult we saw most commonly hanging out with the juveniles.

In the first week of September 2012, we were totally surprised to discover an entire herd of mountain goats near Sunshine Road. After scanning the surroundings, we finally figured out there was a mineral lick just off the road that seemed to be of considerable importance to both ungulates and the wolves alike. We documented several species there, including 13 mountain goats. On September 10, early in the morning, we watched the entire wolf family, including Spirit, travel up to the mineral lick to check it out, but there weren't any ungulates around. It was too bad, because as we had seen them approaching the lick, we had already started speculating about how incredible it would be to watch a hunting scene between the wolves and mountain goats up close.

Yuma: Short-Handed Defender of Pups

On September 11, 2012, we were treated to an unusual series of successful sightings and encounters. Things began when we watched a young male grizzly attempt to approach a fresh deer carcass that Yuma and the pups were feeding on. It's important to note that Yuma was the only adult around and that the four pups, G.B., Trickster, Big Foot and Sunshine, present at the carcass were just 5 months old. Juvenile wolves that young are not capable of defending themselves against a bear.

The grizzly came rapidly up the hill toward the carcass and, surprisingly, Yuma attacked him immediately. The bear was caught completely off guard and was clearly overwhelmed by the quick attack. Because Yuma had demonstrated such absolute determination in the confrontation, the bear knew by instinct that it was best to retreat. Some "opinions" were expressed verbally (the bear let out a few loud protests), some brief communication signals were exchanged and the bear was gone, leaving a victorious Yuma on top of a nearby hill after an impressive display of behaviour. Apparently, Yuma's body language was that of a proud defender of her younger brothers and sisters. Her powerful initiative of fighting off a bear all by herself was one of the most noteworthy cases of formal dominance and age-related risk taking we had ever witnessed in the wild. Since Faith and Spirit were not present at the time of the clash, the whole event could have ended in total failure, which made it even more significant.

After the bear had turned his back and walked off into the distance down the hill, the four juvenile wolves were suddenly full of self-confidence and looked as if they felt invincible. Notwithstanding some lucky circumstances (the bear could easily have been much older, more experienced and better equipped to deal with an adult wolf running at it), the youngsters were behaving like megalomaniacs, especially the brothers G.B. and Big Foot, chasing the young grizzly into the valley unlike anything we had ever seen juvenile wolves do before.

It was that special event that allowed us to identify different examples of sibling bonding and family relationships, as well as other behavioural characteristics such as determination and courage, that helped us better understand the abilities of adult wolves to defend pups.

Another Loss and the "Usual" Risk Taking

On September 28, 2012, Big Foot was killed on the CP railway near Muleshoe. This terrible news was tough for us to stomach for several reasons. Firstly, we really liked Big Foot, with his huge paws, great attitude and boisterous power. He was a definite favourite of ours. Secondly, Big Foot's death was marked with only a tiny footnote in the local newspapers. He definitely deserved better. And, finally, with him gone for good it meant that five of the family's adult and juvenile wolves had lost their lives that summer: the three yearlings Djingo, Jenny and Kimi, the juveniles No Name and Big Foot and one additional pup. Despite the fact that it was the most devastating year in the history of the Pipestone family, the tragedies didn't even register a blip on Parks Canada's website.

On September 30, 2012, the wolves came out of the woods in the early morning and travelled for a short distance on the BVP. Spirit led the group, followed by Faith, Trickster, Yuma and Sunshine. We did not see G.B.

No Name, pictured here as a three-month-old pup, was one of six wolves from the family to lose their lives in the summer of 2012.

Within several minutes, five vehicles had surrounded the wolves and people had jumped out of their cars and trucks and started running after the wolves taking pictures. One young lady in particular didn't hesitate for a second and ran after Yuma as the wolf briefly stood in front of some aspen trees. We kindly asked the woman to return to her car, but she started shouting at us, "Shut up, this is a free country!" It was incredibly disrespectful to the wolves, let alone to us. Evidently, no one had bothered to tell the wolves that the "free country" part only applied to humans. Unfortunately, it does in the Bow River Valley.

On October 3, G.B. was back in the family group. It had snowed and at 7:57 a.m. the complete family was chasing a white-tailed deer along the road. Fortunately enough, nobody was around, but the wolves still didn't have any success. Yuma started to go after mice instead and we were able to film her jumping into the air before catching a mouse and consuming it. G.B. joined in, copying his big sister. After awhile, Trickster joined in and we were able to watch all three wolves mouse hunting. Unfortunately, the luxurious bliss of our uninterrupted wolf watching only lasted for 20 minutes. As the wolves were mousing, a big truck came flying by, saw the wolves and slammed on its brakes. Instantly, the wolves took off, with Faith leading the way across the road and over toward the railway, exchanging one type of risk taking (travelling along the parkway) for another (travelling along the railway).

On October 13, the wolves were back on Sunshine Road again, travelling uphill. The juveniles were in good shape and Yuma started her irresistibly elegant "mouse jumps" alongside the road. But after just five minutes, a bus came

speeding like crazy down the winding road, chasing the wolves off instantly and reminding us how easily any one of the Pipestone family members could lose its life. As usual, nobody was there patrolling the road, where excessive speeding is the norm (despite the fact that everyone in the warden's office knows very well that this is the case).

When Ignorance Is Unacceptable

On October 22, 2012, Chester, a former member of the Pipestones, was killed on the Trans-Canada Highway near Castle Mountain. We have no idea why he was back in the territory, but his death was the seventh wolf fatality in the Bow Valley that year. Together with our dog Timber, we discovered that Chester had got onto the treacherous highway after Parks Canada maintenance personnel left a gate open along the highway fence. It was not the first time this had happened, but it was the first time it had ended in tragedy.

As usual, we immediately reported the open gate to Parks Canada by phone. We were promised it would be taken care of immediately, but nothing happened. So the next day we submitted a written complaint by email, which went unanswered. We followed up over the next three days but still didn't see anything change. A friend of ours who had witnessed the whole thing wrote a letter, too. Finally, after a week of inaction, and after discovering that we weren't the only ones who had registered complaints with the wardens regarding the open gate, we personally visited the Banff warden office. We told two employees that Parks Canada's failure to respond to the "gate issue"

Chester, pictured here in late summer 2011 near Johnston Canyon, was killed on the Trans-Canada Highway near Castle Mountain in October 2012. He was the seventh wolf fatality in the Bow Valley that year.

was unacceptable and that we were considering writing letters to the editors of several local newspapers. Within the day, the gate was finally closed.

The entire encounter left another bad taste in our mouths. It highlights just how serious the problems of wildlife protection are in Banff and how laissez-faire the attitudes of some park personnel can be at times, including contractors working for Parks Canada. After all, it is supposed to be Parks Canada's mandate to manage and protect the natural resources of the park.

Avoidance Tactics

Observing Faith, Spirit, Yuma and the remaining 2012 pups while travelling through their home range in the fall of 2012 and early winter of 2012 – 2013 as they were travelling along the parkway taught us a lot. First and foremost, we learned about the frustrations Faith and Spirit faced when vehicle traffic was at its most intense and their travel was being disrupted several times a day.

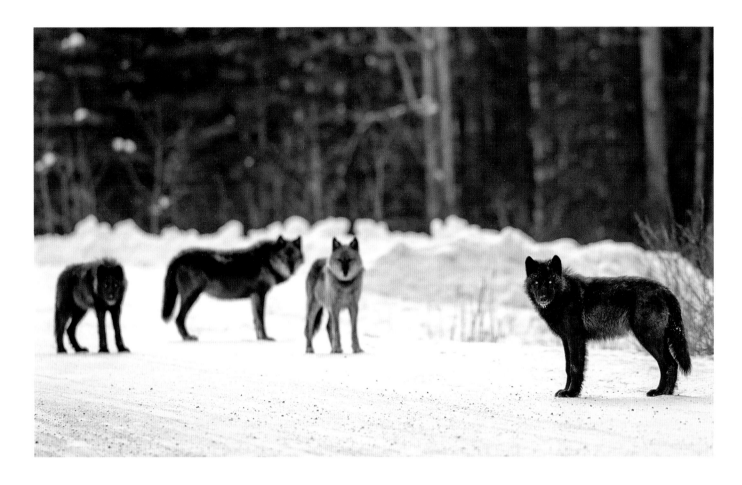

Faith, Spirit and Yuma with one of the juveniles on the Bow Valley Parkway.

Being eyewitnesses to the Pipestones being harassed by photographers on foot was hard to swallow for both us, particularly at that time of the year when the parents had to teach their inexperienced offspring as much as they could about the territory. Being chased by, and running away from, irresponsibly behaving people meant that the family, especially the reserved, Type B Trickster, unneces-sarily wasted a lot of energy avoiding people as they moved about. The good news was that Trickster had his name for a reason: he was excellent at outwitting people who tried to follow him on foot.

Although it may sound cynical, documenting the des-perate moments when Faith and Spirit would take over responsibility in critical situations were the times we

150

often learned the most about what real leadership meant in wolf families. Two-thirds of the time, when people were jumping out of their cars, either Faith or Spirit wisely led the family away into the woods. They would hide tactically behind shrubs and wait for people to leave. Then, after a minute or two, one of them would lead the family back on track toward the BVP. It was interesting to note that Yuma did not lead the juveniles as far away from roads as her very experienced parents did.

Several wolf researchers, including Dave Mech and Douglas Smith, have documented general leadership behaviour in wild wolves. To the best of our knowledge, however, no one has collected data or observations on leadership behaviour in wolf families that travel on roads. Similarly, the tactical hiding behaviour strategy of so-called alpha wolves has not been published before.

Figure 3.6 shows how many times between September

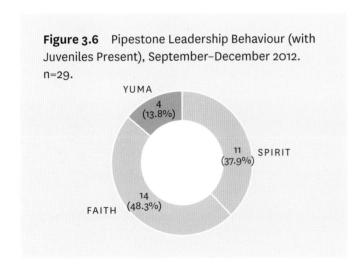

Figure 3.6 Pipestone Leadership Behaviour (with Juveniles Present), September–December 2012. n=29.

YUMA
4
(13.8%)

SPIRIT
11
(37.9%)

FAITH
14
(48.3%)

and December 2012 that Faith, Spirit or Yuma led the juveniles on and off the BVP using the hiding tactic.

In addition, we kept track of how often each pup came onto the road and whether or not it appeared that the pup was relatively comfortable around parked cars. There seems to be a heated debate about the issue of innate behaviours, such as "typical wolf shyness," regarding when they emerge during specific phases of ontogeny (in other words, the point at which they emerge in a wolf's lifespan). We wanted to know whether behaviours like openness and curiosity, which occurred at an early stage in pup ontogeny, were automatically integrated into their chain of actions using roads. In plain English: Do wolf pups born near human infrastructure all behave curiously toward that infrastructure? And has natural selection of wild wolves living in areas of high human presence already resulted in those wolves automatically being fearless or having lost some of their natural fear of humans?

Although we did observe some adaptive behavioural changes during early juvenile development, most of the young wolves' behaviours were typical for their character type. Sunshine and Golden boy, the headstrong Type As, were brash and bold. We would watch them jumping on the road in high spirits and play-running around our SUV almost every morning and evening, whereas Trickster, their headstrong, Type B brother of the same age, never acted spontaneously near roads, cars or any other human objects. Instead, he always detoured at least ten metres around our vehicle and often just stood still at the edge of the road while thinking through what to do next.

Caution while driving through national parks is

generally not only a good idea but should be viewed as an obligation by all, because young wolves (and all young, group- and/or mother-oriented mammals) tend to follow the older ones, especially during travel, as they are strongly bonded. By addressing character-related, socially and ecologically relevant behavioural questions that have thus far received little attention in the literature, we also learned that young Type A wolves like Sunshine and G.B. preferred to imitate the actions of Type A adults such as Faith and Yuma, whereas Type Bs like Trickster more closely followed his Type B idol, his father, Spirit. Our measures of character-based behaviour habits also revealed that Type A wolves slept in the open more often than Type B wolves. In the early morning hours, Faith, Yuma, Golden Boy or Sunshine were often to be found (with some exceptions, of

course) sleeping in little ditches right near the road, while Spirit and Trickster were much more likely to be hidden away under trees or behind bushes.

Also worth noting was the spatial distribution of Yuma and the three youngsters G.B., Trickster and Sunshine when they came out of the forest and encountered parked cars. For the following analysis, we compared the behaviour reactions and estimated distances shown around cars (> or < ten metres) by both bold and shy wolves. As a reminder, Type As are considered to be extroverted, bold types and Type Bs are considered to be introverted, shy types.

Figure 3.7 shows the number of times a yearling or juvenile Type A or Type B wolf approached within ten metres of a parked car or detoured more than ten metres around it.

Yuma on Highway 93 South near Storm Mountain.

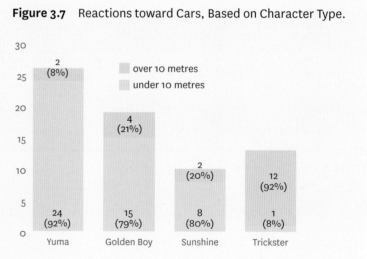

Figure 3.7 Reactions toward Cars, Based on Character Type.

The Amazing Story of Sunshine

The following anecdote deserves the attention it will garner, in part because this is not the first time we have witnessed and documented such an event. The dramatic, eye-opening story we are about to share with you about the youngster Sunshine will be of great interest to wolf lovers and behaviour skeptics alike. In particular, we think behaviourists who insist that no mammal other than the human is capable of showing organized cooperation, taking care of one another and showing empathy will have a hard time explaining the following.

In the early days of November 2012, we received the horrible news that 6-month-old Sunshine had been hit by a train near the family's rendezvous spot and injured badly. In fact, she was so badly hurt that it was difficult for her to even walk. We believe it took her considerable effort just to find some cover and crawl behind a stand of aspen trees and willows. Two resource conservation officers from Parks Canada investigated the scene and seriously considered putting Sunshine out of her misery. Fortunately, we were able to convince both men that there was at least a little bit of wiggle room for Sunshine to recover.

Of course, we knew speaking out on such a controversial topic was debatable and would get questioned. The discussion of emotional behaviours in wolves is not something that gets a lot of consideration among conservative-thinking people. We have faced derision from some for even considering that wolves could show empathy for each other. But for the next three months following Sunshine's injury, the Pipestones showed us more than we could have

Sunshine in July 2012, four months before she was hit by a train.

imagined about what they could do, how they felt and who they were.

We realized that once again we were in a position to learn a lot about ourselves, and our relationship with the natural world, by watching what was about to happen next.

Astonishingly, from November 2012 to January 2013, we witnessed both Faith and Spirit caring for their heavily

153

handicapped daughter by constantly bringing her food and giving her a lot of social support, including resting in contact with her during inactive periods. Sunshine was not able to get her own food, so the family stepped in and took over.

But not all of the wolves knew what to do next. G.B., who had grown up in size and had become one of the most beautiful wolves we'd ever seen, seemed confused by all the hectic commotion taking place around him. Sometimes he showed up on the BVP all by himself and wandered about aimlessly. We could see in his eyes that he didn't really know what was going on. A conservation officer stopped and took a picture of G.B. in the middle of the day and, we have no doubt, returned to the office to report the "habituated wolf" he had seen on the road. We believe that incidents like these are examples of how rumours get started in Parks Canada offices regarding habituated wolves that need to be hazed or aversively conditioned. The real circumstances of the behaviours shown by wolves is there to be discovered, but Parks has continued to show an unwillingness to put in the time on long-term behaviour observations to figure out what's really going on.

Meanwhile, thankfully the adult wolves knew what to do for Sunshine. For instance, on the morning of November 23, we observed all five able-bodied wolves travelling downhill with full bellies toward the Bow Valley. Somehow and somewhere they had either killed something or found a carcass to eat. Hours later, we watched them gather at the Backswamp wetland in the Bow Valley, quite a distance from the rendezvous site. We briefly observed six wolves,

which meant the wolves had joined with Sunshine again. We didn't get to directly observe any of the wolves feeding Sunshine (although it likely happened, because we saw her swallowing a chunk of something after she had been approached by Yuma carrying this same chunk of what we suspected was meat in her mouth). One other thing was absolutely clear: Sunshine was not at the rendezvous site anymore!

Although the mating season had started in early December and Faith and Spirit were often occupied by their reproductive biological needs, they still kept Sunshine in mind for months on end. On December 13, at 9:17 a.m., we watched the family join again at Backswamp and saw Yuma and the juveniles play-running between some bushes as the family started to travel west. And suddenly we realized that there were six of them. Sure enough, one of the juveniles seemed to be somewhat handicapped: it was Sunshine!

However, on December 17, five wolves showed up on the Bow Valley Parkway with Sunshine missing. At this time, she was still completely dependent on their supportive actions. Faith, Spirit and her older sister Yuma continued to provide her with any support they could and continued to move around in order to find something for her to eat. That was not easy at all. There were only a handful of elk left in the Bow River Valley, nearly all of them bulls, and a steadily declining population of white-tailed and mule deer due to the continued mortalities happening along the CP railway tracks. Nevertheless, in spite of this low prey density and scattered distribution, Faith and Spirit still experienced hunting success once in awhile. Soon

afterwards, without hesitation, we saw both parents transporting food to Sunshine.

We now knew Sunshine was able to travel short distances. On December 20, we saw the family roaming around in the back of its rendezvous site. As we watched them through binoculars, we confirmed that there were six individuals and we knew that the Pipestones were once again complete. We felt relieved and happy to know that Sunshine was once again travelling with her family.

Meanwhile, Faith and Spirit, the Pipestone "icons," demonstrated to us again and again their empathy for Sunshine with their tireless efforts. On December 24, 2012, the two of them found a moose carcass along the railway. That afternoon, both of them began transporting large chunks of meat along the Bow Valley Parkway, all the way to the rendezvous site where Sunshine was waiting for her parents to arrive. Their incredibly unselfish actions were particularly remarkable given that they were now fully engaged in mating season. Unfortunately for us, we had forgotten to recharge the empty battery for our camcorder that day and missed recording much of the action. We were sure pissed off at ourselves!

Big sister Yuma got in on the act as much as possible, too, bringing mice and other rodents repeatedly to Sunshine. Considering it was the dead of winter, we could not believe our eyes when even food as tiny as a mouse was presented to the injured female.

Eventually, we were able to determine that Sunshine had suffered a broken leg in the train collision three months earlier. As she slowly healed step by step, her big sister Yuma took on the bulk of the caretaking, sometimes

Yuma often travelled as much as 30 kilometres in a day to find enough food to support her little sister.

travelling as much as 30 kilometres in a day just to support her little sister with food. We could only look on with admiration: it was a monstrous "thumbs up" for Yuma; her support in getting Sunshine back on her feet again was truly incredible. In human terms, one would probably have called Yuma a "superwoman" for her efforts. Every new day, it seemed like she was at a different place – a kill the Pipestones had made, a carcass along the tracks, an open meadow hunting mice – to help her sister eat and get better. And when she wasn't chasing down food of some sort, Yuma was often to be found at Sunshine's side, giving social support in the same ways humans do when they visit a loved one in the hospital. By mid-January 2013, Sunshine was moving around quite well and seemed to be in good health, despite still walking with a considerable limp.

By mid-February 2013, the Bow Valley was full of snow and had been through several deep freezes, yet Sunshine had survived it all. After three months of extraordinary,

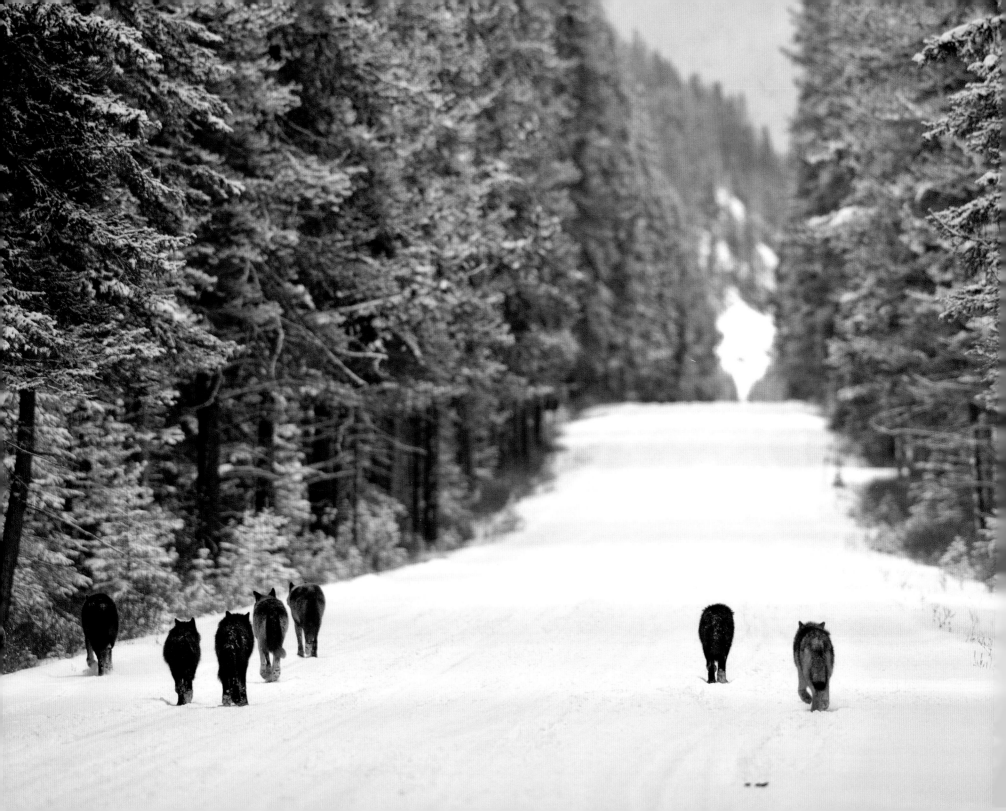

tireless work by the adults in the family, the Pipestones could have proudly pronounced "mission accomplished." A once nearly completely crippled Sunshine had finally made it and was back travelling as an integral part of the family unit.

Only three weeks later, on March 13, 2013, we joyously watched from afar as Yuma, Spirit and Sunshine played a game of tug-of-war over what appeared to be an old bone at one of the family's favourite hangouts, Backswamp. At 7:05 that morning, we watched all six wolves rally in the middle of the frozen swamp. Most importantly, Sunshine was playing again and did not appear to be limping anymore.

We will never forget that early morning, watching the family together once again in a playful, socially relaxed atmosphere. We could see and feel that despite all the losses the Pipestones had mourned in 2012, their socio-emotional structure was still intact. They had made it through an extraordinarily trying year. In order to survive, though, the wolves had to travel a lot. Finding enough vulnerable ungulates within their huge territory was always a challenge. Sometimes we wondered how many kilometres they actually were covering per day. Additionally, we were curious to figure out how fast Faith and Spirit were leading their family members through the Bow Valley.

Based on our measurements via GPS coordinates, the wolves were capable of covering up to 60 kilometres a day, at an average speed of 8.6 km/h. If they were hunting, their average travel speed increased to 10.4 km/h. Of course, the Pipestones were used to travelling on or near the BVP like all the other Bow Valley wolves before them, where they could take advantage of snowplowed pavement, perfectly manicured cross-country ski trails or plowed utility lines. And who can blame them when the alternative was to plow their own path through chest-deep snow? What we have observed in winter, though, is that when the wolves do walk through deep snow in travel formation, it's usually a younger wolf that will lead the way, essentially providing an "energy-saving path" for the older wolves that make the most targeted decisions and take over the actual initiatives. Before a hunt was to take place, though, the older and experienced wolves, like Spirit and Faith, were often found in a central group position when travelling through deep snow toward a selected ungulate.

An Example of Empathy from the Past

Sunshine's recovery with the help of her family members is an amazing story, but is a story like hers a regular occurrence in the wolf world? In other words, is it the exception or the rule? When we look back at our research, our story about the emotional lives of wild wolves began in the summer of 2001. An unforgettable male we named "Yukon" was rolled over by a truck on Highway 93 South but somehow survived the accident. Naturally, we were concerned about Yukon's health and whereabouts, but in the end he managed to recover. It's how he recovered, though, that offered us our first incredible glimpse into the world of wolf emotions.

At the time, we were working in partnership with the Central Rockies Wolf Project and it provided us with our first opportunity to see first-hand how a wild family

Wolves regularly take advantage of plowed roads and easy, man-made, walking routes like railway tracks or manicured cross-country ski trails.

157

Viewing wolves is best done from inside a vehicle pulled safely off the road.

dealt with an injured member. To make a long story short, Yukon could barely walk after getting hit, but his mother Aster kept him company and supported him socially. She did not leave his side for weeks while his father Storm and sister Nisha kept busy transporting food regularly back to both Aster and Yukon.

From our standpoint, those wolves were clearly caring for one another by displaying compassion and empathy, as well as by putting other individuals before themselves. Storm and Nisha could have left seriously injured Yukon behind but instead brought him food in the form of chunks of meat, legs of different ungulate species and even whole Canadian geese. We witnessed extraordinary care, cooperation and what can only be described as "kindness" in Yukon's full recovery. It taught us that while wolves are and always will be socially competitive large carnivores, that is only one side of the coin; they can also show us what emotional intelligence really means.

The lesson to be learned from these stories is that wolves can be very powerful teachers if we allow them to be. Over the years, we have been privileged to be able to document several different wolf families that have displayed empathy for wounded group members. In fact, we have seen nine different instances of empathetic behaviour with injured family members over the course of our project.

We have concluded that what once could have been described as a coincidence or, for that matter, as a single, overemotional anecdote with no biological consequences, is actually quite typical wolf behaviour. Wolves do show empathy for injured individuals in their family; it's now a given, not a coincidence or a tall tale. And after having observed and researched the countless unselfish actions of so many different wolves and their highly social collaboration skills during the "bad days" in life, and discussing our findings with wildlife behaviour experts coming at the issue from so many decidedly different perspectives, we would argue that the empathic and ethical standards of some wild wolf families could actually be interpreted and understood as a kind of "biological evolution." Whether or not there will be a continued evolution of these traits in the future remains to be seen.

Another important lesson to be learned is that every park visitor should show some respect for wildlife and follow these important recommendations for driving in the national parks:

- Do not speed: this is the most important thing for visitors to remember when driving along the roads in Banff National Park. Please observe the posted speed limits and slow down significantly if you see wildlife. Be prepared to stop when necessary. There are animal mothers and fathers out there who don't like their kids getting killed.

- When viewing wolves or other wildlife, every responsible park visitor should feel absolutely obligated to make every effort to do so within the infrastructure of the Bow River Valley from a safe distance by staying in the car with the engine off. Stay quietly in your vehicle to reduce potential disturbance. And please stop when you see a wolf or several wolves crossing a road and wait for several minutes after they cross to ensure there aren't more wolves coming.

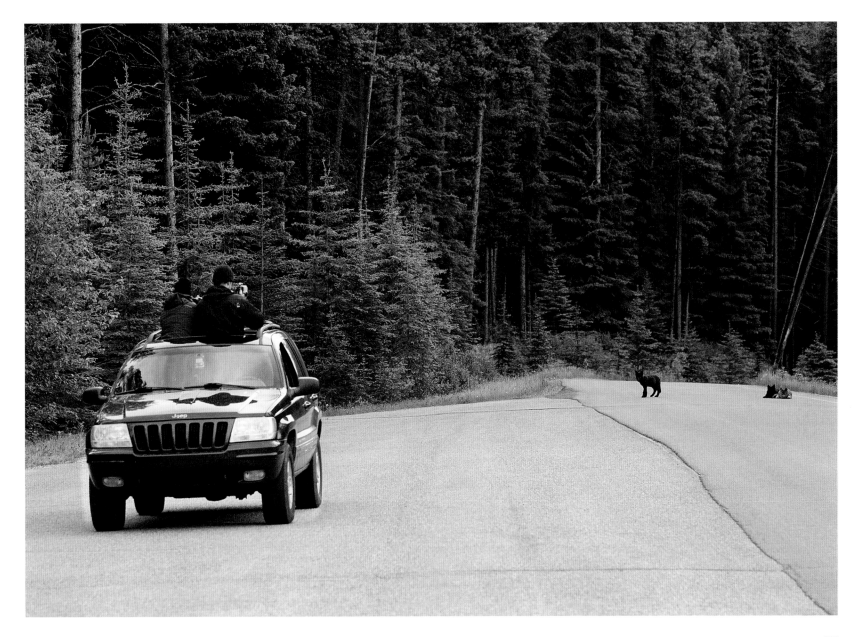

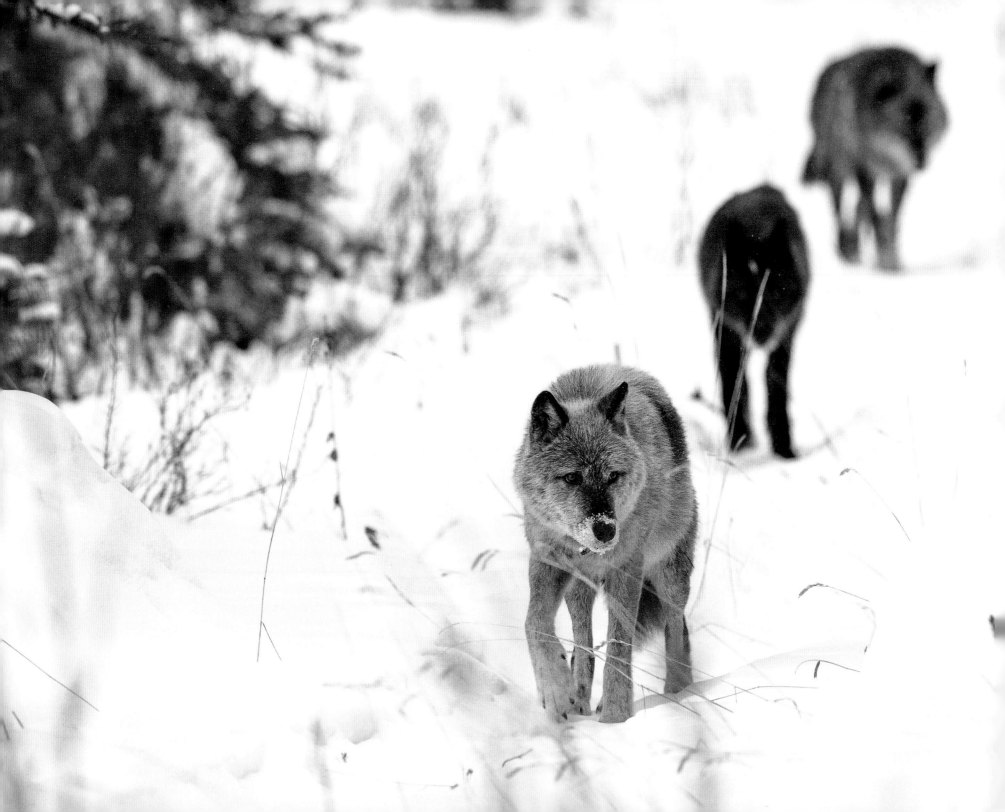

Faith leading the family through Hillsdale Meadows in December 2013. Sunshine is directly behind her, with Spirit third in line.

The Slow but Unstoppable Fall of the Pipestones

The year 2013 did not start out very well at all. In late January, Karin and I were sitting in our SUV, watching the wolves as we usually did (nearly all of our fieldwork occurred from our SUV, because, like dogs – which are able to distinguish between the automobile of their owners and any other car by smell, sight or sound – the Pipestones had developed adaptive strategies to tolerate our specific SUV without becoming too habituated toward cars in general). That morning, Faith and Spirit had spotted our car from an opening in the forest and were scent marking on some mounds of snow. Trickster and Yuma were hunting mice along the road and playing.

All of a sudden, while waiting near a crossing location along the road, I got a strange feeling and felt like a thousand needles were running through my veins. It turns out I was having a heart attack! Thankfully, Karin had the wherewithal to grab some aspirin and forced me to swallow two pills right away. She likely saved my life. The heart attack eventually landed me in a Calgary hospital, where I had several stents installed later that day. I don't think I can ever properly describe just how scared I was that day.

The recovery process meant a change of lifestyle: no driving for four weeks, no stress, no observing wolves and, worst of all, no smoking. In fact, the cigarette I had the morning of my heart attack was my last one – ever.

During my convalescence, my wife Karin went out on a daily basis and did all of the intensive observation work herself. Of course, our dog Timber was with her all the time. Within four weeks, we were both back in the Bow Valley, happily watching "our" wolves, smoke-free for the first time. We like to think the wolves were totally surprised to see and, even more importantly, to smell the German sitting in his SUV without a cigarette in his hand.

Almost right away, the Pipestones crossed the road in front of our car and, voilà, we were back in business – the "observation business." A few minutes later, the family started heading toward the railway and, it being early mid-February, we were excited to see Faith and Spirit looking like they were closely bonded, displaying nuanced courtship behaviour. For the fifth time, it appeared they were mating in the Bow River Valley – good news, indeed.

Wolf Watching as Good Medicine

Being back on the wolf front was wonderful. Although we didn't anticipate there would be any further health complications as a result of our work, we got back into it slowly and cautiously. In fact, rather than impede my recovery, watching wolves turned out to be the best medicine I could have asked for. On February 5, 2013, we watched the Pipestone family chasing an elk. It was a spectacular treat. And, as usual during that time of the year, we weren't surprised that pregnant Faith did not take part in the hunt. The next morning, we saw the two parents standing on the BVP at 9:00 in the morning with giant, full bellies, so we knew the hunt had been successful.

After the wolves had finished off the carcass, they were on the move again. Back on the BVP, they continued on their way undisturbed. How do we know they were feeling undisturbed? First, nobody was there other than us. Second, 20-plus years of observation experience had taught us unequivocally that regularly observed wolves do not respond negatively to parked cars, especially to our parked car because we always left them space to roam freely. Douglas Smith, who has worked for decades on the wolf project in Yellowstone National Park, wrote, "Anticipating wolf travel and retreating or getting into a vehicle are ways to prevent encounters and avoid blocking wolf travel routes."[7]

That morning, we were absolutely sure the wolves each individually recognized our SUV, because even shy Trickster didn't take his typical detour around our vehicle. He just casually sauntered by with neutral body language and

7 National Park Service, *Management of Habituated Wolves*, 10.

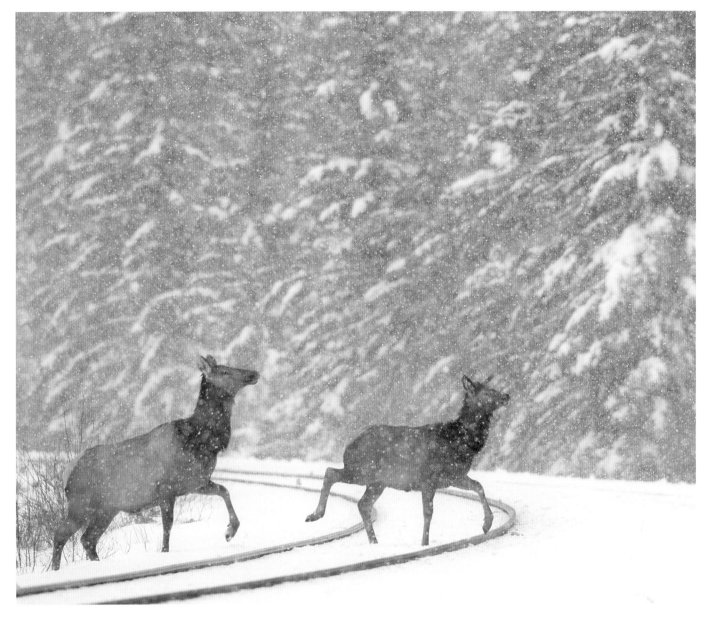

Parks Canada officials conveniently ignored the ongoing slaughter of wildlife on the roads and railways each year and placed the blame for the lack of wildlife in the Bow Valley primarily on the wolves.

without displaying the slightest nuance of avoidance or flight behaviour (Trickster didn't yawn, either, which is a good stress indicator with wolves; if you see a wolf yawning, it means that your presence is causing it stress). By comparison, when we had watched Trickster around other cars, even parked ones with their engines turned off, he would often take a huge detour around them.

On February 27, 2013, at 7:15 a.m., Faith, Spirit, Yuma, Trickster and G.B. were all sleeping in the middle of the BVP, their bellies full. None of them were paying any attention to us as we filmed them from our car, which was about 100 metres away. At 7:33, Spirit got up and slowly trotted along the road. The rest of the group didn't pay any attention at first, but four minutes later, Yuma got up, too. Trickster, G.B. and Faith continued to lie lazily on the road until 7:49, at which point G.B. got up, stretched and urinated standing up. Finally, at 8:13 a.m., nearly an hour after we had first observed them sleeping in the road, an SUV flew by and forced Faith to get up. It chased all of the wolves away from the road. That morning's scene was a perfect example of roughly one-third of our behaviour observations of the Pipestones: the wolves behaved completely naturally while we observed them quietly and respectfully, but then they were disturbed by a totally disrespectful motorist. From when we first saw the Pipestones back in 2009 up until the day of my heart attack, we had carried out 997 observations on one or several wolves, of which 392 (39 per cent) involved the wolves being disturbed by other people.

We actually observed the wolves sleeping right on the road often. To us, this was a perfect example of their

adaptive behaviour capacities. And before anybody starts arguing again that "habituated wolves are potentially dangerous to people," here are the facts: during our entire project with the Pipestones, we did not observe a single case of a wolf approaching a human displaying threatening or predatory body language or being aggressive. Not once. This was a big deal for us, because as our observations had indicated, none of the wolves had become habituated

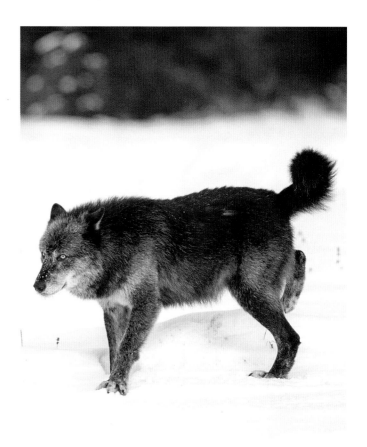

to people, despite encountering humans on a daily basis! Yes, the wolves had adapted to living near humans, but as we have explained, there is no link between the Pipestone wolves' visual appearance on roads and around parked cars and the wolves being a potential danger to humans.

Winter 2012 – 2013

For several years up to and including the winter of 2012 –2013, we had been involved in Dr. Mike Gibeau's Carnivore Monitoring Project in the Canadian Rockies. Our fieldwork was part of a long-term initiative to investigate the effects of human activities on wolves and wolf behaviour patterns in Banff National Park.

Yet, in 2013, we were in for a shock. As the year progressed, we realized that we had never seen such desperation from the adult members of the Pipestones regarding their ability to adequately feed everyone in the family.

However, in March 2013, it appeared to us that things were looking good. The age and sex ratio of the family hadn't changed, and Faith, Spirit, Yuma, Golden Boy, Trickster and Sunshine all seemed to be doing well.

Other than my heart attack scare, we had been observing the family and their activities for seven days a week just like we always had. That particular winter, we had focused our observations once more on the Pipestones' leadership behaviour, their scent-marking behaviour and their submission behaviour, cataloguing how often each subordinate family member would submissively approach their parents, Faith and Spirit.

Table 4.1 shows the number of times each Pipestone wolf was observed in a frontal leadership position between October 2012 and March 2013 along the Bow Valley Parkway.

The flexible leadership behaviour shown by the table could have been a consequence of Sunshine's injury for

Table 4.1 Leadership Positions along the Bow Valley Parkway, October 2012 – March 2013.

Leadership	Spirit	Faith	Yuma	G.B.	Trickster	Sunshine	Totals
October	11	9	7	7	0	6	40
November	13	8	6	9	0	0	36
December	17	22	4	5	2	0	50
January	12	25	3	2	3	0	45
February	11	19	10	2	0	2	44
March	29	27	14	8	0	5	83
Totals	**93**	**110**	**44**	**33**	**5**	**13**	**298**

much of the period studied. Faith had been observed leading the group more than Spirit while she has in heat during the mating season. Yuma and the two juveniles, G.B. and Trickster, were usually ahead of the group in order to stay away from Faith and Spirit during the mating season. And Yuma was often not a part of the travelling family while she was looking after her injured sister Sunshine.

Table 4.2 shows the number of targeted scent markings with urine (n = 125) and the number of overmarkings with urine (n = 103, shown by the numbers in parentheses) of each wolf while travelling along the Bow Valley Parkway between October 2012 and March 2013.

Besides the wolf parents, Spirit and Faith, who directed their urine at specific targets by scent marking,

Table 4.2 Scent Marking and Overmarking along the Bow Valley Parkway, October 2012 – March 2013.

Scent Mark	Spirit	Faith	Yuma	G.B.	Trickster	Sunshine	Totals
Spirit	—	59 (52)	6 (2)	0	0	0	65 (54)
Faith	48 (41)	—	3 (1)	0	0	0	51 (42)
Yuma	6 (4)	3 (3)	—	0	0	0	9 (7)
G.B.	0	0	0	—	0	0	0
Trickster	0	0	0	0	—	0	0
Sunshine	0	0	0	0	0	—	0
Totals	**54 (45)**	**62 (55)**	**9 (3)**	**0**	**0**	**0**	**125 (103)**

Table 4.3 Active Submission Exhibited by the Pipestones, October 2012 – March 2013.

Dominant	Spirit	Faith	Yuma	G.B.	Trickster	Sunshine	
Submissive							Totals Submission
Yuma	31	48	—	0	0	0	79
G.B.	29	36	17	—	0	0	82
Trickster	42	39	21	16	—	0	118
Sunshine	38	36	22	11	7	—	114
Totals Dominant	**140**	**159**	**60**	**27**	**7**	**0**	**393**

overmarking and ground scratching within their core territory, as well as along the periphery of the territory, only yearling Yuma was ever observed scent marking. And when she did, one-third of the time either Spirit or Faith were observed overmarking Yuma's territorial efforts.

Table 4.3 shows the instances of active submission exhibited by the adult and juvenile family members of the Pipestones while approaching their parents Faith and Spirit (and all the other wolves in the family) between October 2012 and March 2013.

Analyzing the submissive behaviour, we can see that it's not always one-directional. The fact that all young wolves submitted toward both parents, Spirit and Faith, was evidence that no strict linear rank order was in place but rather that the social rank order in this wild wolf family correlated significantly with age, *independent of gender*. Contrary to observations on captive wolves, a prominent, dominant, alpha-male status (for Spirit) was not confirmed. However, all of the submissive actions initiated by yearling Yuma and/or the juveniles fulfilled the criteria of a parent–offspring formal dominance system. In fact, in all of the interactions with the parent wolves, Yuma and the three juveniles would approach in either a submissive, low-body posture or, at the very least, would approach in an extremely friendly greeting mood.

Similar to the results we had collected via direct observation of other wild wolf families, the formal dominance system of the Pipestones was characterized by daily family gatherings, including greeting rituals, chorus howling rituals and communicative rituals of interactions and play. Finally, it was evident that all of the subordinate group members accepted the high social status of Spirit *and* Faith, regardless of gender and their agonistic dominance relationships, even though the parents were already nearly 8 years (Spirit) and 7 years (Faith) old (and had started limping on occasion).

Looking "Behind the Scenes" in Early Spring 2013

By systematically checking, we began noticing that the wolves' scats along the road contained more and more traces of mice and other rodents and fewer traces of large prey species. By April 2013, the elk population along the Bow Valley Parkway had dropped to an all-time low of a dozen or so.

As it always had, the Pipestones' core territory in the valley consisted of interspersed wooded areas, as well as a lot of open slopes, meadows, grasslands, swamps and other open spaces. In the past, we had been used to seeing an abundance of wildlife in these areas.

Unfortunately, by the spring of 2013 the good old days of abundant wildlife were long gone along the BVP: mule and white-tailed deer, bighorn sheep, coyote and even snowshoe hare numbers were all at historical lows, just like the elk. Raven activity had slowed to a crawl, and even most of the Columbia ground squirrel colonies along the parkway had disappeared or shrunk dramatically. The only species not in decline was moose, which was making a comeback in areas like Moose Meadows by taking advantage of the lack of elk they had to compete with for food.

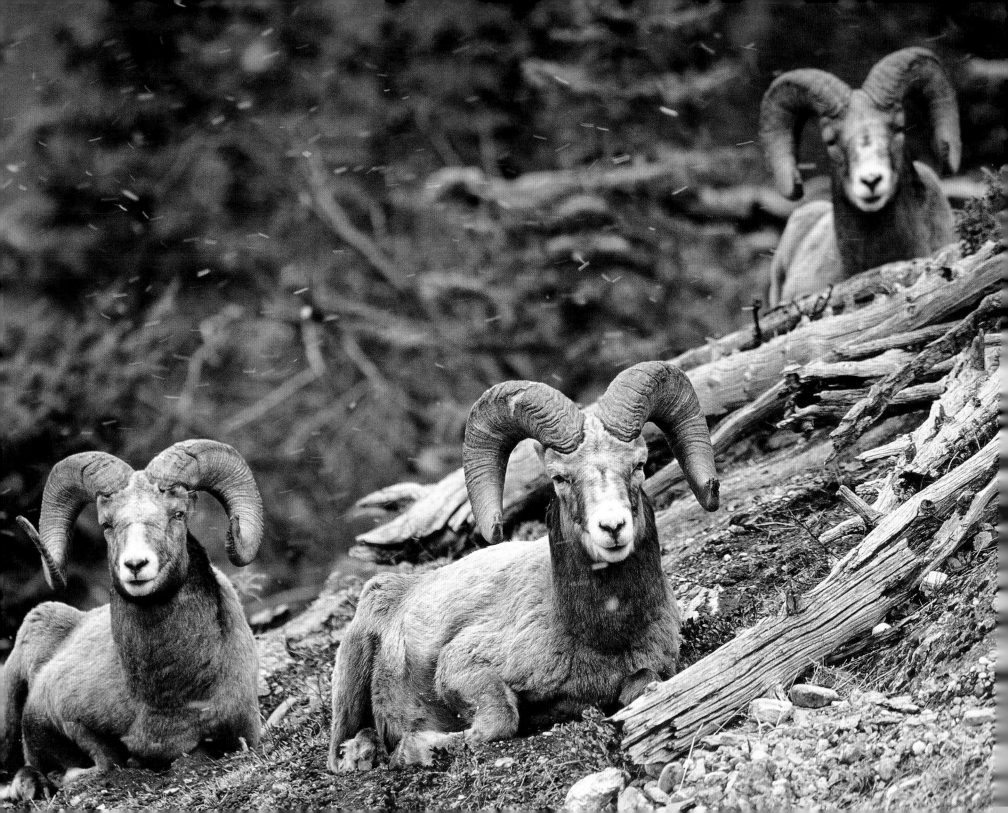

The situation was so dire that several critical articles and comments from concerned residents of the Bow Valley appeared in local newspapers, including the *Rocky Mountain Outlook*, regarding the unacceptably high numbers of wildlife deaths in the valley. We had seen this catastrophic development of a crashing ungulate population coming for a long time.

With less wildlife than ever before roaming the Bow River Valley between Banff and Lake Louise, one would have thought that wildlife management practices would adapt. Yet the opposite was true. Critics were harsh locally, nationally and internationally, yet, if anything, the management decisions in the Bow Valley started to lean even more heavily toward development and commercialization than ever before. The Banff public relations machine kept on rolling, as evidenced by the park's "Awesome Banff" marketing campaign. This aggressive campaign was even shown in advertisement spots on CTV and Global TV on a daily basis.

Meanwhile, we watched in horror as more and more tourist events were approved by Parks Canada for the Bow Valley and Banff. Biking races, ski events, marathons and more were organized right through the heart of the Pipestones' home. In fact, most of these events went right by the den site and the wolves' favourite rendezvous location. And, as usual, the environmental assessments for each of these new events always seemed to come to the same ridiculous conclusion: the impact on wildlife was negligible. What a waste of taxpayers' money.

"The dot on the *i*," as we say in German, was when we became aware of a statement published in a local newspaper that blew us away. We were astonished to read a statement by a biologist affiliated with Parks Canada who was quoted as saying the Pipestone wolves "had eaten themselves out of the valley." This was the most absurd, incompetent comment we had read in decades. At the same time, several park managers were placing one-sided blame for the lack of wildlife in the valley primarily on the wolves, without mentioning their own decisions to remove and cull elk in the valley and without a single remark regarding the ongoing slaughter that took place on the roads and railway each year (though some of the road mortality had been mitigated in recent years by the highway fence on the Trans-Canada). We were so stunned we didn't know what to think. Was this just another one of their "inventive" PR strategies to lay down a false scent away from all the problems that mass tourism and transportation had been causing in Banff for decades?

The Lives of the Pipestones in Summer 2013

In the spring of 2013, we were kept busy measuring the enormous distances that the Pipestones were travelling within the Bow Valley in order to find any food at all. By using a transportable GPS unit, it became obvious that the wolves were travelling nearly twice the number of kilometres per day that spring versus what they had averaged in 2010 and 2011.

In general, our observations determined that the wolves' hunting and scavenging efforts in the Bow Valley weren't very successful. And during the month of April 2013, Spirit was limping badly. In fact, most of the family

The "good old days" of abundant wildlife along the Bow Valley Parkway were long gone by the spring of 2013. This group of bighorn sheep rams was photographed at Bighorn Split in April 2002.

Wolves do not live in groups because they hunt together. They do so because they are highly social creatures with great communication skills. The less social- and habitat-related stress there is, the more wolves play.

members did not appear to be in good shape, possibly a result of several long, risky, strenuous early-spring expeditions into the backcountry (up the Pipestone Valley and the Sunshine Valley).

Then, on April 5, 2013, Golden Boy was killed on the Canadian Pacific tracks near Muleshoe. Once again, we were devastated at the news of losing one of our favourite wolves, particularly this engaging 1-year-old. And, again, we wondered aloud why no one was doing anything about the ongoing carnage on the CP tracks. We couldn't understand why Parks Canada continued to praise its "historic" partnership with CP instead of putting pressure on the corporation to clean up its "grain issue" (the constant grain spills along the rail tracks) and force them into voluntarily reducing train speeds in the parks. While news releases and official statements from Parks Canada regurgitated the same old message about how "everything possible was being done to reduce wildlife mortality," the sad reality was that far too little was being done (and is being done) by either Parks Canada or Canadian Pacific to address and solve this devastating mortality issue.

On April 11, 2013, we watched Yuma and Trickster hunting mice in the rendezvous location for almost half an hour. When they were done hunting, they joined Sunshine and Spirit and the four of them showed up at the den site later that morning. From that day on, we rarely saw Trickster anymore. Meanwhile, Faith was in the den and although it was clear that she had given birth to pups sometime in mid-April (we had seen her prominent nipples), by April 25, she was back on the road again

unusually early with Spirit. Late that evening, we watched the two of them travel along the parkway all the way east to Backswamp, almost 13 kilometres away from the den site. We did not see any other wolves with their parents and we wondered why they weren't. To our relief, two days later we saw Yuma and Sunshine near the den site.

Unfortunately, the number of local photographers chasing the wolves had increased dramatically, in large part because both Yuma and Sunshine travelled a lot on the BVP. For example, on April 30, we watched half a dozen photographers follow Yuma early in the morning while she trotted on the side of the road.

During this time, Spirit started acting much more cautiously and discreetly, sneaking in and out of the den to ensure he didn't get noticed by all of the people. Whenever possible, we documented his movements with our video camera from a distance, but more commonly we were recording Yuma and Sunshine. In late May 2013, the ravens tipped us off to the locations of two kills (both ungulates) near the Bow River. It was great news for Faith and her new pups. From what we saw, her two daughters brought most of the food back, though on May 30, 2013, we also observed Spirit transporting the hind leg of a mule deer buck toward the den location.

Play as an Important Part of Social Stability in Wolf Families

Previously in this chapter, we hinted at the fact that we believed the Pipestones were experiencing a decrease in their quality of life in the spring of 2013. And when we got

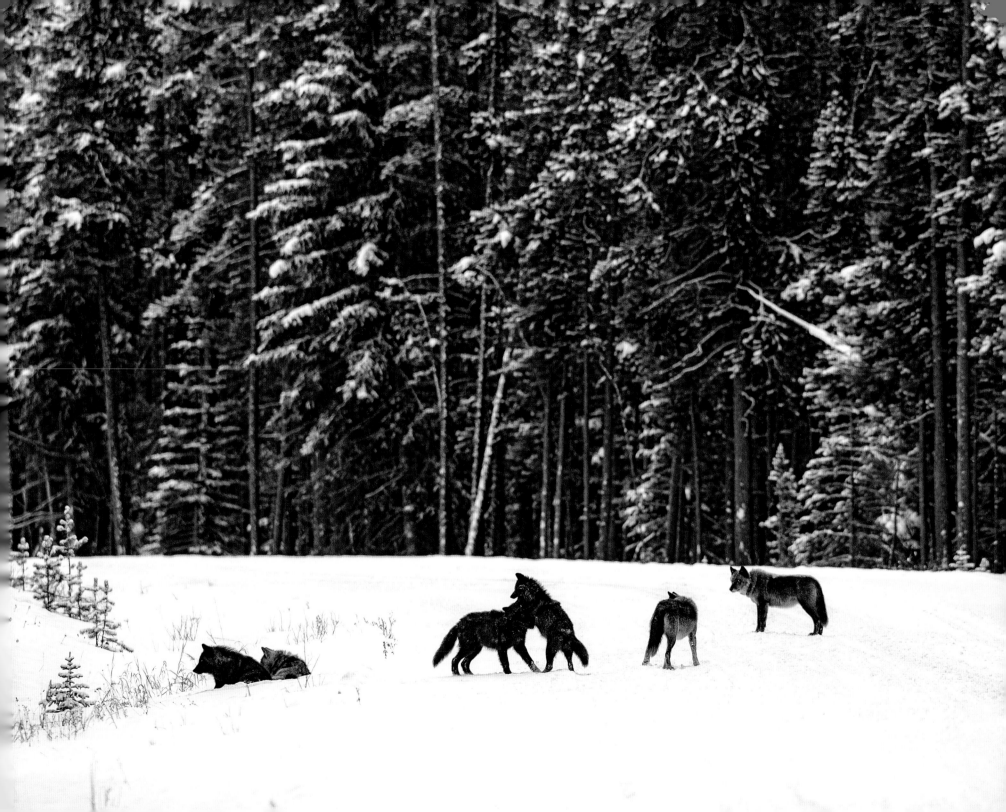

Clockwise from top left: Social play is one of the many different types of play activity among wild wolves.

Play predation is another one of the main types of play activity.

Blizzard play-running in Hillsdale Meadows.

Blizzard tosses a mouse to herself with Chester looking on.

8 Käufer, *Canine Play Behavior*, 141

an opportunity to analyze our observation data on their interactive relationships and were able to compare the number of play sessions of that winter and spring to all past periods at the same time of year, it became obvious that the wolves were indeed experiencing a drop in their quality of life.

Let's revisit something quickly before we get into our observations. Let there be no doubt that wolves do not primarily live in groups because they hunt together. They do so because they are highly social creatures with great communicative skills. Their intense social play, play-runs and play-wrestling allow them to learn from each other's habits, intentions, moods and momentary "opinions." The less social and habitat-related stress there is, the more wolves play. And in order to get into a playful mood, mammals need both a socially and environmentally relaxed atmosphere. Every decent pet owner on earth knows this all too well.

However, the Pipestones seemed to have a real problem on their hands in 2013 in finding a stress-free environment. They had been dealing with a lack of prey, Sunshine's horrific injury and recovery and all of the increased attention from photographers and tourists along the BVP.

In March 2013, despite the fact that Sunshine was fully healed, we noticed Yuma and the three youngsters had stopped playing. Immediately, alarm bells went off for us. Youngsters *need* to play a lot. Without regular opportunities to develop strong socio-emotional bonding and relationships and, most importantly, a sense of "fair play" (in order to reduce aggressive interactions), wild wolves definitely are not capable of doing what they do best: living a

social, and mostly peaceful, life that includes a lot of tolerance, wisdom and negotiation in combination with moral and ethical standards.

What Is Play All About?

Although there is no such thing as a "play instinct" or "play drive," there are separate play systems that can be observed in young wolves at different times during their social development. Besides social play, play predation, play-running and playing with objects (including "tug-of-war") can be regularly observed among wolf pups. We have argued for some time now that a lack of play in social terms inevitably leads to a dysfunctional group behaviour system. As renowned behaviour expert Marc Bekoff was quoted in Mechtild Käufer's book *Canine Play Behavior*, "What could be a better atmosphere in which to learn about the social skills underlying fairness and cooperation than during social play, where there are few penalties for transgression?"[8]

Play and the associated learned behaviour flexibility have their benefits in wolf societies. In the winter of 2001 – 2002, we documented the relationship and direct link between a decreased amount of play and an increased amount of conflict (i.e., a dramatic change in social notification and peace) when we reported the social disintegration of the Fairholme wolf family to Parks Canada. Unfortunately, after having described the stress overloads and the nontypical social separations we witnessed in the Fairholmes, together with all of the events that negatively impacted the family members in terms of fitness and

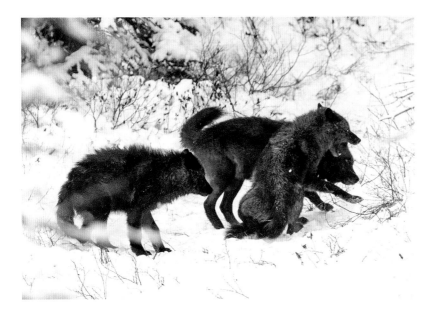

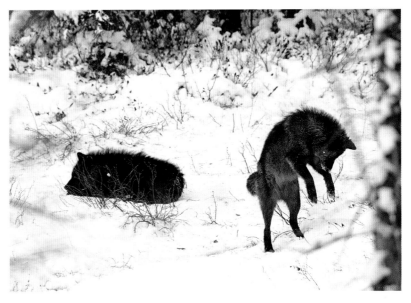

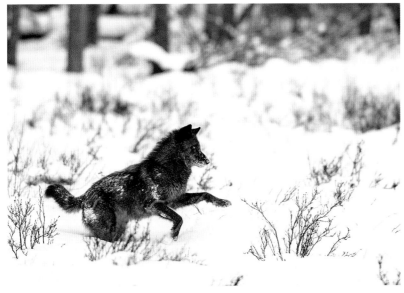

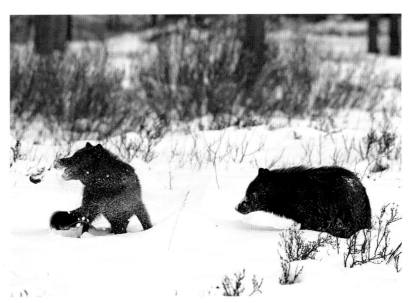

survival, some Parks Canada wildlife managers laughed at us and called our arguments "a stretch of logic." Instead of taking the fact of fewer observed play sessions in the Fairholme wolf family seriously, park managers ignored it completely and continued to cull and relocate "town elk." What kind of "logic" was that?

Every behaviour has its consequences, and as a result of all the elk relocations and cullings, the predator–prey system that had functioned so well around the town broke down completely, and food deprivation led to even more stress for the Fairholme wolves (interestingly, the Fairholmes almost immediately changed their territory and have never come back to prey on town elk in the 14 years since). Truthfully, having to sit and watch the Fairholmes fall apart before our eyes because of reckless management decisions made by park managers who were ignoring the feedback we were giving them made us angry and left us entirely disillusioned with Parks Canada long before we ever met the Pipestones.

One can't deny the fact that the more complex the social group behaviour of an animal, the longer its juvenile development phase is dominated by play initiatives. This is definitely true for wolves. In particular, juveniles and yearlings put their hearts and souls into play. Interestingly enough, they do so even though play consumes time and energy and entails some risks.

More stress means less play and less play means more social instability. So as we sat there watching things unfold in 2013, we realized that history had started to repeat itself. Comparing our field notes on the Pipestones' group play behaviour in the first months of 2013, we discovered that

G.B., Trickster and Sunshine statistically had been playing 40 per cent less than their same-aged brothers and sisters in prior years. In order to understand the socio-emotional background on the voluntary activity of social play, one has to speculate on what "ordinary social life" means without it. Nobody knows for sure how much play is enough play. What we do know, though, is that play is the glue that keeps a wolf family functioning.

The only good news we could take from the start of 2013 was that by March, 1-year-old Sunshine was doing really well physically.

A Change in Leadership

By June 2013, we guessed that Faith was already more than 7 years old and that her lifelong partner Spirit was over 8 years old. The pair of them had repeatedly been seen using the BVP for three weeks, suggesting that both of them preferred the easier travel on the road because of their age. That particular year, it was considerably less strenuous and more energy-efficient using the road than travelling through the wooded terrain of the valley, which was either flooded or muddy after the tremendous amount of rainfall that had occurred in June that year. When searching for food without Spirit, Faith usually teamed up with Yuma, while Sunshine was left hanging out with the new pups.

It gradually became obvious that the old and wise guy, Spirit, wasn't as interested in family-oriented social work as he had been in the past. A lot of his jobs as a leading male had already been taken over by Faith. By this point,

Spirit had become infirm and still had that bad limp that looked as if it had turned into a permanent problem. We believe that Faith had noticed Spirit's health problems and was concerned that her mate was "overdoing it." Of course, such an emotional statement could be considered to be a bit over the top when it comes down to what wolves are actually capable of, but what we are trying to describe is our great respect for Faith for the many attempts she was making to "keep the family business going."

During that spring and summer, Faith had become the central figure and driving force of the Pipestone family. Compared to the years 2011 and 2012, Faith "dominated" nearly all group dynamics, initiating more group departures, group rests, rallies and changes in travelling directions than ever before. She almost always led Spirit, Yuma and Sunshine while travelling on the Bow Valley Parkway.

A typical lineup while the group was travelling was observed at 7:36 a.m. on June 3, 2013, when Faith was in the front, followed by Yuma and Sunshine, then, lastly, Spirit. This formation didn't change at all until the Pipestones were out of sight 23 minutes later.

Faith's headstrong actions and initiatives in formal dominance were simply stunning. Spirit, on the other hand, initiated far less than before and became reactionary to Faith's initiatives. Between May and June 2013, we had made a total of 89 direct observations regarding the Pipestones' formal leadership.

Figures 4.1 through 4.5 show decision-making and initiative behaviour of the Pipestone wolves, specifically the percentage of times each adult member of the Pipestone family initiated group departure, group rest, a rally, a change in travel direction and group leading.

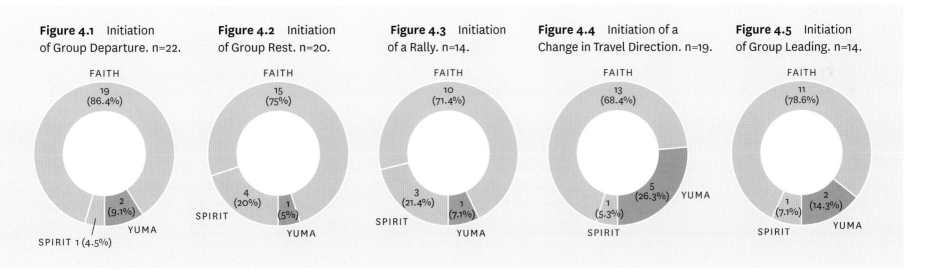

Figure 4.1 Initiation of Group Departure. n=22.

FAITH
19 (86.4%)

2 (9.1%) YUMA

SPIRIT 1 (4.5%)

Figure 4.2 Initiation of Group Rest. n=20.

FAITH
15 (75%)

SPIRIT
4 (20%)

1 (5%)

YUMA

Figure 4.3 Initiation of a Rally. n=14.

FAITH
10 (71.4%)

3 (21.4%)

SPIRIT

1 (7.1%)

YUMA

Figure 4.4 Initiation of a Change in Travel Direction. n=19.

FAITH
13 (68.4%)

5 (26.3%) YUMA

1 (5.3%)

SPIRIT

Figure 4.5 Initiation of Group Leading. n=14.

FAITH
11 (78.6%)

1 (7.1%)

2 (14.3%)

SPIRIT

YUMA

A Black Bear Near the Rendezvous Site

Starting at the end of June 2013, we began preparing sociograms (a graphic representation of social links between individual wolves) and ethograms (as explained previously, catalogues of behaviours exhibited by each wolf) near the family's favourite rendezvous location. By recording what was occurring in the current situation and comparing it with our information collected in the past, it became absolutely clear that Faith, Spirit, Yuma and Sunshine were struggling to feed the six new, hungry pups: three black males, two black females and one gray female. On June 10, at 5:44 a.m., we saw Spirit standing at the edge of the road near the den site. He was still limping, but he was obviously on duty, heading out for a hunt to the west. Spirit walked 15 kilometres to Storm Mountain before we lost him an hour and a half later. We did not see him again for four days, meaning the main protector of the family was far away from the den site.

On June 17, 2013, at 6:25 a.m., a healthy-looking black bear wandered directly into the wolves' rendezvous site. We watched the bear feeding on dandelions and fresh grass along the BVP for over an hour. When we got a good look at him or her from our car, we discovered that it had some sort of open wound on its left shoulder. Eventually, the wolves caught wind of the bear and approached it.

Faith showed some eye-stalking behaviour at the same time that Yuma and Sunshine were running at the bear from opposite directions with their hackles and tails straight up. The two younger females stopped short of the bear and started to bark. These proactive moves were intended to scare the bear away from two pups, which by now were running back toward the den site. Faith took the defense of the core area a step further, attacking the bear without hesitation. She grabbed its back and shook its fur in a fury. The single strike was enough to convince the bear to get out there as fast as it could. During this confrontation, "girl power" had been enough without the direct involvement and help of an alpha male.

The three females didn't follow the bear but instead made a great show of sniffing the ground all around where the bear had been feeding. Faith and Yuma started scent marking, too. Spirit soon appeared and joined in immediately in the scent marking. Both Spirit and Faith over-marked several times, then both started scratching the ground repeatedly. By the time the whole song and dance of reclaiming their territory was finished, we had documented Spirit scent marking ten times and Faith over-marking Spirit's scent marking spots eight times. Yuma had scent marked twice.

Keeping a Watchful Eye in Summer 2013

In the past, we had always been told that park personnel would not be observing wolves, except coincidently. So it was a great surprise when not just one but several park representatives started showing up at the parking lot near the Pipestones' den site regularly near the end of June 2013. These representatives spent an excessive amount of time scouting for wolves, both in the morning and afternoon. It was a complete joke – photographers and Parks Canada associates alike tried to figure out where the pups were

by driving forwards and backwards between the den and rendezvous location to the point where their impatience was sickening. Faith and Yuma had had enough of the shenanigans.

On July 5, 2013, the wolves appeared to have already abandoned the den and rendezvous site, because we saw Faith, Yuma, Sunshine and four black pups travelling as a unit at 5:15 a.m. that morning along the parkway in the prescribed burn area eight kilometres from the den site. At 6:30 a.m., Yuma, Faith and the pups rallied in an open meadow, but unfortunately we still couldn't figure out where the other two pups were and we never did find out what happened to them. Soon afterwards, by skillfully using natural cover, Faith and Yuma took the four pups toward the Bow River, which they must have swum across, because later on we saw the wolves on the opposite side of the river.

From what we had seen, the pups had done their best while travelling as a group to imitate the behaviour of the adults. And, to our satisfaction, when they arrived at their new summer rendezvous location in the Sunshine Valley, Spirit took his job back as a hunting scout in order to find vulnerable prey. Just as they had done in the summers of 2011 and 2012, the wolves repeatedly travelled uphill toward Healy Pass.

Whenever Faith, Yuma and Sunshine crossed a road, two particularly cautious pups got left behind. These were both shy Type Bs, whereas the remaining two bold, Type A pups always managed to follow Faith, Yuma and Sunshine closely.

As we were learning what the wolves' specific knowledge

and usage of their territory (habitat usage specifics) was that summer, we became aware of the fact that Faith and her adult daughters had been operating exceptionally as an all-female unit once again, just as they had done through May and June. Spirit, on the other hand, was only sometimes a part of the family's expeditions. Although we only saw him sporadically, he was probably still acting as a hunting scout for the females and his pups as he continued to hobble around the landscape. Even though he was completely gone at times, he still occasionally carried a deer or sheep leg back to the pups, which would be waiting for him in the valley bottom. During such rare events, the

Wolf tracks in mud near Protection Mountain.

four pups muddled around him and jumped up and down enthusiastically, thrilled to greet their "daddy." But by the next morning, Spirit was always gone again.

That summer, we closely observed who was doing what, when and where and it was obvious again that the all-female unit was making a concerted effort to provide the pups with special guidance through the complicated, mountainous terrain while Spirit wasn't there. However, on September 13, 2013, a black juvenile male was killed on the railway near Castle Mountain. We never did find out how and when the wolves had gotten from Sunshine back into the Bow Valley, but once again, we found ourselves frustrated beyond belief at losing so many wolves, year after year.

Stressful Times

By September 2013, we were finally able to name and distinguish the basic character and rank-order-related personalities of the three pups that had survived the turbulent summer. There was Type A "Elaine," an extremely active and headstrong whirlwind of a personality, along with her Type B sister "Kayla," a pitiable, submissive, mentally weak, scrawny female, and their Type B brother "Tyler," a compact, remarkably tall male pup that seemed overly playful and sociable. On the morning of September 30, Faith led Sunshine, Spirit, Trickster and all three juveniles through an open meadow behind Outlet Creek. That same day, we found the wolves near Lake Louise feeding on an elk carcass. As usual, the concentration of ravens and Timber's nose had led us to the kill site. It was up on a hill

so we could watch it quite easily from a distance, sitting comfortably in our car and filming the wolves' interactions with the ravens. It was interesting to note that Trickster was back, whom we had not seen for some time.

On November 5, 2013, we watched the Pipestones travelling along the Bow Valley Parkway at 5:00 in the afternoon, with almost all of the adults exhibiting stress-related behaviour. Faith continued to lead the group for the most part along the parkway, but she was seen repeatedly licking her nose and yawning (yawning is one of the most common stress indicators for wolves and bears). Spirit also showed stress-related signals, including constant scratching, sneezing and body shaking. Yuma kept humping a lot and showing off a range of other "bad mood"-related behaviours, and even Sunshine seemed extremely stressed, constantly licking her nose and muzzle. Unfortunately, at this point, behaviour observations were only sporadic, because traffic volume on the BVP and on the CP railway had been extremely high all summer and into the fall. According to CTV News at that time, tourist visitation in Banff was up another 9 per cent. No wonder we saw more cars and people than ever before.

And, indeed, things had gotten completely out of control on the BVP and elsewhere in the park. Traffic jams had become the norm, as herds of tourists arrived to view larch stands in their golden displays. The effects of uncontrolled tourism were everywhere and parking lots were jammed to capacity for the entire length of 2013's Indian summer. As a result, when we were fortunate enough to see the wolves along the BVP, the CP railway or even the Bow River, they showed a lot more fear and avoidance

than we had been used to observing. Anyone who knew how to recognize stress symptoms in the wolves' facial expressions could easily identify them: ears flattened, constant yawning and licking, empty eye gazing, lower body postures and tails – we witnessed the full gamut of stress indicators.

It was no wonder they were exhibiting these signs of stress: vehicles were speeding all over the BVP and the roadsides were littered with visitors harassing wolves and other wildlife. We watched people camping illegally overnight in almost every parking spot along the road, and then saw the same people illegally collecting flowers and antlers or entering closed areas. In fact, the only thing we didn't see much of was a park warden or law enforcement officer doing their job.

Mobbing and Bullying as an Indicator of a Shattered Social Structure

With all the evidence of human disturbance, it didn't surprise us when we discovered that the Pipestones' social structure had been compromised. Unfortunately, one concerning aspect of this was the unusually high number of instances of mobbing that we witnessed within the family. Two-and-a-half-year-old Yuma often had to settle dispute after dispute among the juveniles by actively splitting up ugly mobbing scenes. We could see from the overstressed body language she was displaying that 6-month-old Kayla was afraid of her brother Tyler and sister Elaine because of the ordeal they were putting her through each day, mobbing and ganging up on her.

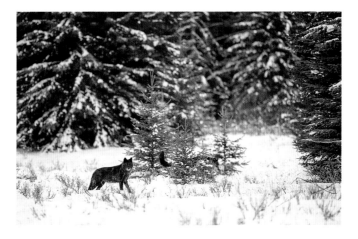

Yuma and Spirit (scent marking behind a tree) at the back of Hillsdale Meadows in late fall 2013.

Bullying or mobbing occurs when two or more wolves chase, pursue, bite or pin down an extremely submissive individual. It's essentially ganging up on a weaker individual and collectively beating them up repeatedly. However, it's noteworthy to mention that when an individual is only momentarily in a subordinate situation and is capable of fighting off the individuals ganging up on it, then it should still be considered play. Sometimes there is a very fine line between bullying, mobbing and playing, because the attacking wolves often switch quickly from social play and play-wrestling to predatory mode.

We watched Yuma insert herself into a number of nasty mobbing scenes that fall, where she showed a clear tendency to take Kayla's side as she was being mobbed, in an attempt to achieve behavioural conformity within the group. But it didn't work. Faith didn't like what she was seeing and often jumped right in the middle of the action to discipline Yuma pretty roughly. This left Sunshine

confused by her mother's agonistic actions, because earlier that summer the three adult females had demonstrated such incredible unity. By the end of the first week of November 2013, Yuma had had enough of being disciplined by Faith and left her family for good, leaving 1-and-a-half-year-old Trickster and Sunshine in charge of hanging out with the three pups. Unfortunately, Tyler and Elaine didn't stop mobbing and bullying their sensitive sister Kayla.

On November 14, Faith, Spirit, Sunshine, Trickster, Tyler, Elaine and Kayla crossed the parkway in the morning in exactly in that order. It had snowed quite a lot and the wolves decided to move along the railway instead toward their old den site near Protection Mountain. Two days later, we watched them all travelling through the deep snow before laying down for a rest in the middle of the road. Apparently, they had made a kill because they all looked content and full. Amazingly, no one else showed up and the family was able to take a break on the road for ten minutes. But this harmony didn't last long. Soon two of the locals showed up and drove too close to the wolves, causing them to get up and move into the forest.

Winter 2013 – 2014 and Its Surprises

By the beginning of December 2013, Faith was busy putting most of her social competence into trying to stay hidden from the hordes chasing her family. Spirit seemed to be doing relatively okay, but he appeared extremely frustrated, too. We had hoped that things would start to quiet down for the wolves at the start of the winter season, but that turned out to be wishful thinking. Word had gotten out that the BVP was the place to find wolves, so whenever Faith or any of the other wolves tried to cross the road, a tourist or photographer was on them and after them immediately.

We really started to notice the negative impact of social media more than ever that winter. Every time a wolf was seen and photographed, an hour later their picture was plastered all over Facebook and Twitter. We would see threads including dozens of Facebook users and wolf experts discussing where the "alpha male and female" of the Pipestones were most likely to be found, along with plenty of talk about how much all of them "love" wolves and about how wonderful it was shooting close-up photos of the wolves. By this time, poor Sunshine was the only wolf bold enough to still be observed travelling on the road with any regularity.

We found it particularly frustrating that the majority of these "wolf-loving" people were not willing to learn basic information about wolf stress-related behaviours and to consequently give the wolves some space whenever they expressed this kind of body language. We had recognized this underlying ignorance several years before that winter (which was the worst one to date) and had stopped talking to anybody along the parkway. This seemed to annoy some of the photographers, who were mad that we wouldn't tell them where to find the wolves.

Karin and I had had enough. So had John. He had actually stopped photographing the family regularly back in June 2012, since he felt his work with the wolves had become somewhat unethical: he felt he was becoming part of the problem rather than part of the solution. We

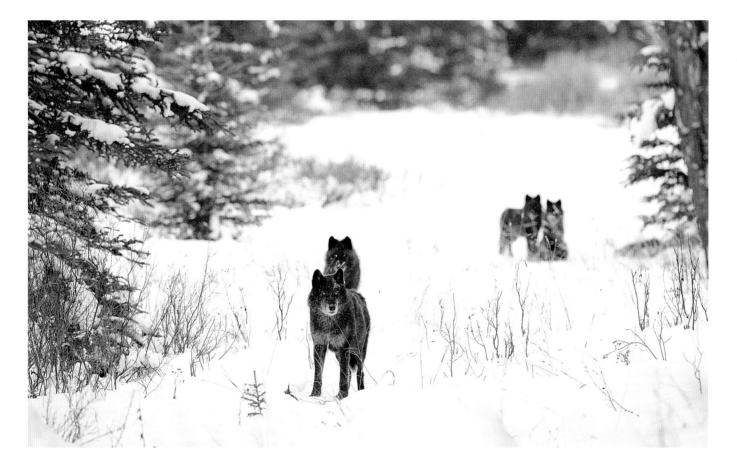

Yuma and the three juveniles, Tyler, Kayla and Elaine. Yuma briefly revisited the family in early December 2013.

realized we had reached the same point. The Bow Valley Parkway had become too busy and there was no sign that Parks Canada was going to do anything about it (it had not made a single attempt to educate the public on how to observe wildlife). In the aftermath of my heart attack, which we felt was likely due at least in part to all of the stress and frustration we had experienced dealing with this new age of wolf viewers, we finally decided to put our home in Canmore up for sale and leave the Bow Valley for good. It was emotionally hard on us, but we knew we had to do it.

Of course, our own frustration was not really the issue that mattered; it was the frustration the Pipestones were dealing with on a daily basis that was truly concerning. We were deeply troubled about their future. So far, the

wolves had somehow been able to survive the chaos that had been taking place in the valley. However, we knew it couldn't last and we no longer wanted to inadvertently show other people where the wolves were (our vehicle had become a beacon for others, who would follow us and park where we were parked).

In the early winter of 2014, things went downhill rapidly for the Pipestones. We analyzed the filtering effect on the Pipestones' movement patterns when they were chased off the BVP or the CP railway by photographers, and we documented these negatively influenced behaviours one last time.

Between early October and mid-December 2013, we recorded a total of 59 attempts by the Pipestone family to approach either the BVP or the railway, with people visually present (not in their cars). Table 4.4 shows the numbers of times (shown in percentages) one of the three group-leading wolves (Faith, Spirit or Sunshine) was disrupted by having to actively avoid humans.

Table 4.4 Active Avoidance Behaviour Shown by Faith, Spirit or Sunshine, Early October – Mid-December 2013.

Disrupted by Humans	Parkway	Railway	Totals
Faith	26 (68.4%)	15 (71.4%)	41 (69.4%)
Spirit	7 (18.4%)	2 (9.5%)	9 (15.3%)
Sunshine	5 (13.2%)	4 (19.1%)	9 (15.3%)
Totals	**38 (100%)**	**21 (100%)**	**59 (100%)**

Shifting Territorial Boundaries and Unusual Feeding Behaviour

Up until late 2013, it was rare for the Pipestones to venture east as far as the Vermilion Lakes. However, the reduced food availability along the BVP had forced the wolves to reconsider their territorial boundaries and they started pursuing a small herd of elk that used the Vermilion area near the town of Banff. Faith started leading the group through the Edith underpass (a wildlife crossing point, often used by hikers too, below the Trans-Canada Highway) much more frequently than ever before so they could hunt the Vermilion town elk. During December 2013, we documented three occasions when the Pipestones covered this new hunting area. Additionally, we watched Trickster travel the railway tracks in the Vermilion area several times on his own.

Mating season had started, which meant Faith and Spirit were kept busy with each other. However, we also noticed that Faith was showing increased agonistic aggression toward her 8-month-old daughters, Elaine and Kayla, which was not typical of Faith at all, particularly since juvenile females are not reproductive competitors.

Our impression of Faith's repeated agonistic showdowns was that they were more related to food competition than anything else, again a by-product of the declining prey population in the Bow Valley. However, her aggressive behaviour directed at her young daughters was difficult to explain on many fronts, because we had never before observed a strict feeding order among the Pipestones when eating large prey species like elk or moose.

To the contrary, we had always seen lots of opportunities for younger wolves to steal food from their parents without eliciting a reaction, and while there was usually some order of access to food resources in the family, the juveniles of the year were almost always tolerated if they tried to access the food. This was more the rule in this family (and in other wolf families we had observed in the past) than the exception. Faith and Spirit had always had the power to control food access whenever they wanted. However, things were different now. Faith didn't formally dominate her older offspring Trickster and Sunshine and restrict their food intake in favour of the juveniles (which is what we had grown to expect from our past experiences). Instead, she started beating up her younger daughters Elaine and Kayla, as well as her juvenile son Tyler.

The result of this aggressive behaviour was that by the third week of December 2013, all three juveniles had become increasingly scared and often kept an unusually long distance (several hundred metres) from carcasses. As we mentioned earlier in the book, a lack of food can cause malnutrition, particularly in young wolves.

We were baffled. Sometimes even experienced wolf behaviour observers don't have a clue why wolves are doing what they're doing. This was the case here.

The Move

On December 23, 2013, Karin and I left the Rockies and moved to the southern side of the Porcupine Hills in southwest Alberta, where we had bought a nice property in an area full of wildlife. We were excited to be able to observe animal behaviour in peace and quiet. Without any disturbance at all, we were even able to document all of the actions around a den and rendezvous location occupied by a huge coyote family with ten group members. The pups were playing and swimming through nearby ponds every day. What a difference to what we had observed in Banff!

In the meantime, our good friend Hendrik Bösch took over the wolf observations on the project. Like us, he was stunned straight away to see just how many disturbances the wolves were dealing with from out-of-control park visitors. He sent out a flurry of complaint letters to Parks Canada but always heard the same excuses we'd been hearing for years as to why it couldn't do anything.

The Pipestones' Final Collapse in 2014

Elderly breeding females tend to produce smaller litters. With that knowledge in hand, we weren't surprised to learn that Faith only had three surviving pups show up at the end of May 2014. There were two black male pups and one black female pup observed. At the time, there was a mandatory night closure in effect on an 18-kilometre stretch of the Bow Valley Parkway. The closure was intended to keep people from disturbing wildlife (John had been part of the committee that recommended the closure, which Karin and I had first recommended to Parks Canada in 2002!) between 8 p.m. in the evening and 8 a.m. in the morning. Unfortunately, we discovered this closure was nothing but lip service when we returned to Banff for a visit in May 2014. We watched a number of park

employees drive right into the den area during closure hours.

In the second week of May, Hendrik relayed the terrible news that 2-year-old Trickster had been badly injured on the Trans-Canada Highway near the Sunshine exchange and had probably died. According to several eyewitnesses, the highway fence had once again not been properly maintained. We couldn't believe it; we checked the fence ourselves and were stunned to discover that the same holes and damage to the fence we had complained about the year before were to blame! And again we wondered aloud why there was always tons of money for the next great commercial event, yet not a single spare dollar to help save wildlife.

At the end of June, Karin and I returned to the Bow Valley for a week to see again first-hand how the wolves were doing, but we only got to observe the three pups, which were all in very poor shape.

Some Unsolved Mysteries Eventually Get Solved

One of the mysteries of early summer 2014 was what had happened to the two yearling females Elaine and Kayla. Nobody had seen them for weeks. We wondered who was doing the babysitting while Faith and Spirit were out looking for food. Several people had observed Spirit still limping badly. Sightings were rare, but when people did see the pups, they were reported as looking extremely weak. By the end of July, two of the pups had died, leaving the one black female pup as the sole survivor from the 2014 litter.

At the end of the summer, I travelled to Banff alone, with the intention of staying for awhile in order to try to figure out what was happening with Spirit and the rest of the family. I arrived in a different vehicle than my usual SUV and went unnoticed by the local photographers who usually tried to follow me around all the time. I covered a lot of ground driving back and forth for days on end, but I eventually started to get a clear picture of what was happening to the Pipestone family. I noticed that Spirit was more or less "out of the game" at this point, and that Faith had become quite skinny. It was also obvious that the yearling females Elaine and Kayla were definitely no longer around. When it came to the socio-emotional state of Faith, Spirit and Sunshine, the basic rules of reciprocal care and social engagement were no longer in play. Even Sunshine was not showing any willingness to play. Worst of all, Faith appeared to be incapable of organizing a division of labour to cooperate together on a hunt. As a result, raising and feeding her last remaining pup seemed to be a losing cause.

The End of an Era

My last detailed survey on the extensive movement patterns of the remaining adult wolves revealed that during September 2014, Faith and Sunshine were travelling without Spirit. The last two sightings I had of him were on September 28 and 29. Sadly, both times I saw him he seemed to only be a shadow of his former self. The field note I took on September 29 said, simply, "Spirit = skin and bones." The great wise wolf, one of our favourites of all time, was never seen again. His probable cause of death? Starvation.

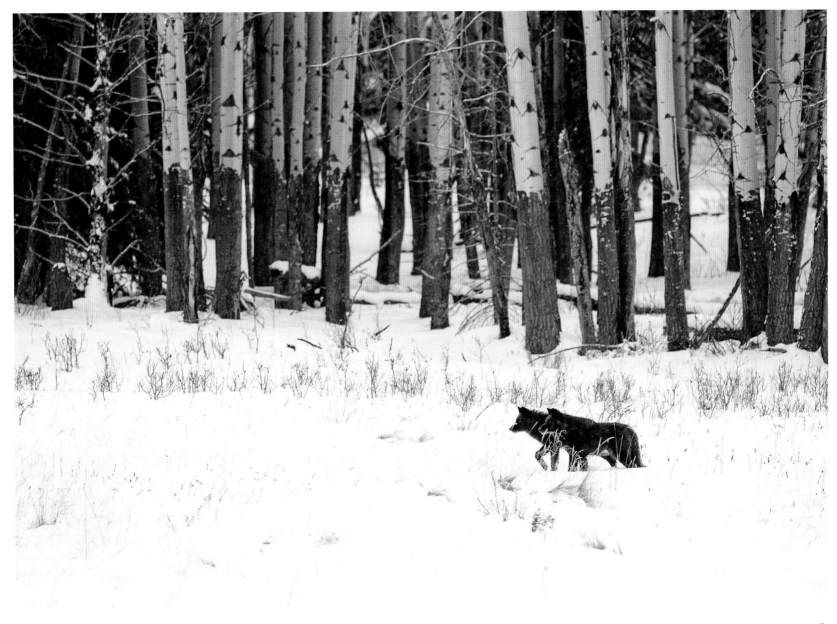

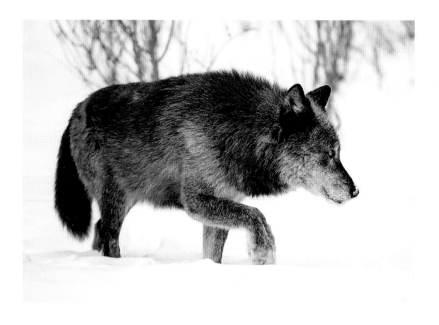

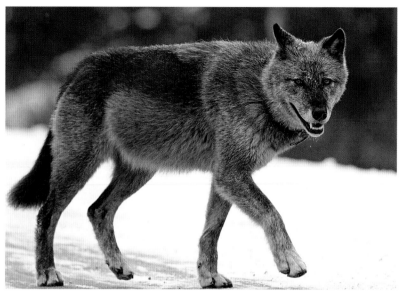

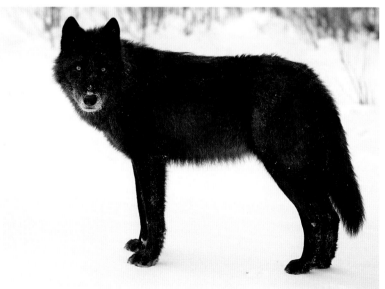

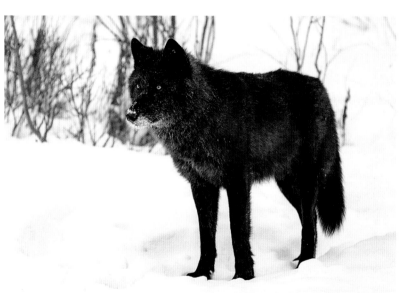

Even though Faith and Sunshine were still around at the Pipestones' main rendezvous location, their lack of hunting success entailed such a high cost for the last remaining pup that it most likely starved to death, too. I realized that the most practical effect of the extremely compromised social structure of the Pipestones was that it would all be over soon. Without a healthy and protective male around, it felt reasonable to predict that Faith and Sunshine were not capable of defending either the resources or the boundaries of their huge territory; the probability of new wolves moving into the Bow Valley and challenging the two females was too high.

Earlier in 2014, Parks Canada started a new public relations policy of hiding as much information as it could on the artificial mortality of large carnivores. As such, it took months before we learned that trains had killed both Elaine and Kayla months earlier. Tyler had also disappeared and we never did find out what had happened to him. And in late October 2014, tragedy struck the now diminished family again. Word leaked out of Parks Canada that a smoky-gray female wolf, in the company of a black wolf, had been hit and seriously injured west of Lake Louise on the Trans-Canada Highway. We knew right away that it was Faith and Sunshine. Parks Canada never found Faith's body, but we knew that the driving force of the Pipestones would never wander the Bow Valley again. Sunshine was the only one left, the sole surviving member of the Pipestones.

At the start of winter 2015, Sunshine continued to use the Pipestones' core territory. She was seen several times trotting up and down the BVP getting harassed by pho-tographers, none of whom showed her any mercy or gave her the space she deserved. Once again, we were saddened to see how many people seemed to have no ethics, no moral compass and no compassion for these animals they claimed to "love."

Sunshine disappeared during that winter after a brand new wolf pair showed up and started to occupy parts of the old Pipestones territory. Whether or not Sunshine was physically replaced by these new wolves, which denned at the Pipestones' traditional den location in April 2015, will always remain a mystery. Whatever did happen, it was clear by the spring of 2015 that the famous Pipestones that had ruled the Bow Valley for so long were finally finished.

Why Did the Pipestone Wolf Family Completely Disappear?

There can be no doubt that a combination of factors led to the demise of the Pipestones. The reasons why this highly adapted wolf family "died out" definitely include the old age of the breeding pair, as well as the constant artificial disruptions of the family's social structure because of the incredibly high mortality on the valley's railways and highways (which then resulted in fewer "social helpers," bonding relationships and learning social skills during regular play sessions). As we have championed for a long time, functioning wolf families are defined by an amalgamation of voluntary cooperating individuals, their tight net of strong social-bonding relationships and their collective efforts at occupation of a territory executed within certain ecological limits. Behaviour is always an adaptation in time and space.

Clockwise from top left:
One of the last photographs John took of Spirit, December 2013.

The death of Faith (pictured here in December 2010) in October 2014 signalled the end of an era.

Yuma left the family in November 2013.

Sunshine was the last surviving member of the Pipestones. She was last believed to have been seen in the Bow Valley in February 2015.

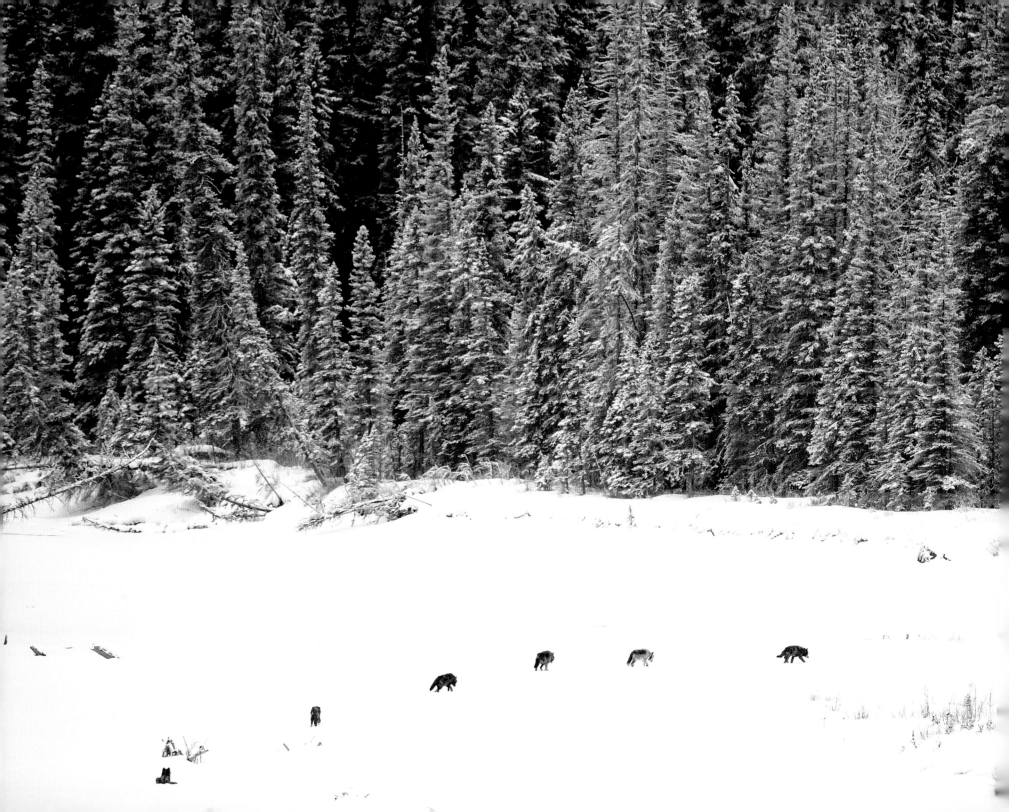

Without question, the ruthless mass tourism that took place in the Bow Valley was not compatible with any sort of long-term quality of life for the Pipestones (or for the Bows before that). This might sound overly dramatic, but we are convinced that it hits at the essence of the problems that exist in Banff: when wolves have an increased visibility on social media, then have their den location advertised at the same time as traffic in the park is exploding and visitors are running helter-skelter out of control, then something is fundamentally wrong with the system and wolves will always be the ones that suffer.

However, a very rational biological explanation of why the Pipestone family didn't make it is that its breeding pair was too old to deal with such a scarce distribution of ungulates, as well as all of the stress created by human disturbance.

At the end of their lifespan, Faith and Spirit were both confronted with a serious dental problem – both of them hardly had any teeth left! To the best of our knowledge, a dental issue like this has never played such a vital role in the collapse of a wolf family; Faith and Spirit simply couldn't collaborate on hunts with the younger wolves because they couldn't hold onto or grab prey. Over the final year, Faith and Spirit were losing their ability to bite and kill large prey species, because their teeth were either worn right down or were completely gone. Their lack of teeth was problematic because so many yearling wolves and subordinate family members, which could have done the job of bringing down prey, were killed on railways and highways.

Another key reason for the Pipestones' collapse was the low prey density. Unofficially, that's what Parks Canada

wants: fewer elk, fewer wolves. Again, we strongly disagree with such an attitude and have to ask: Where is the moral compass in pushing for lower elk and wolf populations while at the same time encouraging an explosion of tourists? As far as the wolves are concerned, taking desperate risks chasing wild sheep and goats high in subalpine and alpine terrain is not a good long-term survival strategy. Going after goats, for instance, instead of chasing elk and deer in the valley bottoms as wolves should be doing, resulted in Faith and Spirit being in much poorer shape than they should have been in. It also resulted in them having less time to spend with their pups than they normally would have. In that final year, the low prey density likely led directly to the pups starving to death.

When Faith and Spirit were younger, this low density of prey and the chasing of higher-risk game weren't as much of a concern. Younger wolves are capable of maintaining a hazardous predator–prey relationship for awhile. But as soon as they became older, they were no longer able to compensate for the above-mentioned problems and issues with youth. The difficulties all became important factors in why the Pipestones didn't survive.

By comparison, when we recall our time observing wolves in the mid- and late 1990s when elk were plentiful – up to as many as 1,000 elk roamed the Bow River Valley – we saw wolves leading much longer lives. For instance, when breeding male Stoney and breeding female Betty of the Cascade wolf family died in 2000, they were 10 and 11 years old, respectively. Similarly, breeding female Aster of the Bows died of natural causes in December 2002 at almost 11 years of age. So, with a thriving elk population

The final picture John took of the Pipestones, as they walked on the frozen Bow River on February 19, 2014. Sunshine leads, followed by Faith, Spirit and the three juveniles.

around, the quality of life of a wolf family is much higher and parent wolves get older.

The Pipestones and Their Reactions toward Park Visitors, 2009 – 2014

There has been an ongoing debate among park wildlife managers about "habituated Banff wolves." However, when it came to the Pipestones, the discussion was theoretical in nature because there just wasn't much knowledge about the wolves' actual behaviour when reacting toward park visitors (and their dogs) After hearing repeatedly about how "habituated" the Bow Valley wolves had become, we had had enough. We knew Parks Canada hadn't conducted a single behaviour study on the wolves posing a potential danger to people.

During dozens of unofficial discussions with park resource conservation officers, law enforcement officers and wildlife managers, we realized that their general interpretation of what "potentially dangerous wolves" were was wrong. For instance, they were confusing predatory behaviour and equating it to mean the wolves were behaving aggressively toward people. One day, a warden even told me that he saw the wolves "play-hunting." We also continuously heard wildlife managers from Parks Canada over the years say it was "not good" to have wolves near vehicles and using roads and that they didn't want wolves on the road because mortality rates would increase, especially among bold individuals. We never got any explanation of what "not good" meant other than their incorrect theories about the wolves "becoming too habituated."

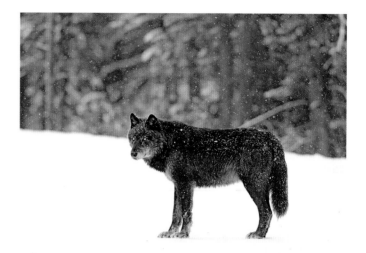

However, curiosity, adaptation, predatory behaviour and aggression are all based on totally different functional behaviour systems, and, among other factors, each comes with clearly distinguishable body language. And it's not as if the whole phenomenon of Bow Valley wolves adapting to a human-dominated environment and interacting with people was new. In fact, it was an old story that keeps on repeating itself for no good reason.

The reality was that Parks Canada had never made an effort to observe the Pipestone wolves and collect information on their presence in the vicinity of humans. Instead, its opinions were all based on hearsay; somebody had told somebody that somebody else had seen such and such. As we pointed out in the case of "habituated" G.B., Parks Canada personnel simply had no clue when it came to wolf behaviour.

It surprised us that these opinions were still present within Parks Canada, because even in the early 1990s a section of the BVP became known as "wolf alley" due to the frequent sightings on that road. In addition, seven years previous, Peter Dettling and I had described in detail in *Auge in Auge mit dem Wolf* how 39 – 59 per cent of our direct behaviour observations of the Bow Valley family were of wolves in close proximity to human infrastructure. And not one of those wolves had shown any aggression toward humans.

As far as the Pipestones were concerned, we collected precise information from the day they set foot in the Bow Valley until their demise. This included detailed protocol on their reactions toward people using two criteria based on distance: greater than 100 metres and less than 100 metres. In order to methodically collect relevant wolf behaviours in interactions with humans (and their dogs) out of their vehicles, we categorized five different behaviour scenarios.

- Attack: A wolf approaches a human (with or without a dog) in a typical predatory crouch, with its body lowered and using eye stalking as a precursor to the stalk, the chase, the bite and the kill. Any part of this sequence would be considered an attack.

- Threat: A wolf approaches or circles a human (with or without a dog) in a threatening posture, displaying stiff, upright body language with hackles up and tail erect.

- Bluff charge: A wolf runs toward a human (with or without a dog) in a threatening manner in an attempt to scare the human off. A tactic used to try to assert dominance when the animal is feeling threatened.

- Leave: A wolf leaves the area after noticing a human.

- Tolerate: A wolf stays in the area after noticing a human.

Interestingly, in the years 2009 – 2013, we only succeeded in documenting a total of 140 direct encounters between a Pipestone wolf and a human (with or without a dog). It is important to note that this data does not include observations of people running after wolves, which we often did observe and which always triggered flight behaviour from the wolves.

Table 4.5 shows the behaviour reactions of 16 different wolf individuals (Type A or B characters) confronted with a human standing at a distance estimated at either over 100 metres or under 100 metres (with or without a dog), as well as with a human walking toward a wolf at a distance estimated at either over 100 metres or under 100 metres. No encounter involving a human with a dog walking toward a wolf was observed.

Wolf Behaviour Analysis

Seventy-four per cent of the 140 encounters between a wolf and a human (with and without a dog) were observed with a distance of over 100 metres (but not more than 150 metres) between the subjects, whereas only 26 per cent were under 100 metres. However, importantly, as all the

Table 4.5 Wild Wolves and Their Behaviour Reactions toward Humans.

Behaviour Reaction Wolf (n = 140)	Human Standing (with dog)		Human Standing (without dog)		Human Standing (with dog)		Human Standing (without dog)		Human Walking Toward Wolf (no dog)		Human Walking Toward Wolf (no dog)	
Distance	> 100 metres		> 100 metres		< 100 metres		< 100 metres		> 100 metres		< 100 metres	
Type A or B	A	B	A	B	A	B	A	B	A	B	A	B
Attack	0	0	0	0	0	0	0	0	0	0	0	0
Threat	0	0	0	0	0	0	0	0	0	0	0	0
Bluff Charge	0	0	0	0	0	0	0	0	0	0	0	0
Leave	4	5	13	9	3	1	5	2	11	10	15	22
Tolerant	3	1	10	7	1	0	3	1	6	4	3	1
Totals	**7**	**6**	**23**	**16**	**4**	**1**	**8**	**3**	**17**	**14**	**18**	**23**

zeroes in the corresponding columns indicate, not one direct attack, threat or bluff charge toward a human (with or without a dog) was observed in the five years of data observations collected. It's also important to note that in 71 per cent of all observed encounters, the wolf left the area when confronted by a human (with or without a dog); they only behaved tolerantly in 29 per cent of the documented cases. Bold, Type A wolves left the area in 66 per cent of all encounters with humans (with or without a dog) and behaved tolerantly in 34 per cent of all documented cases. Shy, Type B wolves left the area in 78 per cent of all encounters with humans (with or without a dog) and only behaved tolerantly in 22 per cent of all documented cases (and only 7 per cent of Type B wolves that encountered humans at a distance less than 100 metres behaved tolerantly).

Wolves' tendencies to retreat and show avoidance and/or fear were most obvious when humans tried to approach the wolves. Thirty-five observations were made when humans without a dog approached a bold, Type A wolf, and in 74 per cent of those cases, the wolf would leave the area. Thirty-seven observations were made when humans approached a shy, Type B wolf and the shy wolf only behaved tolerantly five times.

Regardless of its basic character type, we never saw a Pipestone wolf behave in a habituated (fearlessly approaching a human) or food-conditioned manner (fearlessly begging for food) toward humans (with or without a dog).

It is extremely important to note that although all of the Pipestone wolves were exposed to park visitors more than any other wolf in Banff National Park, none of them ever showed any potentially dangerous, aggressive or predatory behaviour toward humans. And of all the wolves that showed some degree of tolerance and curiosity toward humans (with or without a dog), all of them still exhibited avoidance and/or fear behaviours during all 40 tolerant encounters observed. In this context, we were not able to document any cases of so-called abnormal behaviour.

If we summarize our field observations on wolf–human encounters (with or without a dog), we can't help but conclude that the link park employees have repeatedly tried to create between wolves that have adapted their behaviour to live in close proximity to human infrastructure and those same wolves being a potential danger to humans is wrong. The whole theory and hypotheses simply do not hold any water. In fact, it's our belief that with the onset of uncontrolled park visitation and the social media firestorm that accompanies wolf sightings these days, it is the wolves that need protection from "aggressive" and/or "predatory" humans, not the other way around.

The Pipestones' den location, which as we previously mentioned has been occupied by a new wolf family since April 2015, is just 200 metres away from the Bow Valley

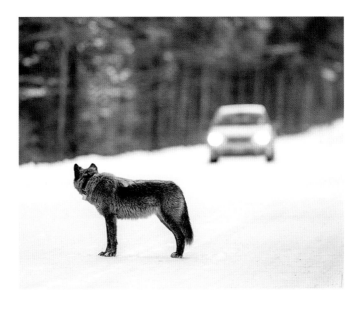

Blizzard facing an oncoming car on the Bow Valley Parkway, December 2011.

Parkway. These new wolves, like the Bows and the Pipestones before them, need to raise their pups in part by using the road close to their den site on a daily basis. It's our belief that the new generation of "wolf lovers" is going to have to be actively managed to avoid running into the same problems the Pipestones had to deal with that disrupted their natural behaviour patterns and movements so severely.

193

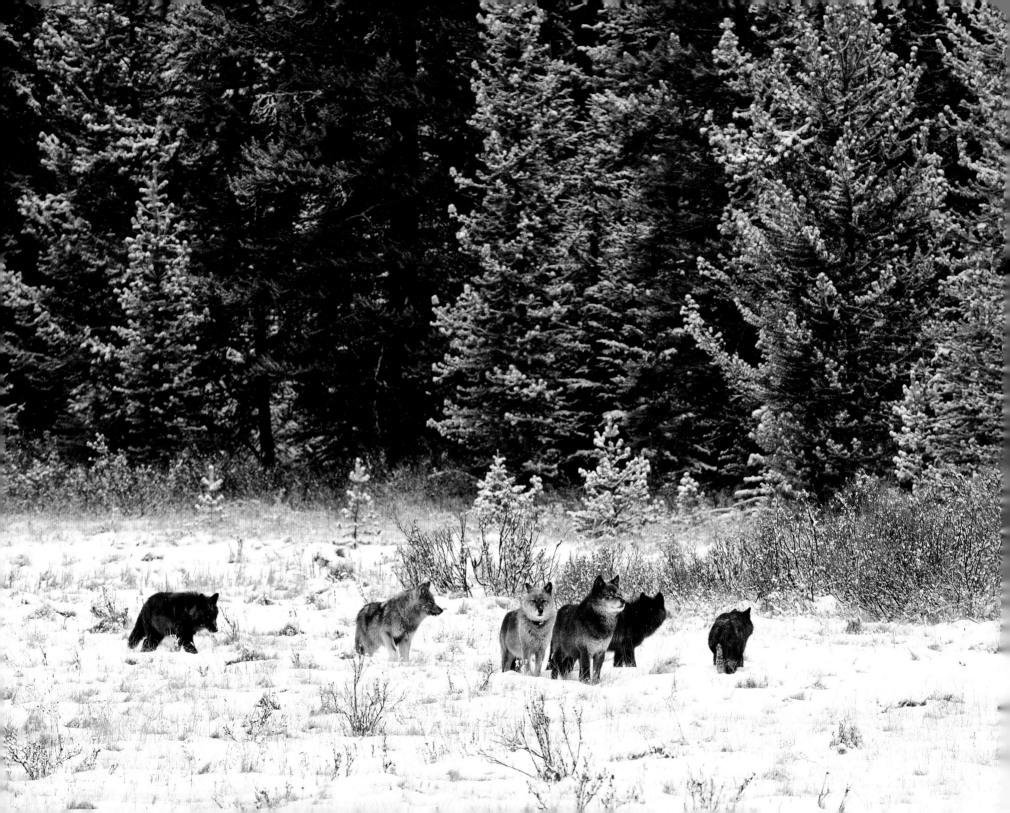

What future do wolves have in the Bow Valley? Will they live forever onwards in Canada's flagship national park in a "wildlife ghetto"?

Outlook for the Future

The question of whether or not there will be some wolves in the Bow River Valley moving forward can be answered emphatically with a "yes." There will always be wolves in the valley because the Bow Valley functions as a key travel corridor in the Canadian Rockies. However, the question then becomes How long can individual wolf families and individual wolves live in the Bow River Valley long-term and what sort of quality of life will they have? Long-term survival will not be possible if they can't find enough to feed on, and if they continue to have to deal with the many social disruptions they currently face.

Rusty (left) and
Kootenay (right)
are the leading
male and female
of the new Banff
Town wolf family
in the Bow Valley.

If the situation doesn't change for the better, we predict that at some point in the future, elk may actually have to be reintroduced back into parts of the Bow Valley. That might sound strange, but let's see how the town elk population is doing five years from now. As far as the elk population along the Bow Valley Parkway is concerned, it is already rare to spot a female elk anywhere along the BVP.

The Current Wolf Situation

At the time of writing, in early March 2016, a new family had already established territory in the Bow Valley using the same old path system the Pipestones and the Bows had used. According to John, the new "Banff Town" family (as named by him) is led by a light-gray breeding female that he believes migrated from Kootenay National Park, based on past observations he had made of the Kootenay wolf family. Of course, without DNA analysis, no one will ever know for sure.

The new wolf story likely started where it always starts: with a reproductive female ("Kootenay") meeting a reproductive male ("Rusty") and starting a new life together in monogamy. In early 2015, the new wolf pair successfully produced a litter of pups in the core area of the Bows and the Pipestones. In August 2015, a local photographer observed two gray pups and one black pup. Later that summer, as well as during the fall of 2015, the five wolves were seen regularly roaming the Fairmont Banff Springs Hotel golf course and hunting elk and deer on the outskirts of the town of Banff. The family has established a territory that encompasses most of the Bow Valley

between Banff and Lake Louise, as well as parts of the valley surrounding the town site (which, as we have documented, the Pipestones never did).

In early winter 2015, the wolves continued to be successful in developing adaptive behaviour strategies enabling them to get used to the daily rhythms of people and their infrastructure. During that time, breeding male Rusty and his only black juvenile son were chased around and radio collared by the same helicopter crew that takes part in the senseless killings of hundreds of wolves in northern Alberta. Obviously, Parks Canada does not care about that at all and instead hires such ethically questionable people.

The good news, though, and most importantly, is that the adults and youngsters alike have been observed playing a lot. We sincerely hope this is a good sign for the future. As canine behaviour specialist Mechtild Käufer wrote, "Play shapes how the animal displays aggressiveness, sexual behavior, maternal behavior, and behavioral, hormonal, and neurochemical responses to stress and novelty as it matures."[9]

And, as we described when we discussed the collapse of the social structure of the Fairholme wolf family in 2003 and the Pipestones in 2013 – 2014, the lack of play in these families showed that they were not able to develop the necessary social skills and behaviour flexibility to adapt to their ever-changing ecological living conditions. Although park officials have suggested repeatedly in newspaper interviews and on the radio that "the wolves in Banff are doing well," it should be noted that without information on play behaviour via direct observations, no manager

9 Käufer, *Canine Play Behavior*, citing Camille Ward, Erika B. Bauer and Barbara B. Smuts, "Partner Preferences and Asymmetries in Social Play among Domestic Dog, *Canis lupus familiaris*, Littermates," *Animal Behaviour* 76, no. 4 (2008): 1191.

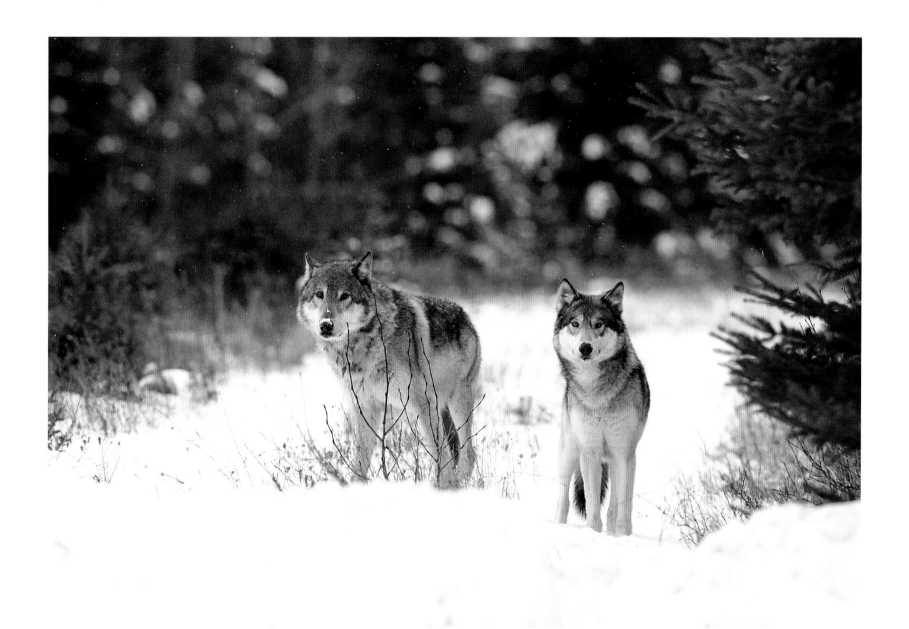

in the world would be able to predict whether or not the wolves of the Bow Valley are doing well in the long term.

It is our hope that the mistakes of the past will not be repeated this time around. Parks Canada has already hinted that it may finally stop culling the town elk now that a wolf family is preying on them and reducing their numbers naturally. We believe that finally putting an end to the elk cull (if that will actually be done!) is a critical first step in recovering the park's ungulate population, regardless of whether or not the Banff Town wolf family continues to prey on the elk, and that the only way to ensure the long-term survival of the wolves is by having a stable prey base. After all, there are no "problem elk" that need to be removed. Rather, it's problem people that are the issue!

Unfortunately, we predict that the town elk the new wolf family seems to be after will continue to decline in number because of the short-sighted culling program and the high mortality on the roads and rails. And, of course, it is the wolves that will be blamed for "eating all the elk."

The Commercialization of Banff National Park

The urgent but unanswered question is this: Can Parks Canada finally strike a real balance between ecological integrity and mass tourism in Canada's flagship national park? So far, it has failed to do so and has left us wondering if it is already too late. Will all Bow Valley wolves live forever onwards in a "wildlife ghetto," devoid of true wilderness characteristics, just like the Pipestones did? What are the precise plans for the future? Will Parks Canada

show any willingness to reduce the unacceptable levels of disturbance for wolves by park visitors? Is "human management" in the cards?

Let's face the facts: Parks Canada just completed an upgrade to the Bow Valley Parkway to drastically increase visitor use on the road, which included large, prominent, solar-powered signs along the Trans-Canada Highway advertising the distance to the BVP's starting point, as well as information kiosks at both parkway entrances encouraging visitors to look for wolves. When we saw these for the first time, we thought, "You have got to be kidding me." Is this what Parks Canada thinks being responsible for wildlife and an ecologically intact system is supposed to look like in practice?

The most disturbing part for the wolves, besides being constantly harassed, was how often we heard about the internal disagreements within Parks Canada over how to deal with wildlife. In the world of wildlife managers, there always seemed to be a discrepancy between the official version of how to deal with tourists harassing wildlife and entering closed areas and the off-the-record version. The official line has always been one of awareness and education, followed by more awareness and education. Off the record, many of these same managers feared losing their jobs if they spoke out honestly about the problems that were occurring. For that, the Harper government was blamed over and over again – well, that era has come to an end.

However, it's pretty obvious that the notion of "raising awareness" has completely failed. And it doesn't help to report people behaving illegally or irresponsibly; the standard of evidence required to actually charge

Downtown Banff on a *quiet* morning.

199

someone under the Canada National Parks Act is far too onerous for most park visitors reporting to authorities to ever collect. Regardless, most of the time Parks Canada didn't have the manpower or desire to investigate further.

The only thing that kept us going sometimes were the private meetings we had with some great locals. Several of these locals were far-sighted, headstrong retired park wardens who shared our horror at what the Bow Valley had become. One went so far as to call it "a purely business-driven circus." They agreed with us that misbehaving park visitors should, without exception, be punished and face the consequences of their actions. These same people were extremely concerned that Parks Canada had let their responsibility for environmental stewardship severely lapse. We agreed wholeheartedly with everything these former park wardens had to say.

The issue of uncontrolled mass tourism is closely linked to a responsibility and an obligation to preserve wolves, bears and all other wildlife species for future generations. Either you protect wildlife 100 per cent or you go fully commercial. There is no argument anymore for having a balance between the two, because it just doesn't offer enough protection for wildlife. At present, there is no balance in Banff. Parks Canada continues to encourage higher visitation while at the same time claiming it is protecting wildlife. Well, anyone can see that this strategy has completely failed. Parks Canada listened to too many commercial enterprises and organizations and decided it wanted to have it all, arguing that people shouldn't be excluded from national parks. Well, mission accomplished. We believe five million visitors a year and tens of thousands of vehicles every single weekend qualify as an inclusion of people in the parks. Not a soul has been excluded, it would seem.

Recently, millions of dollars have again been invested in tourist infrastructure, but there never seems to be any money left over for wildlife crossing signs (which Karin and I first recommended to Parks Canada in writing in 2002). Incredibly, along the entire stretch of the 48-kilometre Bow Valley Parkway, after all those years of recommendations, there is not a single wildlife crossing traffic sign. We personally checked again in early March 2016: no wildlife crossing signs – nothing had been done. That says it all.

Enough is enough: Banff's wildlife deserve more.

Have We Passed the Point of No Return?

Parks Canada also seems to have failed to connect the dots between development issues and climate change. The Bow River Valley has become a completely commercially dominated landscape, yet Parks Canada is light years away from realizing the impact climate change is already having, including devastating El Niño effects, in the valley. Current discussions centred on enlarging the ski hills at Mount Norquay and Lake Louise only demonstrate the ignorance at the core of this issue. Recently, in February 2016, we became aware of the fact that Parks Canada had approved the doubling of the Lake Louise ski area. Everybody knows that same area is considered to be prime grizzly habitat! Yet Parks Canada does not see any problem.

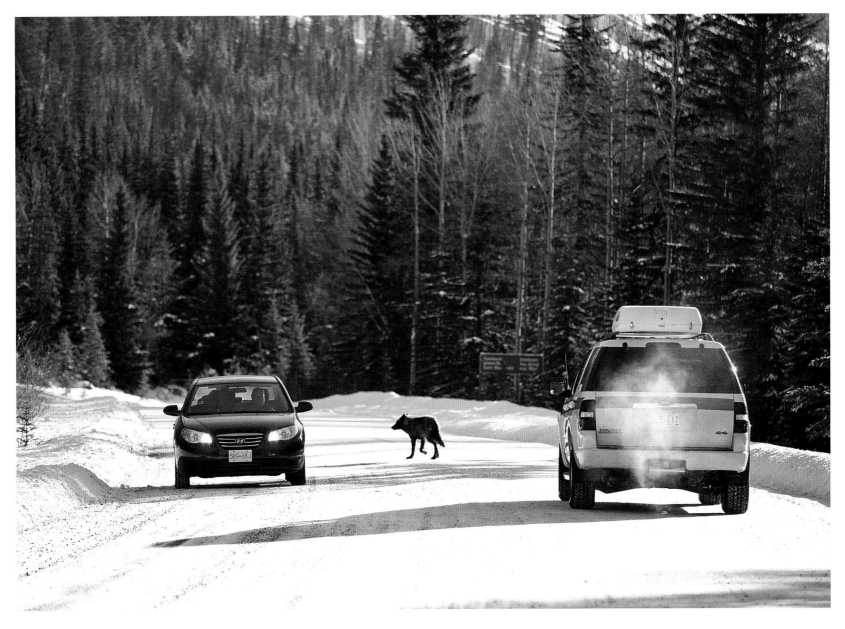

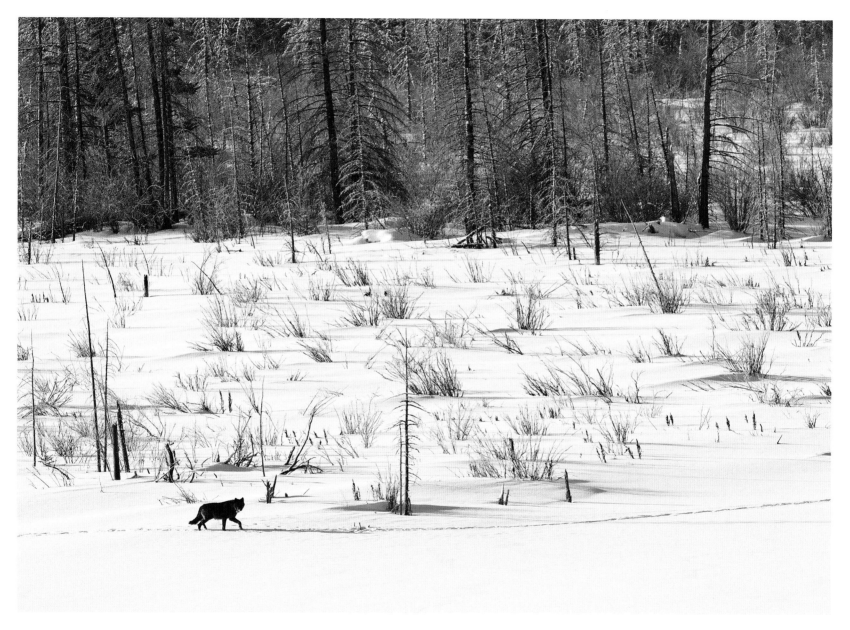

Here is the thing: the days of endless, long-lasting, bitterly cold winters are over. Rather than focusing on when and where the next tourist event should take place, and where the next additional snow-producing machine should be placed, Parks Canada should be focused on managing the park's resources in a much more environmentally strict manner. No national park needs to have three ski areas. Human demand isn't relevant. What is relevant is how much space wildlife needs to live in the park.

Instead of urgently debating the problems associated with a rapidly changing landscape full of disappearing glaciers and dry riverbeds, the management plan for Banff is still dominated by issues that deal only with mass tourism. Instead of taking climate change seriously, it is making recommendations for vegetation management to create a landscape with more aspen trees to mimic what the landscape would have looked like 150 years ago. Not a single park researcher is looking at the effects of today's pollution levels from the millions of vehicles that travel through the park each year.

Outreach

There has been a decade-long discussion on how to deal with tourism, but we're still not much closer to real solutions. To the contrary, it all got worse, and the people responsible for boosting mass tourism and approving it all don't know what to do. In 2016, *Bow Valley Crag & Canyon* reporter Daniel Katz wrote, "Visitation to Banff NP in the fiscal year of 2015 – 2016 is projected to increase 7.4% from the year previous, according to numbers from Parks Canada revealed at the 18th Annual Banff National Park Planning Forum."[10] Instead of helping wildlife to better survive, nobody in Banff seems to have an adequate answer at all when it comes to the issue of how to manage record numbers of visitors. Instead, chaos reigns everywhere.

For years, we have been running in circles. We don't need more studies to "study the study" (the original report of the Banff National Park Canid Ecology Study was first released in 1990, yet most of the environmental and ecological recommendations it made were never implemented). What we need to establish are clear guidelines on how to observe wildlife as guests *in their habitat*.

Here are our nine recommendations:

1. Establish a year-round night closure for the Bow Valley Parkway for everyone without exception.

2. Establish strict quotas for driving the Bow Valley Parkway and other sensitive wildlife areas.

3. Create more car-sharing solutions and look at moving to more bus systems similar to the Denali National Park wildlife-viewing model.

4. Publish a very precise and animal-behaviour-oriented brochure for wildlife viewing, which should be handed out at all park gates. It would include mandatory rules such as stay in your car at all times while watching animals, pull over to the side of the road, turn your engine off, do not chase after animals and always leave a minimum distance of 50 metres between you and any wildlife species.

Human demand isn't relevant. What *is* relevant is how much space wildlife need to live in the park.

[10] Daniel Katz, "Parks Canada Looks for Ways to Manage Record Numbers of Visitors," *Bow Valley Crag & Canyon* 117, no. 7 (February 17, 2016): 11.

Once again, the Bow Valley is being led by a vibrant, outgoing female that makes many of the key decisions for the family, just like Delinda did before her with the Bows, and Faith with the Pipestones. Here, Kootenay leads the Town family along the Canadian Pacific railway tracks within a kilometre of the town of Banff (Rusty is in the rear) in November 2015.

5. Institute an education program for park visitors that includes presentations on animal behaviour and other topics, such as why wildlife corridors and closed areas are necessary and why they should be respected.

6. Install speed bumps (every kilometre) along the complete Bow Valley Parkway between Five Mile Bridge and Lake Louise.

7. Create and enforce a detailed ticketing system including clearly defined fines.

8. Establish a transparent yearly reporting system in order to inform the public about the number of large carnivores and ungulates that have been killed on the railway.

9. Install a radar control system along the Trans-Canada Highway, the complete Bow Valley Parkway and Highway 93 North and South.

Final Remarks

We realize that some people may take offense to some of our critical, but always objective, statements. None of this was meant to be personal. As a whole, we are extremely critical of Parks Canada because we wanted to be honest about the stresses that wildlife in Banff endure on a day-to-day basis.

We know there will be critics arguing that Karin, John and I have helped to commercialize the wolves, that we're as much a part of the problem as anyone. But we counter-argue that this was observational fieldwork that had to be done. The bottom line is that we couldn't sit idly by and watch the ecological integrity of the Bow Valley fall to pieces before our eyes. Similarly, without John's vivid photos, how many of you would have picked up this book? We did not take our observation work lightly; we poured our hearts and souls into this work, not to mention our bank accounts.

I apologize if I have offended anyone with what I have written. But the truth is I am a straight-shooting German Canadian, an extroverted Type A and certainly not much of a diplomat. But being a bit too bold and a bit too outspoken means I have been able to lend my voice, along with Karin's and John's, to those of the wildlife under siege in Banff, particularly the wolves'. Karin, John and I believe that's the least Spirit, Faith and all of their sons and daughters deserve.

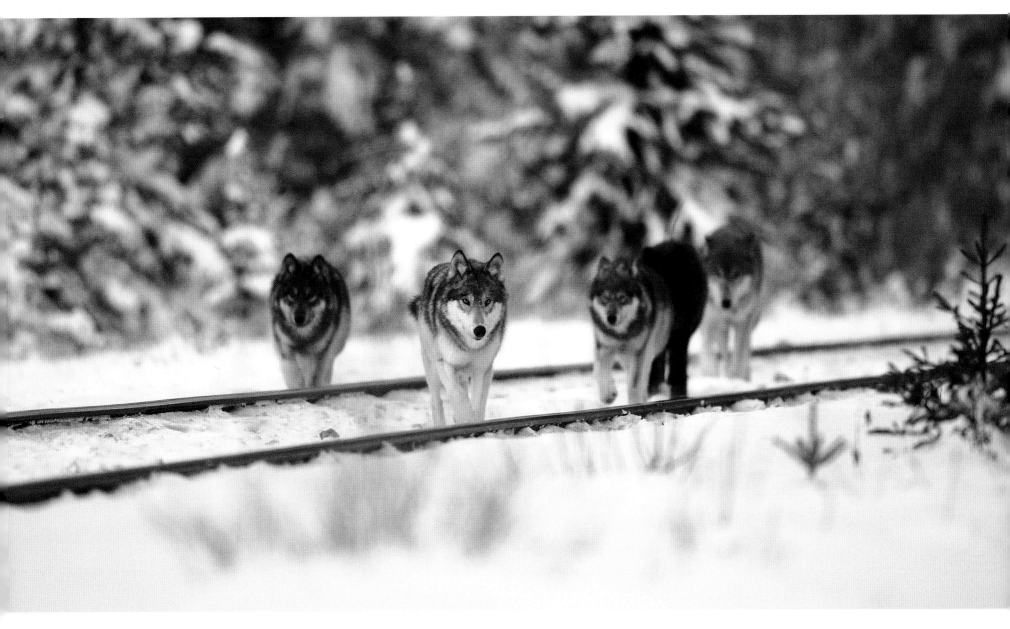

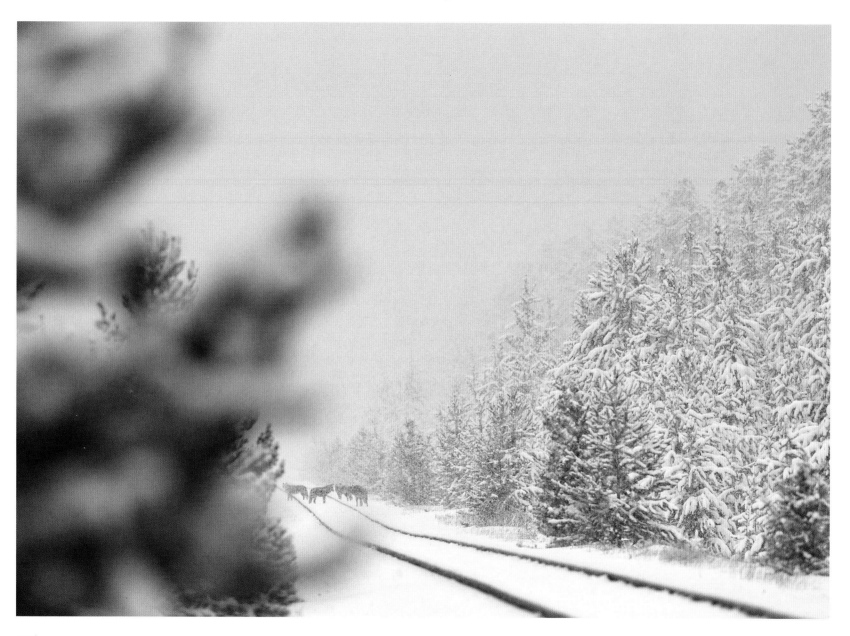

EPILOGUE

ONCE WIDELY DISTRIBUTED throughout Banff and surrounding areas, most wolves were eradicated from the Canadian Rocky Mountains south of Jasper National Park before 1914. However, in the late 1930s, natural recolonization and subsequent range expansion allowed wolves to re-establish themselves in most areas of the Canadian Rockies, including Banff National Park. However, a regional carnivore reduction program eliminated wolves again in the 1950s. Following cessation of wolf control in the mid-1960s, wolves began a second recolonization of remote areas of southern British Columbia and Alberta from which they had been eliminated. In the mid- to late 1970s, observations of solitary wolves were reported in Banff National Park. In 1985, pack activity was documented in southern Banff National Park.

In 1992, I was in Banff National Park studying the ecology and behaviour of the newly established population of wolves. Following a prolonged absence of more than 40 years, wolves had returned to the Bow Valley, where they had once roamed freely, probably for millennia. Given the disturbing and ominous previous failures of wolves to survive in the park, however, their subsistence was uncertain. Accordingly, the pressing research question was What do we need to know that will help park managers safeguard wolves and assure their survival?

Ostensibly protected, wildlife species in Banff live perilous and impoverished lives, constantly exposed to hazardous highway and rail traffic and displacement from developments like hotels, ski hills and golf courses. Their livelihood and survival are threatened by excessive and ever increasing demands of people, who are encouraged and enabled by a parks policy that unfailingly favours the destructive wants of humans over the integrity of the natural environment. An exemption from regulations that protect the environment is often given to activities incompatible with wildlife.

Notably, this was the third time wolves had recovered from the damaging and deadly pressure of human

Wildlife in Banff live a perilous and impoverished life, constantly exposed to hazardous highway and rail traffic.

harassment since the late 1880s. Twice in the 20th century wolves had been eliminated from the park for extended periods because of purported conflict with humans, including competition for the elk, deer and moose that the wolves depended on for survival. Despite the efforts of park wardens to protect what was an unmistakably vulnerable wolf population, a repeat of this same deadly pattern was already becoming evident in the 1990s.

Absorbed by this problem, I was ground tracking wolves through a meadow near Highway 1A in Banff National Park when a sizeable domestic dog standing motionless 50 metres in front of me caught my attention. At first, I thought he was alone, but a distance away, hidden by bush, was his human companion. Both were stationary as statues, intently observing a nearby coyote some 20 metres beyond. In my mind, they appeared to be conversing about what they were seeing, constantly comparing notes through frequent but brief glances. Having spent the previous 15 years studying wolves and coyotes in the boreal forest of Manitoba, where three dogs served as my constant companions and principal interpreters of canid behaviour and ecology, I remember thinking that I fully understood the silent conversation unfolding in front of me. Watching the two strangers converse was like seeing a reflection of myself doing what I most loved – observing wild canids in their natural environment. The dog, which had initially attracted my attention, made the first friendly overture when he slowly approached me and, in a relaxed gait, greeted me with a wagging tail and broad smile. Fittingly, he escorted me across the meadow to meet his colleague, who turned out to be the renowned canid

behaviourist Günther Bloch. In turn, Günther properly introduced me to his dog Chinook, a handsome Russian Laika who accompanied him everywhere.

That serendipitous meeting ultimately fostered and evolved into a close friendship and enduring professional collaboration that centred on understanding the behaviour and ecology of wild wolves. During the years that followed, Günther opened my eyes, mind and heart, helping me to recognize that the problems the wolves in Banff were facing were an outcome of our incoherent perspective as researchers and conservationists, as well an overall disregard for wolves by those who make decisions, especially when confronted with the competing interests of commerce and recreation. Lacking adequate or proper knowledge, wildlife managers were happily ignoring the inconvenient facts of wolf behaviour and ecology, while consistently sanctioning the human-centric policies that were detrimental to wolves but favoured by government authorities. These misguided management practices explained why wolves had disappeared previously from the park, and why wolves in Banff would have no future without a change of policy that accounted for their life requisites.

Contentiously forthright and honest, Günther has stood the conservatively dogmatic and deliberately human-centric idea of conservation and management on its head, showing it to be authoritative but inadequate when preservation of other species such as wolves is the priority. I came to appreciate that management for wildlife, as opposed to management of wildlife, is what Günther has striven for – a radically different premise that directly

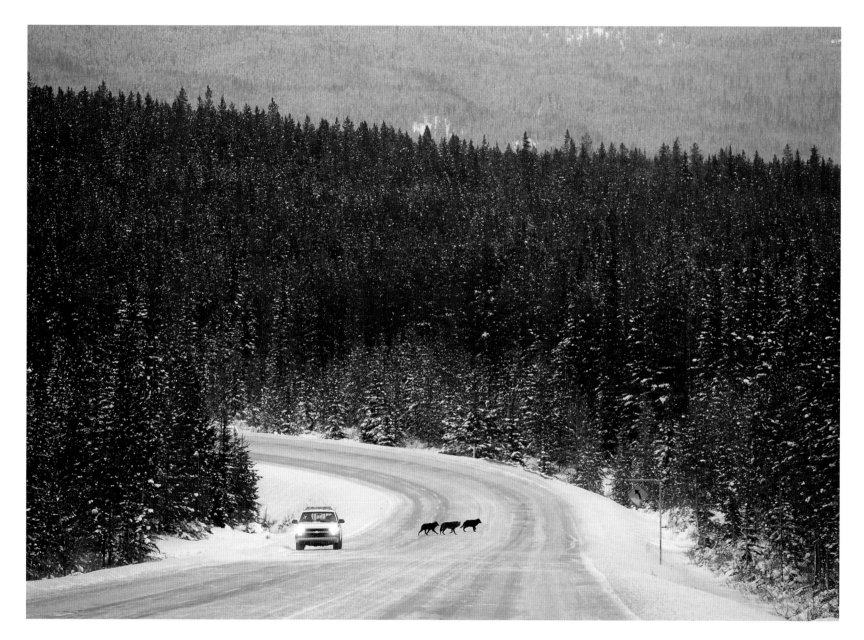

conflicts with the long-established conventional wisdom. Simply, conservation and management of wildlife should be for the benefit of wildlife and people, rather than for people alone.

Günther is steeped in the demanding academic tradition of renowned Austrian ethologist Konrad Lorenz. He has been inspired and mentored by Swedish behavioural scientist and wolf specialist Erik Zimen, who was my teacher as well and Lorenz's last student. Günther's approach to wolf conservation derives from skepticism toward the customary North American studies of wildlife ecology that are typically carried out without concern for, or understanding of, animal behaviour or the importance and welfare of individuals. These studies are intended to provide information that helps ensure the persistence of populations and species, with success being measured by how many animals survive.

Outspoken as always, Günther believes this approach to be naively superficial and often dangerously ill-informed when it comes to protecting wolves from the unremitting pressures of people. He contends that in order to understand the mechanisms of wolf biology and ecology, and ultimately the application of conservation and management, observing wolves and the full range of their behaviours in the natural context of their environment is essential. He has recognized, however, that science provides the basis for challenging the status quo but does not give us permission to do as we please.

Science, as he explained to me, keeps our empirical facts transparent and accountable, whereas ethics keep our values transparent and accountable. Together, science and ethics complement each other as points of reference from which better conservation policies can be plotted. Accordingly, ethical arguments provide the rational basis for consideration of other beings. And from an ethical perspective that considers the intrinsic value and welfare of individual animals, the conservation of wolves is about more than just populations and ecological processes. Ultimately, values (moral, cultural and political) are the primary influence of policy. Until we get them right, we will constantly be chasing our tails over the conservation and management of wolves, and always to their detriment.

—Paul Paquet

Pipestone Population Trends

The following graphs show the population trends in the Pipestone family from October 2009 to October 2014.

Figure A.1 Population Trend in the Pipestone Family (Adults), October 2009 – October 2014.

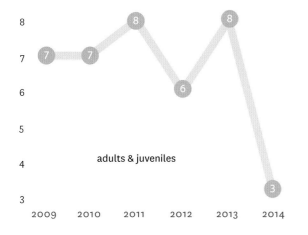

Figure A.2 Population Trend in the Pipestone Family (Pups), October 2009 – October 2014.

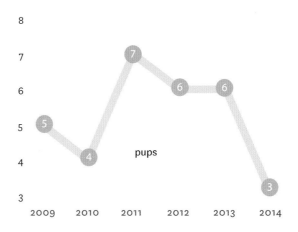

APPENDIX B

Pipestone Sex and Age Ratios Relating to Character Types

The following six tables show the sex and age ratios, as well as the character types, of the adult and juvenile Pipestones.

Table B.1 Pipestones Sex Ratio, Age Ratio and Character Types, 2009.

Spirit	breeding male	approx. 4 years		shy B-type character
Faith	breeding female	approx. 3 years	bold A-type character	
Chesley	yearling male	approx. 1 year	bold A-type character	
Rogue	yearling male	approx. 1 year		shy B-type character
Skoki	juvenile male	born April 2009		shy B-type character
Blizzard	juvenile female	born April 2009	bold A-type character	
Raven	juvenile female	born April 2009		shy B-type character
Totals			**3 bold A-type characters**	**4 shy B-type characters**

Table B.2 Pipestones Sex Ratio, Age Ratio and Character Types, 2010.

Spirit		approx. 5 years		
Faith		approx. 4 years		
Skoki	yearling	born April 2009		
Blizzard	yearling	born April 2009		
Chester	juvenile male	born April 2010	bold A-type character	
Meadow	juvenile female	born April 2010		shy B-type character
Lillian	juvenile female	born April 2010	bold A-type character	
Totals			**2 bold A-type characters**	**1 shy B-type character**

Table B.3 Pipestones Sex Ratio, Age Ratio and Character Types, 2011.

Spirit		approx. 6 years		
Faith		approx. 5 years		
Blizzard	adult female	born April 2009		
Chester	yearling male	born April 2010		
Djingo	juvenile male	born April 2011		shy B-type character
Yuma	juvenile female	born April 2011	bold A-type character	
Jenny	juvenile female	born April 2011		shy B-type character
Kimi	juvenile female	born April 2011		shy B-type character
Totals			**1 bold A-type character**	**3 shy B-type characters**

Table B.4 Pipestones Sex Ratio, Age Ratio and Character Types, 2012.

Spirit		approx. 7 years		
Faith		approx. 6 years		
Yuma	yearling female	born April 2011		
Golden Boy	juvenile male	born April 2012	bold A-type character	
Trickster	juvenile male	born April 2012		shy B-type character
Sunshine	juvenile female	born April 2012	bold A-type character	
Totals			**2 bold A-type characters**	**1 shy B-type character**

Table B.5 Pipestones Sex Ratio, Age Ratio and Character Types, 2013.

Spirit		approx. 8 years		
Faith		approx. 7 years		
Yuma	adult female	born April 2011		
Trickster	yearling male	born April 2012		
Sunshine	yearling female	born April 2012		
Tyler	juvenile male	born April 2013		shy B-type character
Elaine	juvenile female	born April 2013	bold A-type character	
Kayla	juvenile female	born April 2013		shy B-type character
Totals			**1 bold A-type character**	**2 shy B-type characters**

Table B.6 Pipestones Sex Ratio, Age Ratio and Character Types, 2014.

Spirit		approx. 9 years		shy B-type character
Faith		approx. 8 years	bold A-type character	
Sunshine	adult female	born April 2012	bold A-type character	
Totals			**2 bold A-type characters**	**1 shy B-type character**

APPENDIX C
Pipestone Parent–Offspring Formal Dominance System

Wolves communicate through body language. The first real constant in the active demonstration of social status with wolves in the wild is their body language. Formal dominant individuals such as parent wolves most often move in a self-assured way, which includes holding their tail horizontally or high in the air and showing intensive scent-marking behaviour. Subordinate individuals express either socio-friendly body language or submission-type behaviour and show urination behaviour. It should be noted that appeasement behaviour is generally just as important as dominance behaviour, either to promote a friendly atmosphere or to at least keep up a social distance (individual distance). Gestures and body postures of active submission in juvenile wolves, however, seem to be age-related and develop smoothly from the food-begging behaviour of pups. In fact, it isn't possible to differentiate between food-begging behaviour and active submission. A juvenile wolf that is begging for food actively, or that is being submissive, normally approaches an adult in a very excited way, wagging its tail, laying its ears flat and licking the corner of the adult's mouth. For passive submission, however, a lower-ranking individual will roll sideways on the ground and the higher-ranking wolf most often sniffs the submissive's body or genital area.

During nearly all of our direct observations we noticed age-related, but not gender-related, active submission shown by all members of the Pipestone family toward both parent wolves, Spirit and Faith. Even if active or at least passive submission gestures of a breeding female toward an "alpha male" had been observed in the past, we have rarely been able to find any conformation for this being "typical behaviour." The only exceptions to this that we observed in the past were constellations (group units) with breeding females being significantly younger than breeding males, with an age difference of at least 3 – 4 years.

Apart from communication through body language and postures as an expression of formal dominance conditioned by time and space, the only other real constant we have been able to document was scent-marking behaviour. Spirit and Faith showed scent-marking behaviour, overmarking and scratching. In contrast, low-ranking individuals did not mark but urinated with bent legs (males) or squatted with their genital area low to the ground (females), passing larger amounts of urine without scraping or scratching. Thus, all Pipestone yearlings and juveniles showed standing urination (males) and squatting urination (females).

Regardless of whether the Pipestones' specific family unit was Spirit and Faith with juveniles, Spirit and Faith with yearlings and juveniles or Spirit and Faith with adults, yearlings and juveniles, the fundamental rules of communication in active or passive submission were always applied toward the wolf parents, Spirit and/or Faith.

The following four tables (social matrixes) show the number of interactions in each year between between January 1, 2010, and December 31, 2013, in which a low-ranking wolf accepted the higher social status of a dominant parent or other adult wolf by actively demonstrating submission and showing a clearly recognizable lowered body posture that included appeasement signals. Wolf pups aged 4 months or less are not included in the matrixes.

Table c.1 Dominance/Submission within the Pipestone Wolf Family, 2010.

Dominance/Submission	Spirit	Faith	Blizzard	Skoki	Chester	Meadow	Lillian
Spirit (father, 4 years)	–	0	0	0	0	0	0
Faith (mother, 3 years)	0	–	0	0	0	0	0
Blizzard (adult daughter, 1 year)	68	92	–	18	0	0	0
Skoki (adult son, 1 year)	55	39	0	–	0	0	0
Chester (juvenile son, 6 months)	99	77	42	35	–	2	0
Meadow (juvenile daughter, 6 months)	66	92	61	41	33	–	5
Lillian (juvenile daughter, 6 months)	102	138	99	59	22	6	–
Totals (n = 1,251)	**390**	**438**	**202**	**153**	**55**	**8**	**5**

Table c.2 Dominance/Submission within the Pipestone Wolf Family, 2011.

Dominance/submission	Spirit	Faith	Blizzard	Djingo	Yuma	Jenny	Kimi
Spirit	–	0	0	0	0	0	0
Faith	0	–	0	0	0	0	0
Blizzard	33	112	–	0	0	0	0
Djingo (juvenile son, 6 months)	111	87	59	–	3	3	0
Yuma (juvenile daughter, 6 months)	99	104	88	0	–	0	0
Jenny (juvenile daughter, 6 months)	94	130	77	16	21	–	0
Kimi (juvenile daughter, 6 months)	107	144	99	78	31	24	–
Totals (n = 1,520)	**444**	**577**	**323**	**94**	**55**	**27**	**0**

Table c.3 Dominance/Submission within the Pipestone Wolf Family, 2012.

Dominance/Submission	Spirit	Faith	Chester	Yuma	G.B.	Trickster	Sunshine
Spirit	–	0	0	0	0	0	0
Faith	0	–	0	0	0	0	0
Chester	88	79	–	22	0	0	0
Yuma	93	166	18	–	0	0	0
G.B. (juvenile son, 6 months)	133	99	56	49	–	3	0
Trickster (juvenile son, 6 months)	102	91	51	39	2	–	0
Sunshine (juvenile daughter, 6 months)	91	144	53	66	12	11	–
Totals (n = 1,468)	**507**	**579**	**178**	**176**	**14**	**14**	**0**

Table c.4 Dominance/Submission within the Pipestone Wolf Family, 2013.

Dominance/Submission	Spirit	Faith	Yuma	Sunshine	Tyler	Elaine	Kayla
Spirit	–	0	0	0	0	0	0
Faith	0	–	0	0	0	0	0
Yuma	77	132	–	0	0	0	0
Sunshine	99	141	49	–	1	0	0
Tyler (juvenile son, 6 months)	111	98	54	39	–	0	0
Elaine (juvenile daughter, 6 months)	101	117	89	44	22	–	0
Kayla (juvenile daughter, 6 months)	119	133	91	50	29	12	–
Totals (n = 1,608)	**507**	**621**	**283**	**133**	**52**	**12**	**0**

APPENDIX D
Pipestone Leadership Behaviour

In our survey, we were able to confirm that Faith demonstrated a lot of leadership right from the start, as soon as the Pipestones came into the Bow River Valley. When Spirit got older, Faith made decisions in a majority of cases relevant for the family group. This takes us to the extremely contentious subject of "leadership behaviour" in a wild wolf family. The concept of the continuously leading "alpha male" simply did not exist with the Pipestones.

After having directly observed several wolf families for long periods of time during a variety of activities (within and outside their core territories, in different seasons, different landscapes, different snow conditions and under different traffic density on roads and railway tracks), and having noted which wolf individual led the family group, we were not surprised to see a lot of flexibility and variability. Most of the time, however, Spirit led the group when a vital decision in connection with a hazardous situation had to be made. In contrast, it didn't seem to matter at all who led the group within the Pipestones' core area. In fact, Spirit and/or Faith led the group most of the time when deciding the fate of the family in situations that dealt with reproduction, food provisioning and avoiding hazards. Juvenile wolves, on the other hand, led the group on travels through their core area if no hunting motivation was recognizable.

Where a path forked or in areas at the boundaries of the Pipestones' territory, the leading juvenile wolf would stop and stare, then turn its head around to one of the parent individuals to establish visual contact. Either Spirit or Faith would then come up and make the decision as to which direction the family was to go. Sometimes, a juvenile wolf would only use visual communication to ascertain whether Spirit and/or Faith wanted to come up in front and would then continue leading the group in a certain direction. Obviously, Spirit and Faith didn't even have to be in the front position to lead the Pipestone family. Some field researchers such as Douglas Smith use the new ethological terms "non-frontal-leadership" or, alternatively, "central-position-leadership" to describe such occasions.

Often in sports, it is a midfield player (e.g., football or soccer) who pulls the strings and manipulates the actions of everybody involved from a central position. With wild wolves, the leadership of a family varies considerably, depending on what motivates an action. Thus, Faith always led when she was heading for den sites at different locations in order to scrutinize their safety. In such situations, for instance, all other members of the family, including Spirit, would follow her everywhere. On the other hand, Spirit would assume leadership when a potentially dangerous situation (e.g., expansion into unknown terrain, crossing busy roads or railways, encountering enemies or dangerous predators) would necessitate it.

Spirit and Faith shared a lot of leadership on the hunt. When killing prey, they acted in harmony and with determination. No juvenile or yearling wolf was forced to follow their parents; many chose to experience the hunt on their own. However, when juvenile wolves (under the age of 8 months) pursued prey without the leadership of their parents, which happened fairly often, their hunting success was low. With adult members leading the hunt, this was a different story with the juveniles, because their hunting success with Spirit and/or Faith backing them up was much higher. Regardless of which wolf had either killed or found large prey species or a carcass, all of the family

members fed almost at the same time. It was rare to see a distinct feeding order.

The following three tables show which wolves were leading the Pipestone group over a measured distance of at least 100 metres, excluding setting off to hunt but including crossing roads, leading along the Bow Valley Parkway or the CP tracks, leading through highway underpasses and/or leading into unknown territory outside the Pipestones' usual territorial boundaries. The tables show the leadership behaviour that occurred between November 2009 and November 2013, excluding pups under the age of 4 months.

Table D.1 Leadership Behaviour (Frontal Position) in the Pipestone Wolf Family, 2009 – 2010.

Leadership	Spirit (%)	Faith (%)	Chesley (%)	Skoki (%)	Blizzard (%)	Raven (%)
2009 (n = 28)	10 (36%)	8 (29%)	5 (18%)	2 (7%)	3 (10%)	0
2010 (n = 700)	279 (40%)	299 (42%)	0	11 (2%)	109 (15%)	2 (0.3%)
Totals (n = 728)	**289**	**307**	**5**	**13**	**112**	**2**

Table D.2 Leadership Behaviour (Frontal Position) in the Pipestone Wolf Family, 2011 – 2012.

Leadership	Spirit (%)	Faith (%)	Blizzard (%)	Yuma (%)	Djingo (%)	Jenny (%)
2011 (n = 660)	233 (35%)	244 (37%)	118 (18%)	52 (8%)	13 (2%)	–
2012 (n = 706)	255 (36%)	259 (37%)	–	122 (17%)	55 (8%)	15 (2%)
Totals (n = 1,366)	**488**	**503**	**118**	**174**	**68**	**15**

Table D.3 Leadership Behaviour (Frontal Position) in the Pipestone Wolf Family, 2013.

Leadership	Spirit (%)	Faith (%)	Yuma (%)	Djingo (%)	Trickster (%)	Elaine (%)
2013 (n = 548)	89 (16%)	374 (68%)	66 (11%)	14 (3%)	4 (1%)	1 (0.2%)

APPENDIX E
Pipestone Mortality in Relation to Age and Character Type

In ethology, as well as in animal behaviour biology, the frequently used term "shy and bold model" should be rephrased as "extroverted Type A and introverted Type B character or personality." According to our latest long-term behaviour insights collected in the Bow River Valley, the two mentioned basic characters are clearly recognizable in wild wolves. However, we used the term "Type A" for tendentious, extroverted wolf individuals that showed active and curious exploratory behaviour reactions in unknown situations or toward unknown objects. The "Type B" character was used for tendentious, introverted wolf individuals that showed reactive and restrained behaviour reactions in unknown situations and toward unknown objects.

Some wildlife managers have hypothesized that extroverted, boldly behaving wolves using roads and railway tracks are more vulnerable to being hit by vehicles or trains than introverted, shy and more cautious wolves. However, our observations suggest that this theory cannot be confirmed.

The following table shows which adult, yearling or juvenile individuals of the Pipestone wolf family, of either character Type A or B, died on either the highway or the railway in the years 2009 – 2013. Pups under 5 months of age are not included.

Between 2009 and 2013, a total of 16 members of the Pipestone family were killed either on highways or on railways; five were bold Type As, while 11 were shy Type Bs. That means only one-third of the total wolves killed were Type As, but an astonishing two-thirds of the wolves were Type Bs, suggesting that bold and extroverted wolves were killed less often because they were more visible to park visitors and drivers. Besides the fact that Type Bs were less visible than Type As, shy Type B wolves were also killed more often because they darted across roads, whereas bold Type As would often stand in the middle of the road where drivers could see them and had more time to slow down.

Table E.1 Pipestone Mortality Related to Character Type, 2009 – 2013.

Mortality	2009	2010	2011	2012	2013
Type A adults	0	0	1	1	
Type B adults	0	0			
Type A yearlings	0	0			1
Type B yearlings	0	1	1	3	2
Type A juveniles	0	0		1	1
Type B juveniles	0	2	1	1	
Totals (A and B)	0	3 Type Bs	1 Type A and 2 Type Bs	2 Type As and 4 Type Bs	2 Type As and 2 Type Bs

BIBLIOGRAPHY

Bekoff, Marc. "The Development of Social Interaction, Play, and Metacommunication in Mammals: An Ethological Perspective." *Quarterly Review of Biology*, no. 47 (1972): 412–434.

———. "Social Play Behaviour: Cooperation, Fairness, Trust, and the Evolution of Morality." *Journal of Consciousness Studies* 8, no. 2 (2001): 81–90. http://www.imprint.co.uk/pdf/81-90.pdf.

Bekoff, Marc, and Jessica Pierce. *Wild Justice: The Moral Lives of Animals*. Chicago, IL: University of Chicago Press, 2009.

Bloch, Günther. "Feldforschungsbericht." Bad Münstereifel, Germany: Canid Behaviour Centre, Winter 2001–2002.

———. "Mensch und Wolf in Koexistenz? Datengestützte Überlegungen zum Anpassungsverhalten eines nicht bejagten Wolfsbestandes gegenüber Menschen." Bad Münstereifel, Germany: Canid Behaviour Centre, 2015.

———. "Social Structure, Population Trend, Sex Ratio, Character Types, Mortality and Dispersal in Two Wolf Families: 'Bows' & 'Pipestones.'" Bad Münstereifel, Germany: Canid Behaviour Centre, 2013.

Bloch, Günther, and Karin Bloch. "Alpha-Concept, Dominance and Leadership in Wolf Families." *Wolf! Magazine* 20, no. 2 (2002): 3–7.

———. "The Influence of Highway Traffic on Movement Patterns of the Bow Valley Wolf Pack on the Bow Valley Parkway of BNP." Bad Münstereifel, Germany: Canid Behaviour Centre, 2002.

———. *Timberwolf Yukon & Co*. Nerdlen/Daun, Germany: Kynos, 2002.

Bloch, Günther, and Peter Dettling. *Auge in Auge mit dem Wolf*. Stuttgart, Germany: Kosmos, 2009.

Bloch, Günther, and Mike Gibeau. "Adaptive Strategies of Wild Wolves in the Bow Valley of Banff NP." Paper presented at the Wolf & Co – 5th International Symposium on Canids, Filander, Fürth, Germany, 2011.

Bloch, Günther, and Paul Paquet. "Wolf (*Canis lupus*) & Raven (*Corvus corax*): The Co-Evolution of 'Team Players' and Their Living Together in a Social-Mixed Group." Bad Münstereifel, Germany: Canid Behaviour Centre, 2011.

Cafazzo, Simona, Eugenia Natoli and Paola Valsecchi. "Scent-Marking Behaviour in a Pack of Free-Ranging Domestic Dogs." *Ethology* 118, no. 10 (2012): 955–966.

Cafazzo, Simona, Paola Valsecchi, Roberto Bonanni and Eugenia Natoli "Dominance in Relation to Age, Sex, and Competitive Contexts in a Group of Free-Ranging Domestic Dogs." *Behavioral Ecology* 21, no. 3 (2010): 443–455. doi: 10.1093/beheco/arq001.

Callaghan, Carolyn. "The Ecology of Gray Wolf (*Canis lupus*) Habitat Use, Survival and Persistence in the Central Rocky Mountains, Canada." Ph.D. diss., University of Guelph, 2002.

De Waal, Frans. "What Is an Animal Emotion?" *Annals of the New York Academy of Sciences* 1224 (2011): 191–206.

Dettling, Peter. *The Will of the Land*. Victoria, BC: Rocky Mountain Books, 2010.

Ellis, Cathy. "Wolves Hunting on Edge of Town." *Rocky MountainOutlook*, September 23, 2015. http://www.rmoutlook.com/Wolves-hunting-on-edge-of-town-20150923.

Feddersen-Petersen, Dorit. *Ausdrucksverhalten beim Hund: Mimik und Körpersprache, Kommunikation und Verständigung*. Stuttgart, Germany: Kosmos, 2008.

———. *Hundepsychologie*. Stuttgart, Germany: Kosmos, 2004.

Fox, Michael. *Behaviour of Wolves, Dogs and Related Canids*. New York: Harper & Row, 1972.

Gibeau, Mike. "Use of Urban Habitats by Coyotes in the Vicinity of Banff." Master's thesis, University of Montana, 1993.

Goodman, Patricia, et al. "Wolf Ethogram," Ethology Series no. 3. Battle Ground, IN:

North American Wildlife Park Foundation, 1985.

Heinrich, Bernd. *Die Seele der Raben*. Frankfurt am Main, Germany: S. Fischer Verlag, 1994. Published in English as *Mind of the Raven: Investigations and Adventures with Wolf-birds*. New York: HarperCollins Cliff Street Books, 1999.

———. "Team Players." *Dogs Magazine*, no. 6 (2010): 114–117.

Katz, Daniel. "Parks Canada Looks for Ways to Manage Record Numbers of Visitors." *Bow Valley Crag & Canyon* 117, no. 7 (February 17, 2016): 11.

Käufer, Mechtild. *Canine Play Behavior: The Science of Dogs at Play*. Wenatchee, WA: Dogwise Publishing, 2014.

Kleiman, D.G. "Scent Marking in the Canidae." *Symposium of the Zoological Society of London* 18 (1966): 167–177.

Lazarus, Richard, and Bernice Lazarus. *Passion and Reason*. Oxford, UK: Oxford University Press, 1994.

Mech, L. David. "Alpha Status, Dominance, and Division of Labor in Wolf Packs." *Canadian Journal of Zoology* 77, no. 8 (1999): 1196–1203.

———. "Leadership in Wolf, *Canis lupus*, packs." *Canadian Field Naturalist* 114, no. 2 (2000): 259–263.

National Park Service. *Management of Habituated Wolves in Yellowstone National Park*. Yellowstone National Park, WY: National Park Service, 2003. http://www.pinedaleonline.com/news/2009/02/habituatedwolves9-2003.pdf.

Pal, S.K. "Urine Marking by Free-Ranging Dogs (*Canis familiaris*) in Relation to Sex, Season, Place and Posture." *Applied Animal Behaviour Science* 80, no. 1 (2003): 45–59.

Panksepp, Jaak. *Affective Neuroscience: The Foundations of Human and Animal Emotions*. Oxford, UK: Oxford University Press, 1998.

———. "The MacLean Legacy and Some Modern Trends in Emotion Research." In *The Evolutionary Neuroethology of Paul MacLean: Convergences and Frontiers*, edited by Gerald A. Cory Jr. and Russell Gardner Jr., ix–xxvii. Westport, CT: Praeger, 2002.

Paquet, Paul. "Summary Reference Document, Ecological Studies of Recolonizing Wolves in the Central Canadian Rocky Mountains, Final Report, April 1989 – June 1993." Prepared for Parks Canada, Banff National Park Warden Service, 1993.

Paquet, Paul, David Huggard, and Shelley Curry. "Banff National Park Canid Ecology Study: First Progress Report April 1989 – April 1990." Prepared by John/Paul Associates for the Canadian Parks Service, 1990.

Peterson, Dale. *The Moral Lives of Animals*. New York: Bloomsbury Press, 2011.

Radinger, Elli H. *Die Wölfe von Yellowstone: Die ersten zehn Jahre*. Wetzlar, Germany: Van Doellen, 2004.

Rennicke, Jeff. "Playing Around: In a natural world that rewards efficiency, can wild animals conceivably engage in something as frivolous as play?" *National Parks* 81, no. 3 (Summer 2007): 16–17.

Schenkel, Rudolf. "Expression Studies on Wolves: Captivity Observations." Department of Zoology, University of Basel, 1946. Scanned English-language typescript downloadable in PDFs from www.davemech.org/schenkel.

Smith, Douglas. "Wolf Pack Leadership, Howling Publication." Canmore, AB: Central Rockies Wolf Project, 2002.

Smith, Douglas, Daniel Stahler and Debra Guernsey. *Yellowstone Wolf Project, Annual Reports 2002, 2003, 2004, 2005*. Yellowstone National Park, WY: National Park Service, Yellowstone Center for Resources, 2002–2005.

Trumler, Eberhard. *Das Jahr des Hundes*. Nerdlen/Daun, Germany: Kynos, 1985.

Ward, Camille, Erika B. Bauer and Barbara B. Smuts. "Partner Preferences and Asymmetries in Social Play among Domestic Dog, *Canis lupus familiaris*, Littermates." *Animal Behaviour* 76, no. 4 (2008): 1187–1199. doi:10.1016/j.anbehav.2008.06.004.

Zimen, Erik. *Der Wolf*. Stuttgart, Germany: Kosmos, 2003.

———. "On the Regulation of Pack Size in Wolves." *Zeitschrift für Tierpsychologie* 40, no. 3 (1976): 300–341.

────. "Social Dynamics of the Wolf Pack."
In *The Wild Canids: Their Systematics,
Behavioral Ecology and Evolution*, edited by
M.W. Fox, 336–362. New York: Van Nostrand
Reinhold Co., 1975.

────. *Wölfe und Königspudel: Vergleichende
Verhaltensbeobachtungen*. Munich, Germany:
R. Piper & Co., 1971.